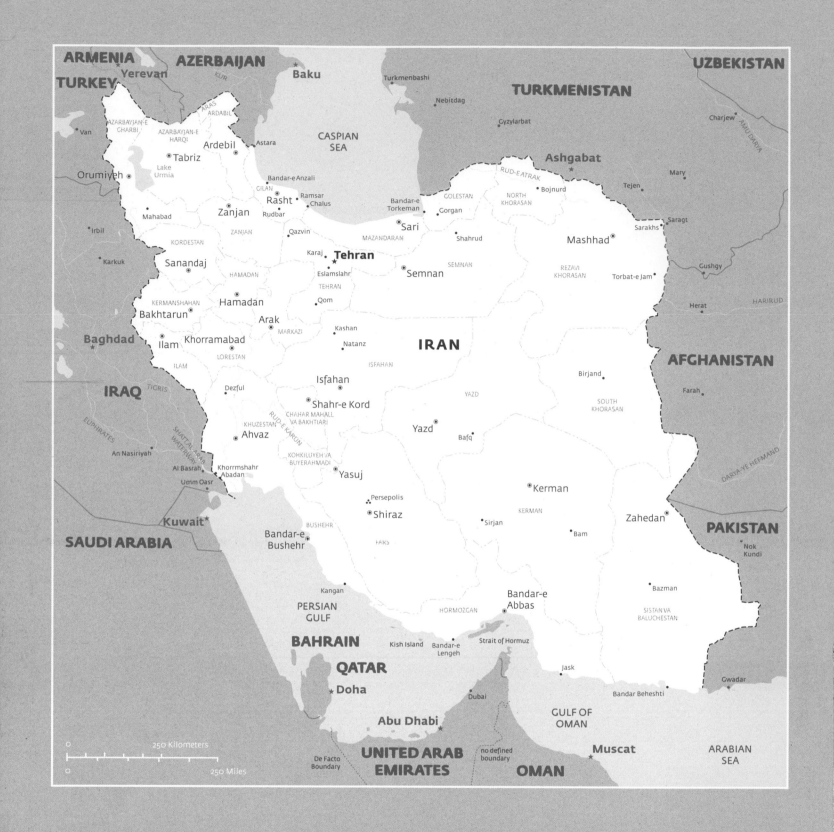

INSIDE IRAN

MARK EDWARD HARRIS
FOREWORD BY ABBAS KIAROSTAMI

CHRONICLE BOOKS
SAN FRANCISCO

ACKNOWLEDGMENTS

My extreme gratitude to my friends and colleagues Mehrdad, Nasrin, Hossein Farmani, Anna Bolek, Sheila and Bob Harris, Rikke Nielsen, Kelly Wearstler, and Patricia Gajo, as well as to Steve Mockus for his editing skills, and to Azi Rad for her thoughtful design. Grateful thanks also to James Felder, Jocelyn Miller, Adrian Curry, Ahmad Kiarostami, and Abbas Kiarostami.

Library of Congress Cataloging-in-Publication Data:
Harris, Mark Edward.
Inside Iran / Mark Edward Harris ; foreword by Abbas Kiarostami.
 p. cm.
 ISBN: 978-0-8118-6330-8
 1. Iran—Pictorial works. 2. Iran—Description and travel. I. Kiarostami, Abbas. II. Title.

 DS254.7.H37 2008
 955—dc22
 2008008324

Manufactured in China

Designed by Azi Rad
This book was typeset in Fedra Sans

10 9 8 7 6 5 4 3 2 1

Chronicle Books LLC
680 Second Street
San Francisco, CA 94107

www.chroniclebooks.com

CONTENTS

ABOUT PHOTOGRAPHY

FOREWORD BY ABBAS KIAROSTAMI

I have to confess that I never liked the term *nature morte* (meaning "still life," literally: dead nature), as it always seemed like an oxymoron to me. Even looking at a dead bird does not remind me of "dead" nature. In fact, it seems more representative of a special event in the cycle of life—a special event with a feel of magic. There is always something magical about life and death, and something even more magical about fixing one special moment, which may apparently have nothing special about it, forever.

So many times, I have witnessed the introduction of a strange upheaval into the heart of everyday life, an unusual presence in the midst of the well-known scenery, and god knows how thankful I have been at that special moment for having my friend the camera with me, and for being

able to move a finger and make the fatal "click" once again. Each time I take a photograph, it is a version of the same experience; not only have I once again easily accepted the intrusion of magic into the realm of reality, but I have been able to fix that moment forever. That is why, to paraphrase a character of Thomas Bernhard's, I snuck into art to get away from life. And what a getaway! This in spite of the fact that life eventually catches up to you.

While looking at the photographs in this book, it surprised me that I was especially enjoying the presence of human beings in the pictures, something that I purposely avoid in my own photographic work. In this collection I enjoyed the magical presence of contemporary moments placed in a historical context. I know those kids in the photographs; they are

the same all around the world. And I know those historical monuments—the pride of the land, they all look the same, too. Suddenly, I got the strange feeling of seeing much more than simple photographs. To me, the pictures represented the great challenge of this century: the temporal versus the eternal. And the message was now obvious to me. Once again, we have to choose life!

They say that one has to write with his ear; well, Mark Edward Harris definitely took these photographs with his heart. This is why we can look at these pictures and hear the stories they have to tell

when you want to get away from it. A photograph is not the image of an illusion, nor the representation of the real. Reality does not disappear under a scrutinizing eye; it just tells us its story. Let's listen to it.

INTRODUCTION

It was with more than a little trepidation that I boarded the IranAir 747 at London's Heathrow Airport bound for Tehran in spring 2007. A group of fifteen British sailors and marines had just been released by the Islamic republic after having been captured by Iranian forces just two weeks earlier in the mouth of the Shatt al Arab waterway that separates Iran and Iraq (they had been accused of illegally entering Iranian waters). It was yet another diplomatic crisis at a time when tensions over Tehran's nuclear ambitions were already setting up the potential for an armed conflict.

Having been named a member of the "axis of evil" in U.S. President George W. Bush's State of the Union address in 2002, having seen what had already happened to another member of the triumvirate, Iraq, and having witnessed the rhetoric going on between North Korea and the United States, how would the Iranian citizenry feel about an American traveling freely around their country, especially one armed with professional photographic equipment? Several Americans of Iranian descent were already being held in the country, accused of spying for the United States.

I had previously traveled to North Korea, in 2005 and 2006, with a similar goal in mind. I wanted to document scenes of daily life little seen or understood by the West at a time of heightened tension, when it seemed all the more important to see what people's lives were like in a country whose future was likely to be played out in a geopolitical chess game. President Bush's declaration that "states like these [Iraq, Iran, North Korea], and their terrorist allies, constitute an axis of evil, arming to threaten the peace of the world," gave me an inescapable sinking feeling that the United States was sliding into a very deep chasm from which it would be difficult to extricate ourselves.

Iran is among the eighty countries I have had the

political conflict, including the former Soviet Union, East Germany, Vietnam, Cuba, Lebanon, Israel, the two Irelands, and the two Koreas. I've been surprised every time by what I have seen and experienced.

After landing at Tehran's Mehrabad Airport, I spent several weeks traveling 7,000 miles on the ground, emerging from Iran with a very different impression from the one I had going in. Life on the streets was much more vibrant and open than I had expected. While many people—both in Iran and in the outside world—see the chadors and burqas as a physical manifestation of oppression, the business and social interactions I witnessed between the sexes did not quite match up. I was surprised to see women running restaurants and acting as contractors on construction sites. To be sure, the difference was more marked between the cities and the remote areas of the country (from which the ruling mullahs draw much of their support), where women were dressed more conservatively, but this distinction in itself was something of a revelation to me, and I wanted to learn more.

On my first visit to Iran, I explored the heart of the country, including the historic cities of Qom, Kashan, Shiraz, Isfahan, and Yazd, and the ruins of Persepolis. I returned several months later to retrace some of my steps and to cast farther afield, traveling to the Persian Gulf, the Caspian Sea, and the Afghan and Iraqi border regions.

Iran is a socially and politically complex country of some 70 million people, with a long, rich, and complicated history. I hope that this book will in its way contribute to a more engaged curiosity about and perhaps a better understanding of this fascinating place in the world.

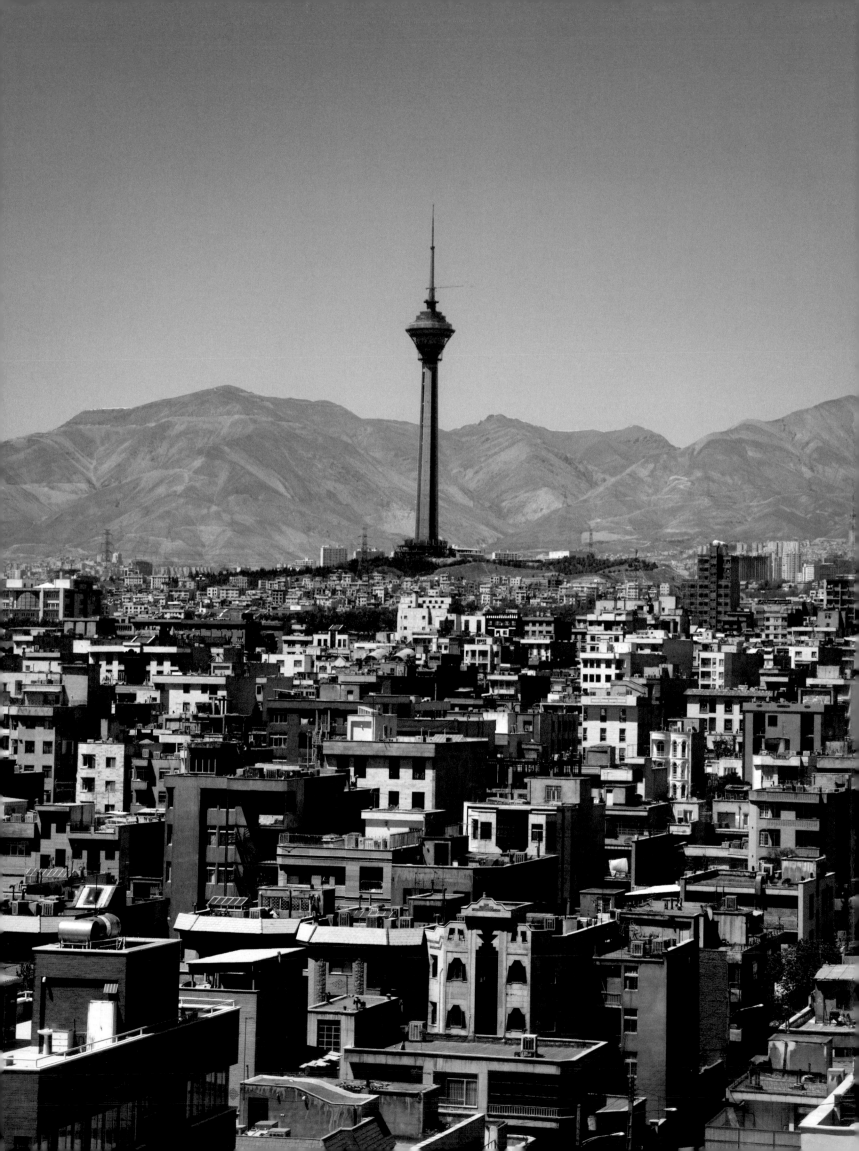

MORE THAN 14 MILLION PEOPLE LIVE IN IRAN'S SPRAWLING CAPITAL CITY, 4,000 FEET ABOVE SEA LEVEL IN THE SOUTHERN FOOTHILLS OF THE ALBORZ MOUNTAIN RANGE.

Tehran, like the rest of Iran, is not how we see it typically depicted in Western media. Since the takeover of the U.S. Embassy in 1979 and the ensuing hostage crisis, we have been exposed to pictures of anti-American murals, women trolling the streets covered in black chadors, and the occasional street execution. This is a small part of a much bigger picture. What we do not see are the throngs of young people hanging out in teahouses, pizza parlors, and shopping malls, or commuting to and from school and work, or mothers and fathers interacting with their children—in other words, scenes of daily life.

In Tehran and some other more cosmopolitan cities such as Isfahan and Shiraz, some of the tensions between religious conservative and Western influences are evident. Battles are often fought in subtle ways and most often by women: head scarves are pulled back to reveal a little dyed hair, or manteaus (long coats less restrictive than chadors, but still meant to obscure a woman's curves) are worn a little tighter than the norm. Shoes, purses, eyeliner, eyelashes, and lipstick are used to show off an individual's sense of style. Sometimes, under the chadors and manteaus are designer clothes.

Since so few parts of a woman's anatomy are visible, those parts that are may be accentuated, sometimes with cosmetics, sometimes with cosmetic surgery. (Tehran is said to be the nose job capital of the world. I saw, but did not photograph, several women with telltale dark circles under their eyes and bandaged noses.)

During my second trip to Iran, a "summer blitz" by authorities took place to enforce the women's dress code. Two college women I talked with had been stopped recently at two different malls because their manteaus were deemed too short and their hair too exposed. In both cases, female police officers covered in black chadors told them to cover their hair and wear longer manteaus. Under such conditions, it seems strange that shops in these same malls display slinky cocktail dresses in their windows.

The better-off men and women I met often recalled the prerevolution days with fondness. That said, there was not—to my outsider's eye, at least—a pervasive sense of depressive restriction. On the contrary, there seemed a lively interaction and energy, with smiles and salaams in greeting among passers-by and vivid conversations in teahouses and on the street.

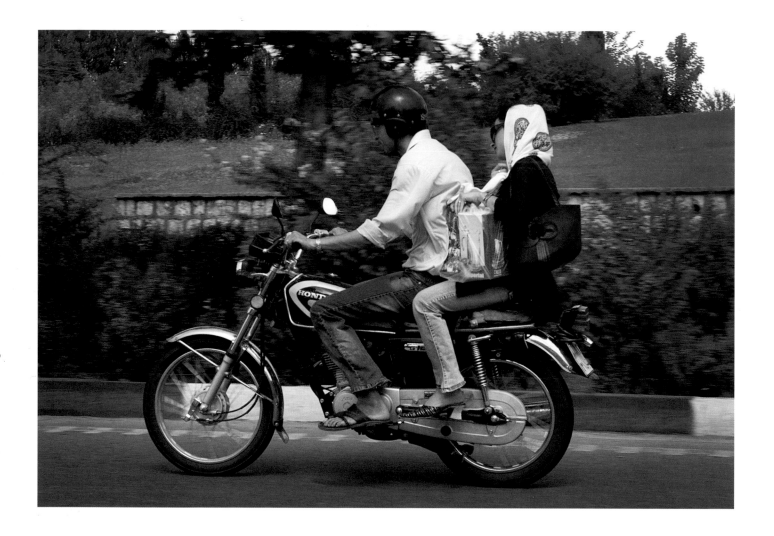

ABOVE
A couple on a motorcycle in northern Tehran.

OPPOSITE
A movie poster viewed from the back of a Tehran taxi.

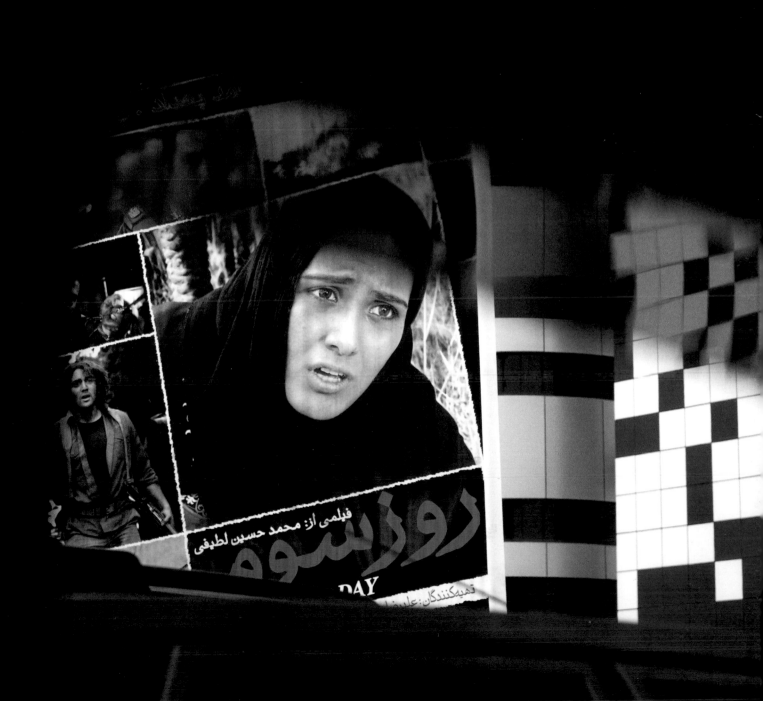

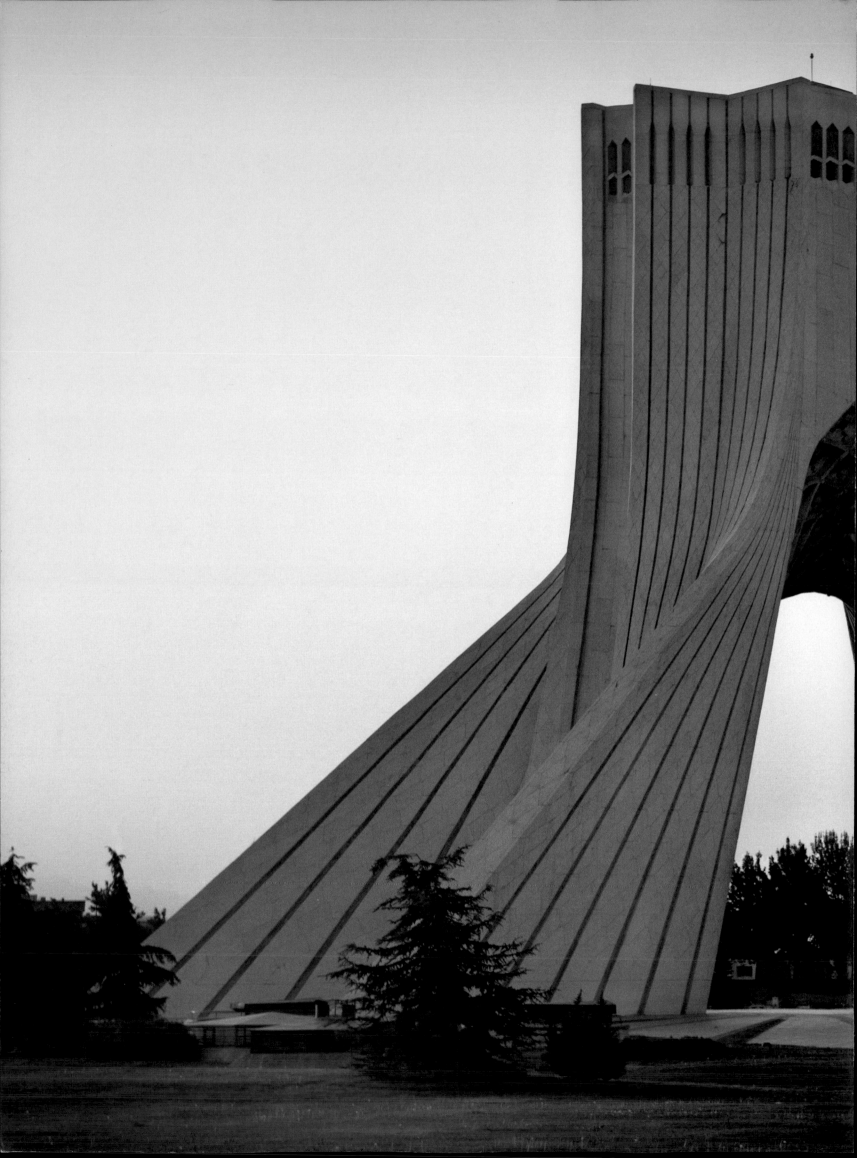

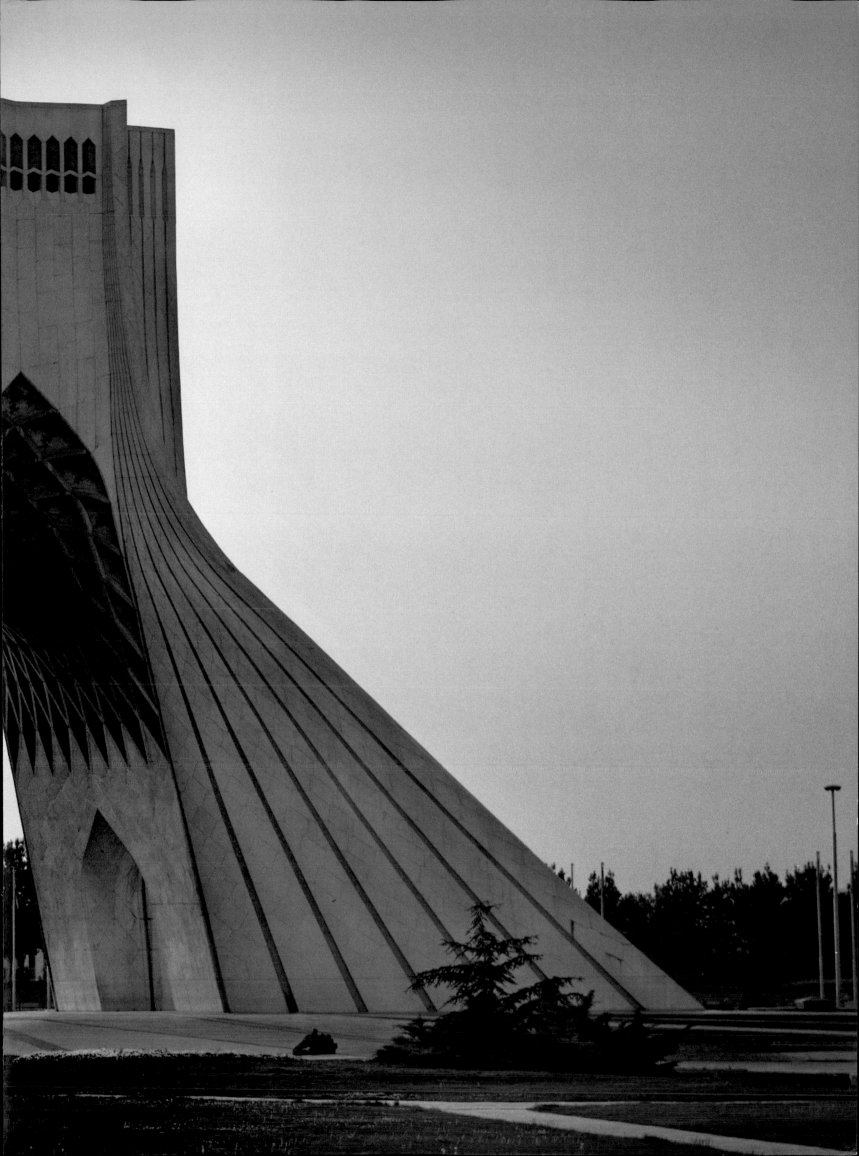

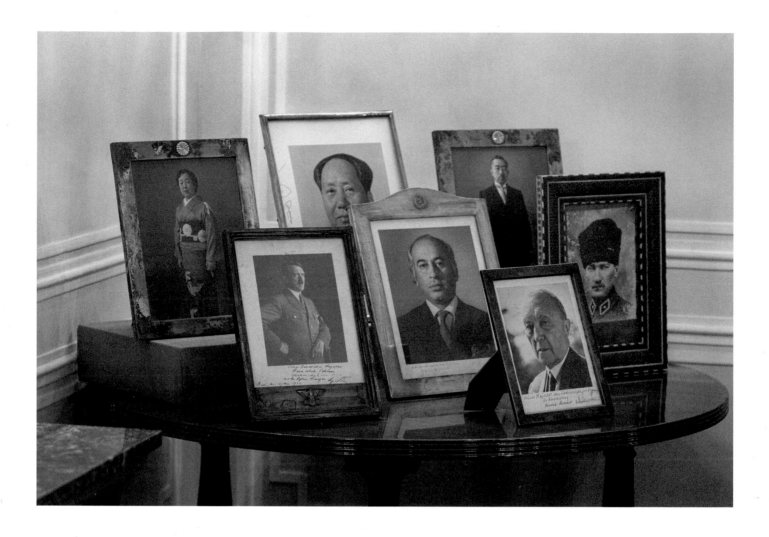

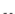

ABOVE
Photographs of the shah's "friends" at the Sadabad Palace in northern Tehran.

OPPOSITE, TOP AND BOTTOM
Rooms at the shah's Sadabad Palace, which now houses a museum complex.

PREVIOUS SPREAD
The 148-foot-tall Azadi (Freedom) Tower is located on the western approach to Tehran from Mehrabad Airport. Built as part of the shah's lavish 1971 celebrations of the 2,500th anniversary of the founding of the Persian Empire, it incorporates fourteenth-century architectural and twelfth-century decorative influences. The celebrations were intended to foster nationalist pride, but the $120 million festivities (including a silken tent city for foreign dignitaries built amid the ruins of Persepolis) contributed to a sense of the shah's conspicuous consumption.

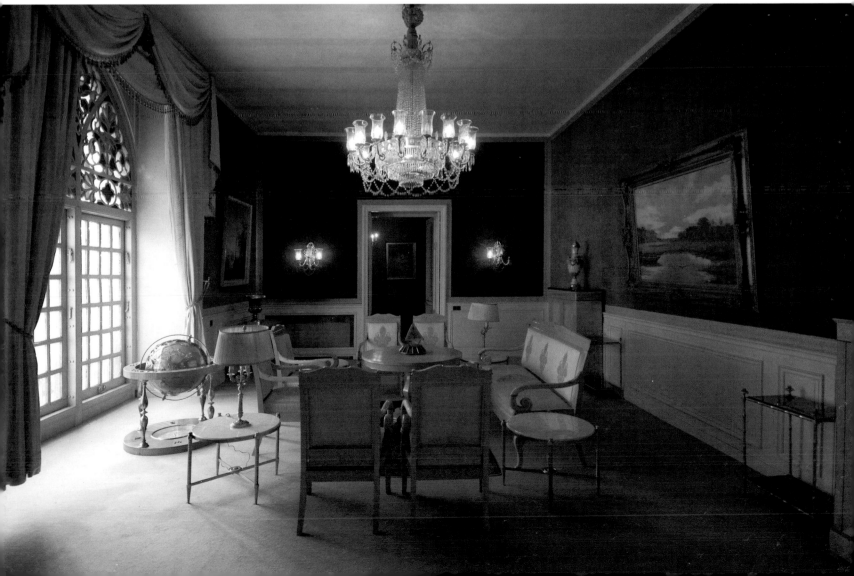

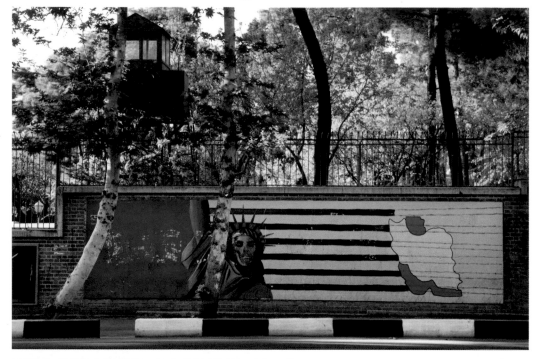

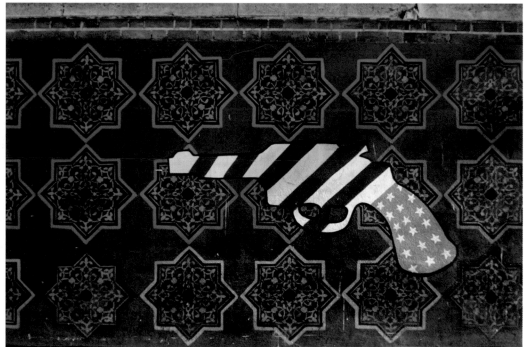

Anti-American murals on the wall
of the former U.S. Embassy in Tehran.
On February 14, 1979, during the
Islamic revolution following the
ouster of the widely unpopular shah
(king) Mohammed Reza Pahlavi
and the return of supreme religious
leader Ayatollah Khomeini from exile,
young revolutionaries stormed the
U.S. Embassy and seized one hundred
hostages, who were released shortly
afterward. In November, while the
shah was being treated in a New York
hospital for a gallbladder condition
and cancer (after having fled to Egypt,
then Morocco, then the Bahamas),
militant students seized the embassy
and took seventy-two hostages. This
time there would be no quick release.
Yasser Arafat, head of the Palestine
Liberation Organization, negotiated
the release of thirteen hostages. Six
American diplomats escaped, and
one hostage was released due to a
medical condition. In April 1980,
U.S. President Jimmy Carter ordered
an aborted rescue attempt. The
fifty-two remaining hostages were
released the day that Carter's succes-
sor, Ronald Reagan, was inaugu-
rated—January 21, 1981, 444 days after
the hostages were first held captive.
The shah, a political hot potato,
left the United States for Panama
in January 1980, accepted Egyptian
President Anwar Sadat's invitation
to go to Egypt in March, and died in a
Cairo hospital that July.

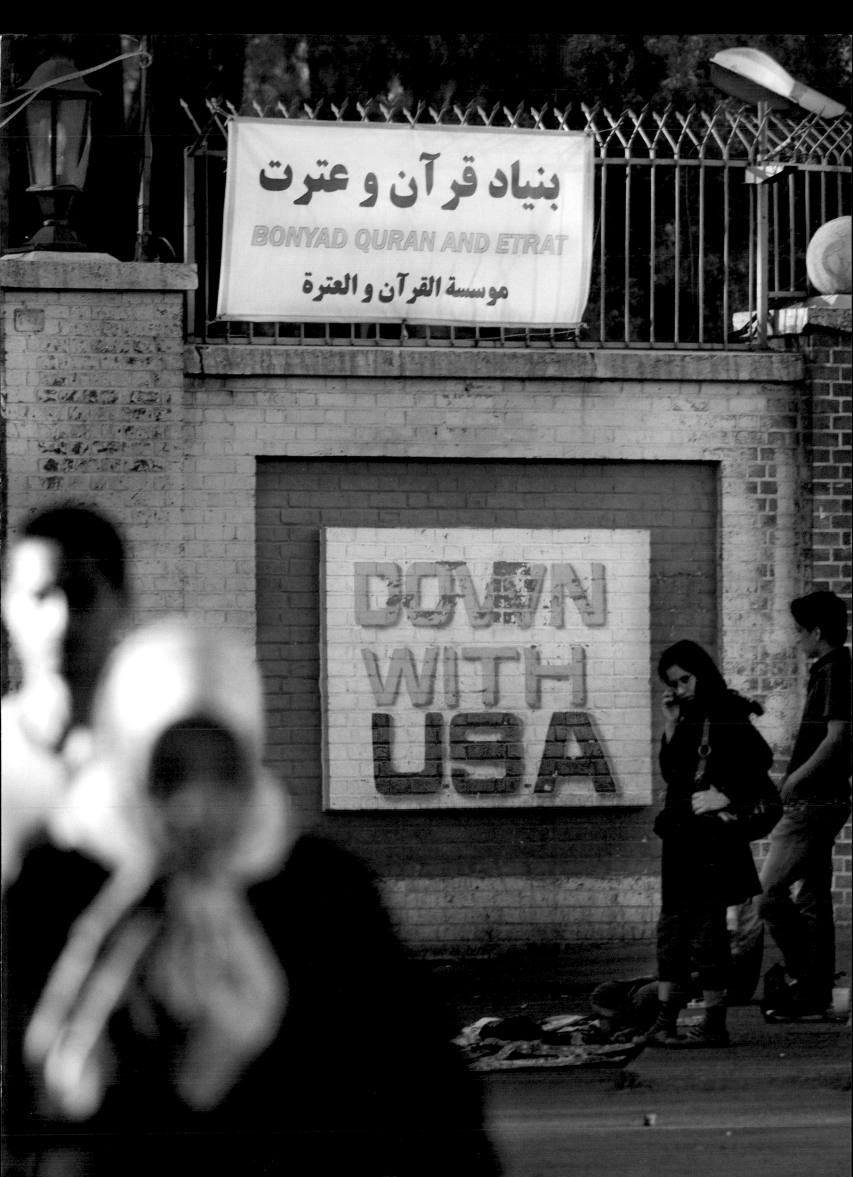

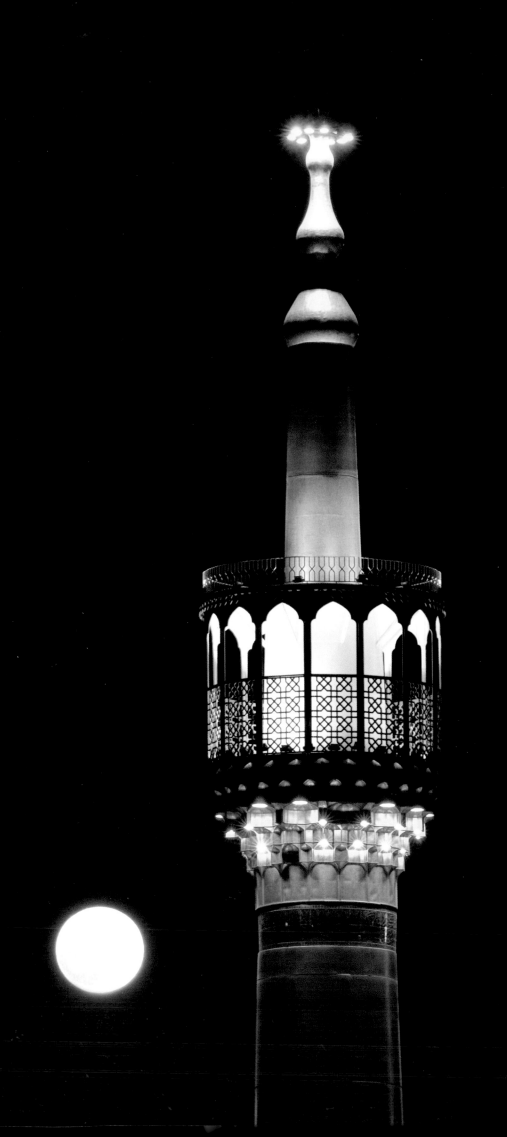

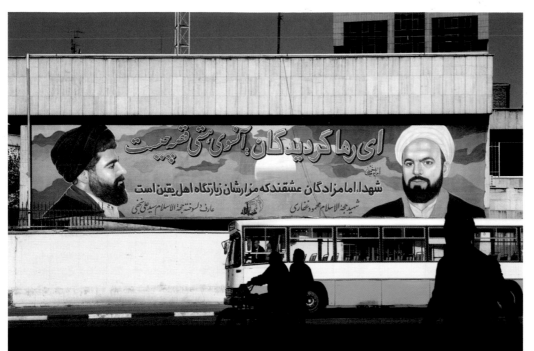

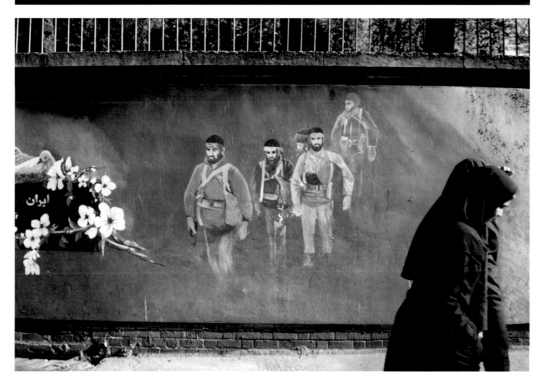

LEFT, TOP

Daily life in Tehran moves past a billboard that reads "Oh those who have found salvation: what is the story behind life? A Martyr's love is saintly and his or her tomb a shrine for the wise and the strong-willed.
—Imam Khomeini"

LEFT, BOTTOM

A mural depicting Iraq-Iran war martyrs on the wall of the former U.S. Embassy in Tehran.

OPPOSITE

Minarets of the tomb complex for the late Ayatollah Khomeini on the southern outskirts of Tehran near the cemetery of Behesht-e Zahra (Paradise of Zahra). Construction of this complex began in 1989 after Khomeini's death. A key figure due to his opposition to the shah, his role in the Islamic revolution, and his inspiration for the current Islamic republic (and its conservative values), Khomeini was mourned by an estimated 10 million people. His funeral is the world's largest on record. Every year on June 4, the anniversary of his death, hundreds of thousands of mourners visit the shrine, where Khomeini's body rests under a gilded dome.

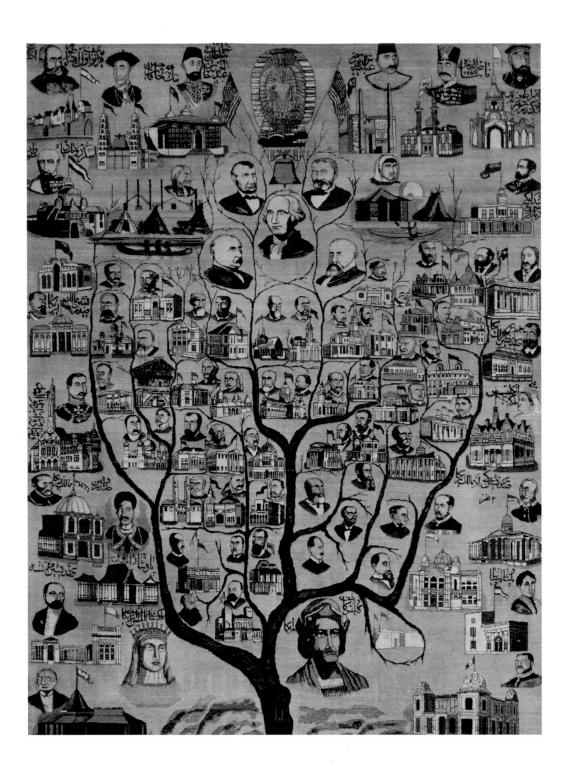

ABOVE
The family tree of U.S. presidents depicted in this carpet in the collection
of the Carpet Museum of Iran was possibly made for the 1904 Louisiana
Purchase Exposition in St. Louis. The museum features works dating from
the sixteenth century.

OPPOSITE
Children play in a park near the Carpet Museum of Iran.

TEHRAN

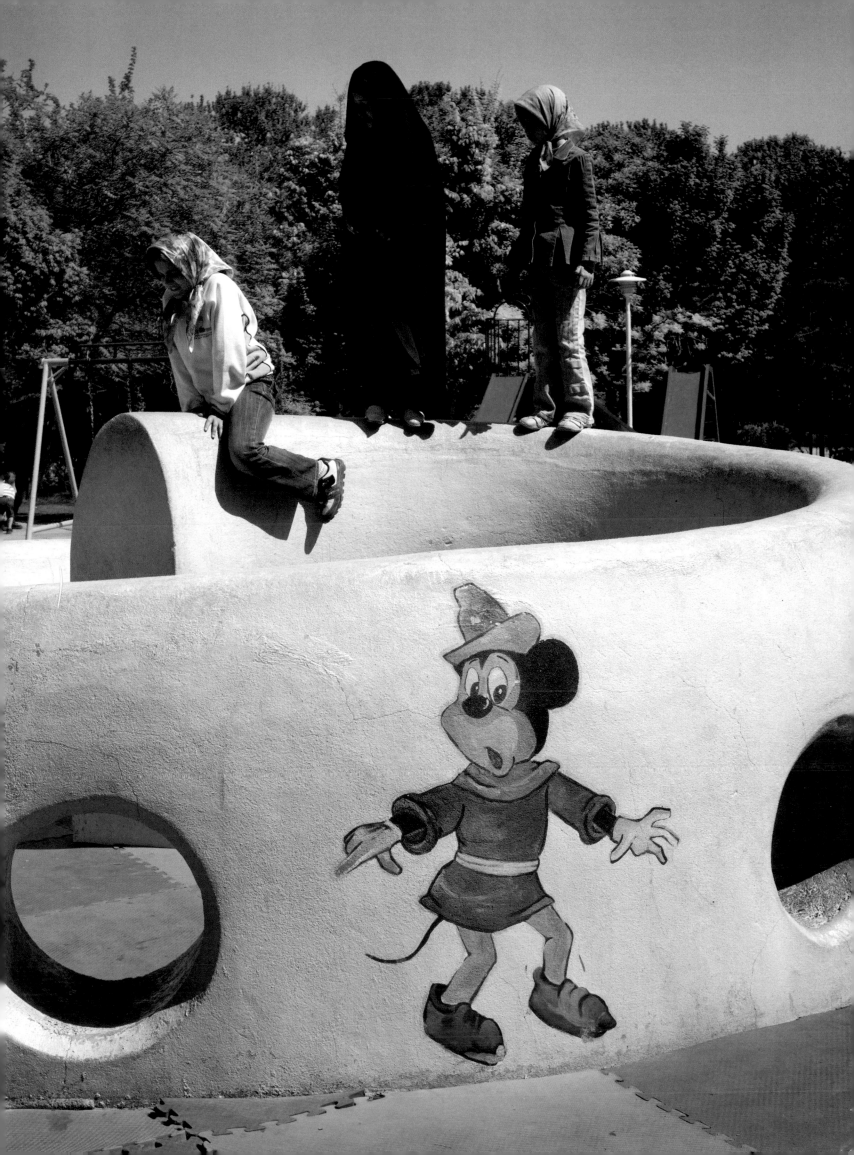

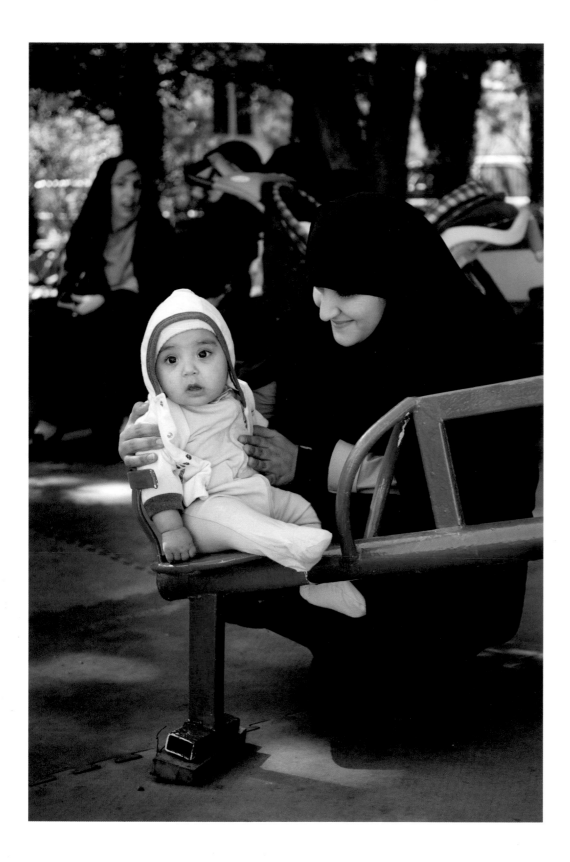

22

ABOVE
A mother and child at a park near the Carpet Museum of Iran.

OPPOSITE
Schoolgirls on a field trip to Golestan (Flower Garden) Palace.

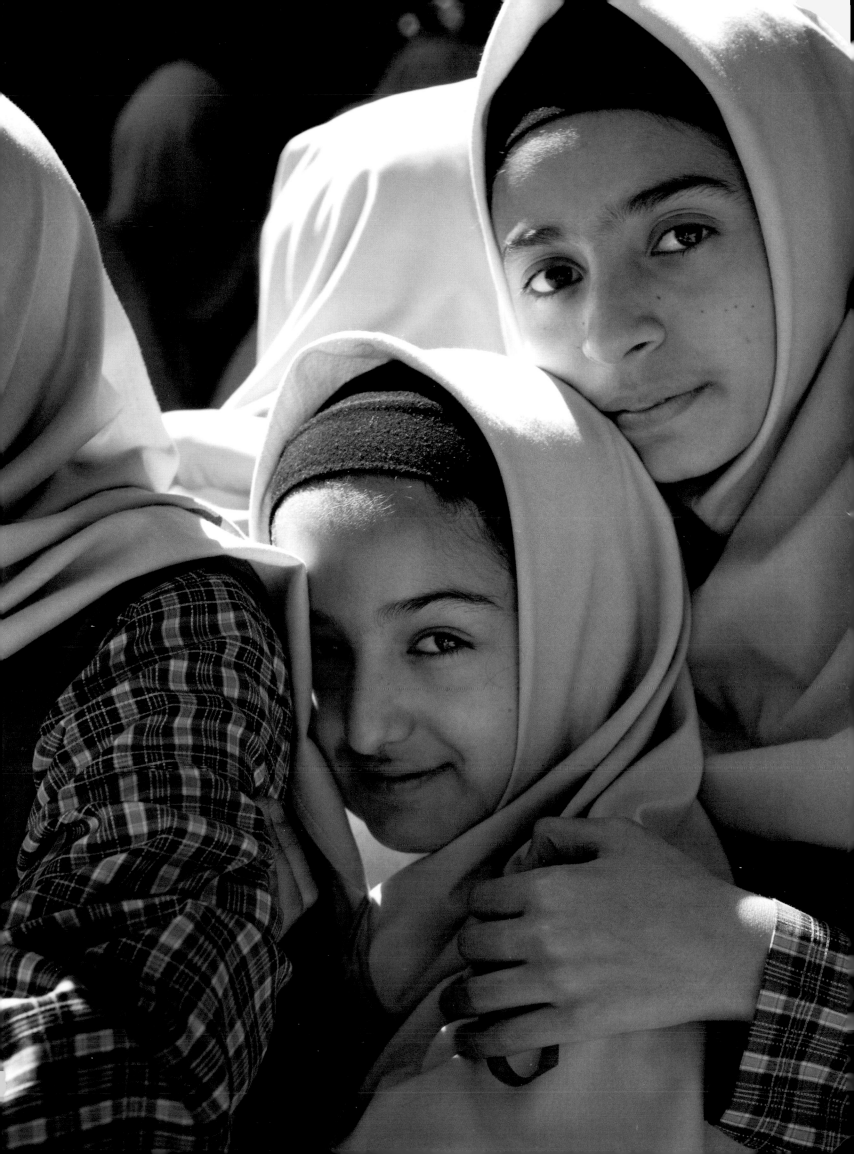

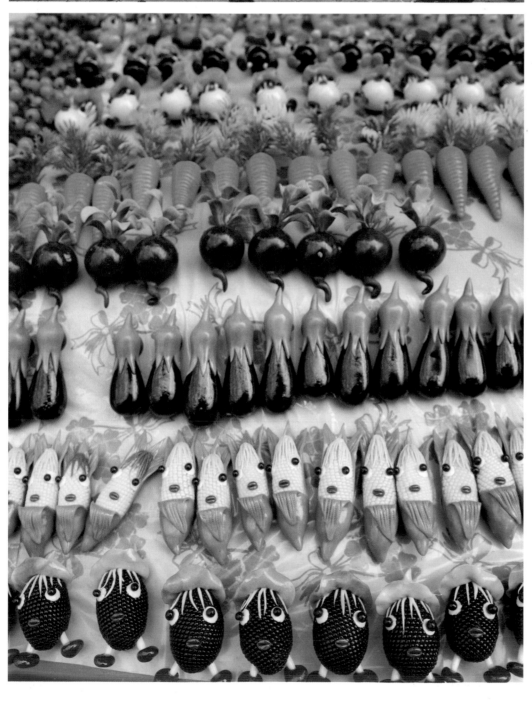

THIS SPREAD
A former village, Darband is now a popular neighborhood in northern Tehran. Restaurants, shopping, and food stalls here are especially popular with young Iranians. It is also the starting point of a major hiking trail into the Alborz Mountains.

FOLLOWING SPREAD
A view of the snow-covered Alborz Mountains from the top floor of Tehran's Laleh International Hotel.

24

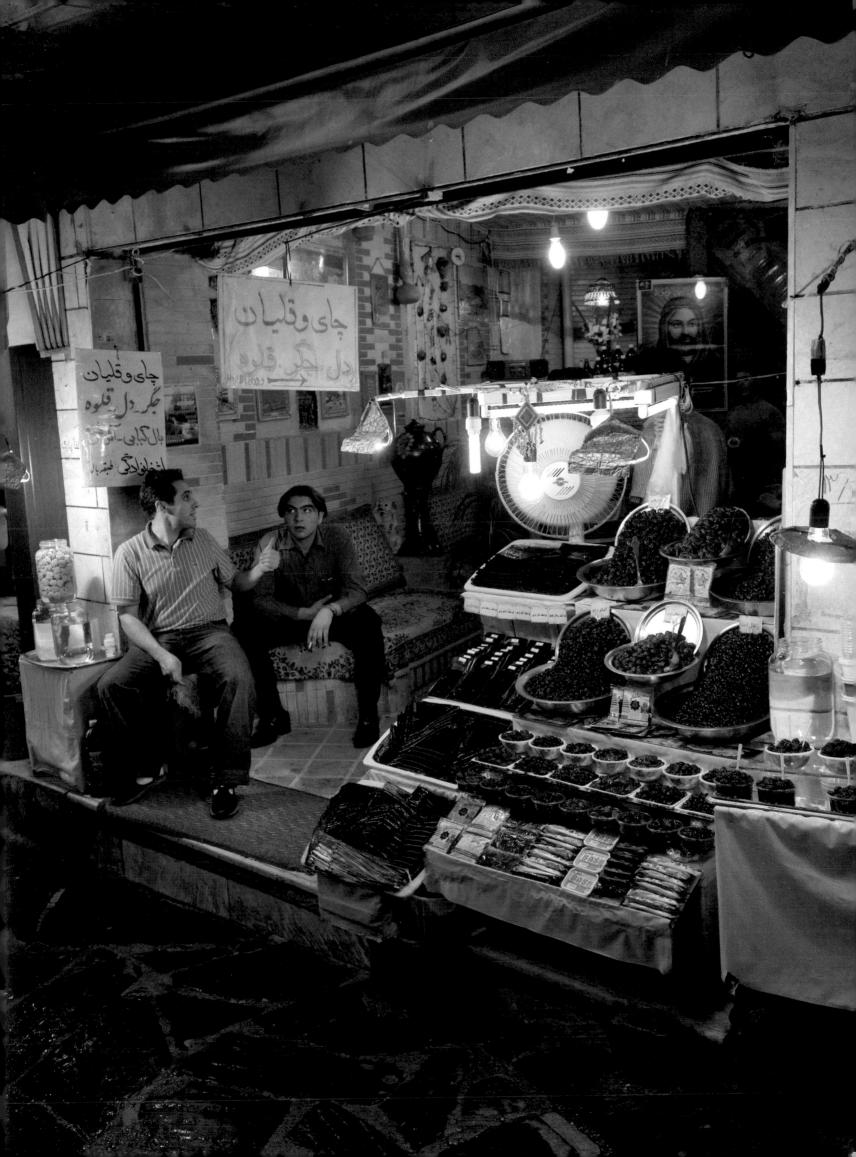

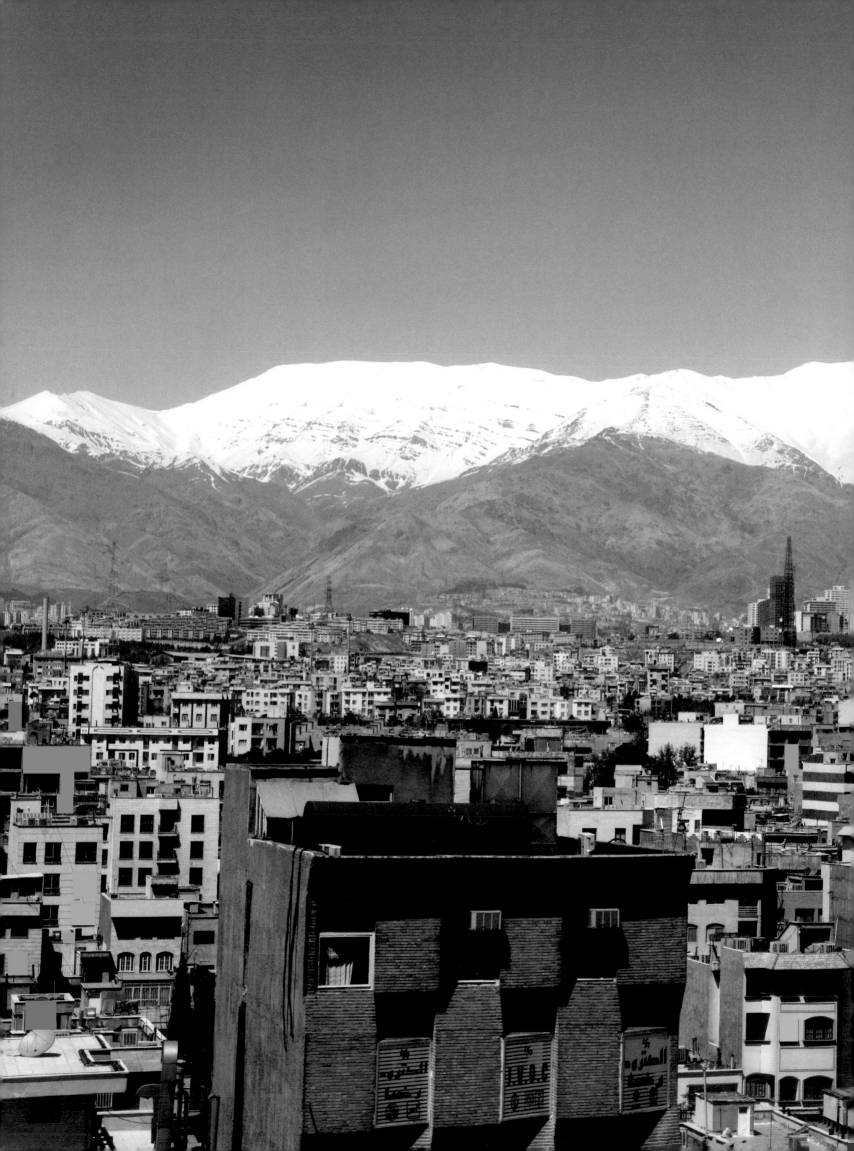

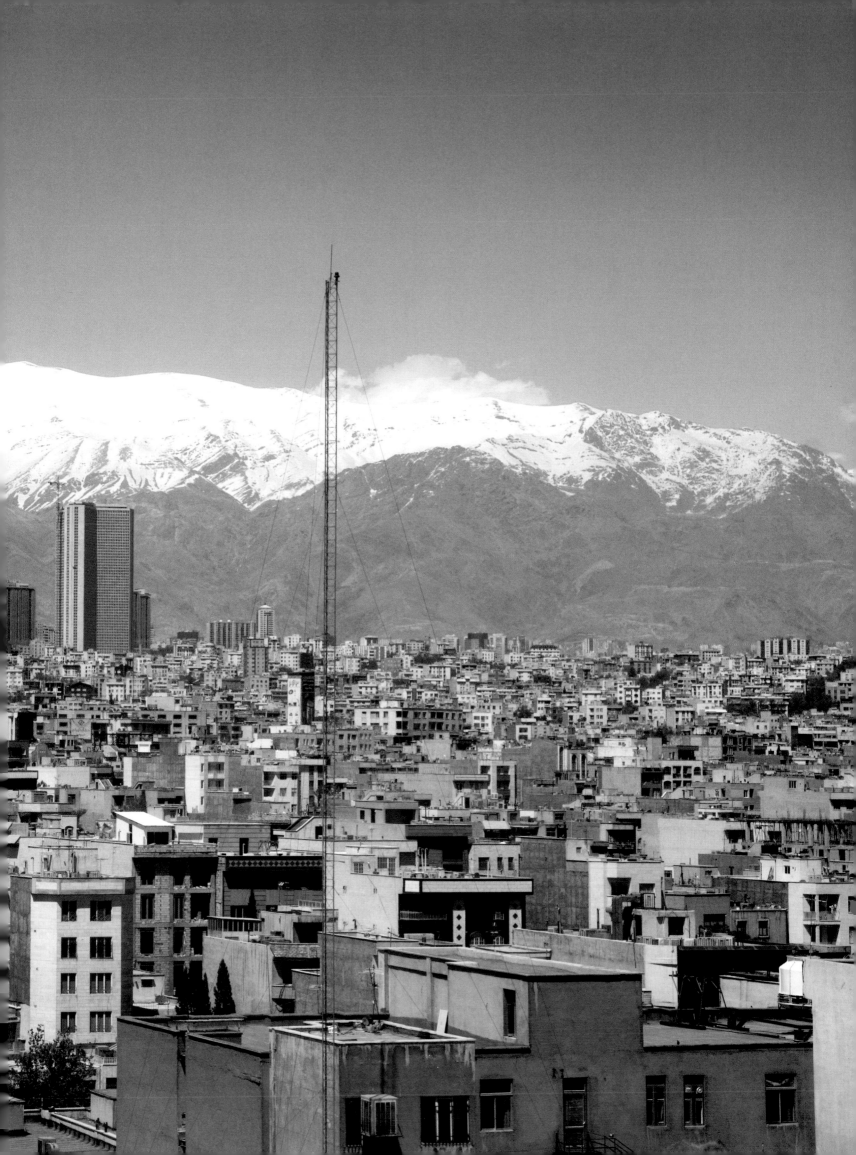

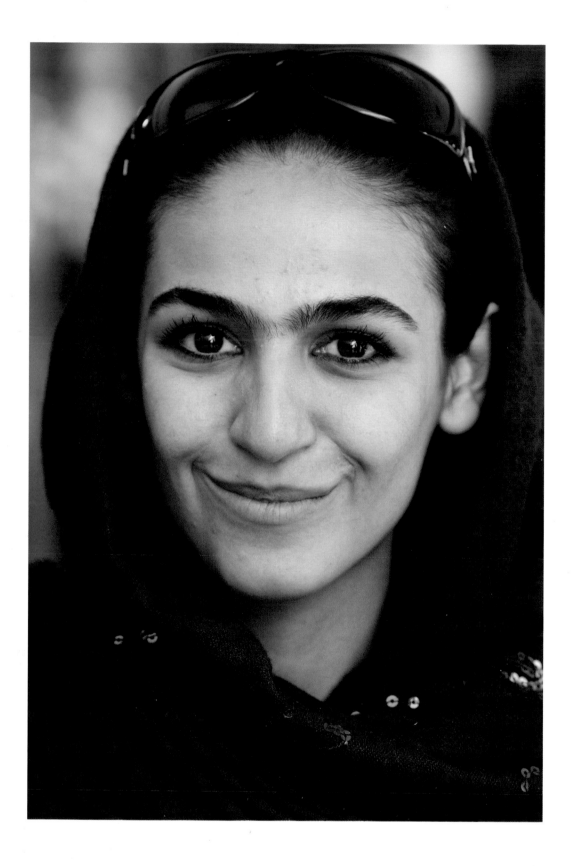

28

ABOVE
A high school student in Karaj.

OPPOSITE
Two patrons at a riverside restaurant in Karaj on the outskirts of Tehran perform
the Friday noontime prayer before lunch. The Shur River flows in the background.

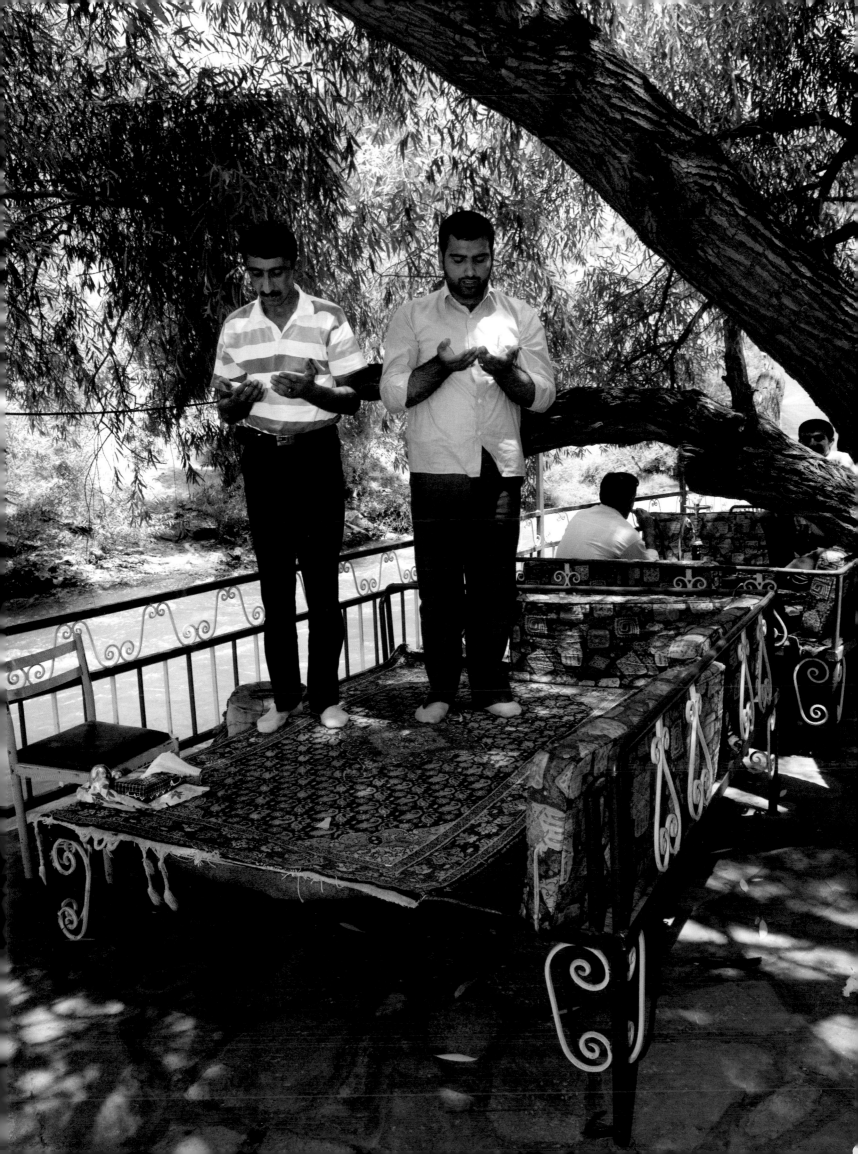

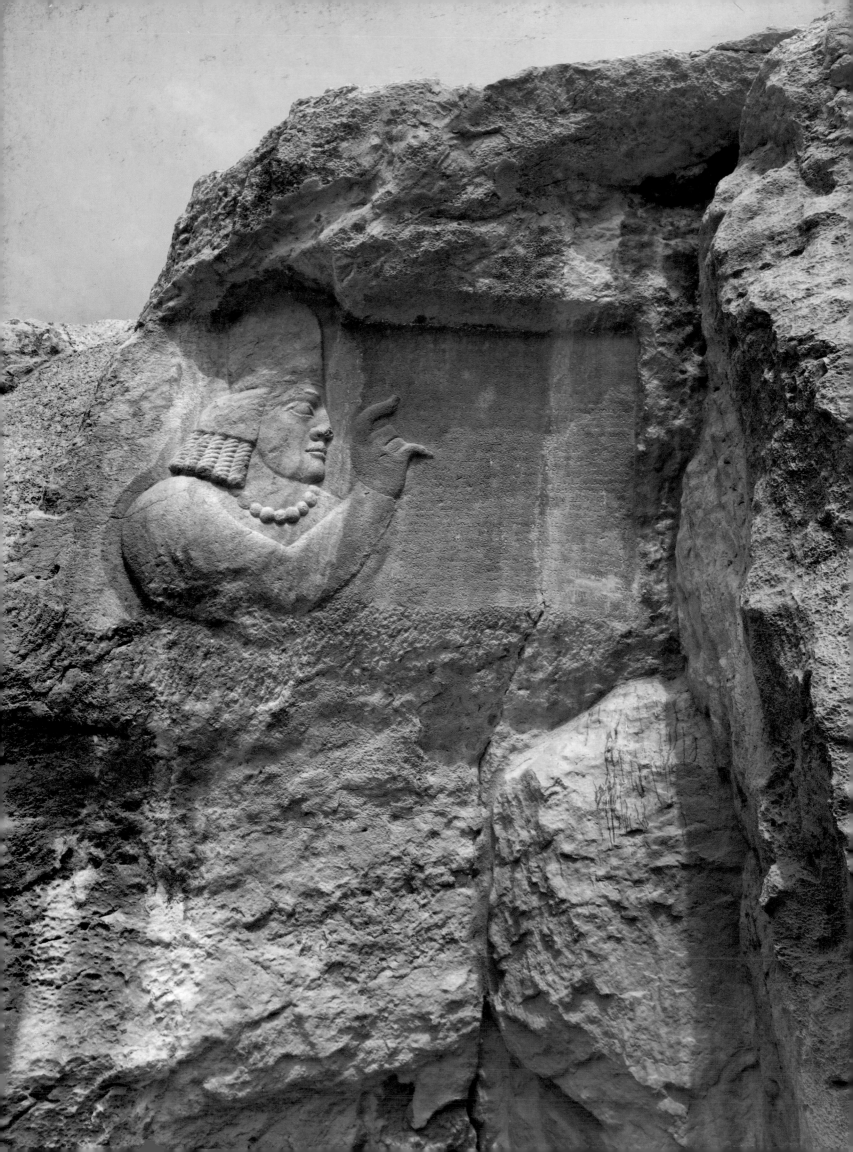

HEART OF IRAN

THE GEOGRAPHIC HEART OF IRAN COMPRISES AN INCREDIBLY DIVERSE AND IMPRESSIVE GROUP OF HISTORIC TOWNS AND MONUMENTS, RANGING FROM THE SHIA HOLY CITY OF QOM TO THE ANCIENT RUINS AT PERSEPOLIS TO THE CLASSIC CITY OF SHIRAZ. IT IS ALSO WHERE THE SMALL MOUNTAIN TOWN OF NATANZ IS LOCATED, WHICH IN RECENT YEARS HAS BECOME A BIG DOT, AND PERHAPS EVEN A TARGET, ON THE WORLD GEOPOLITICAL MAP BECAUSE OF A MAJOR NUCLEAR SITE BEING DEVELOPED NEARBY.

Along the major roads that connect these sites in central Iran, one can see *caravanserais*, ancient roadside inns that supported travelers on trade routes, including those on the legendary Silk Road. While most of these inns are returning to the earth from which they were made, some have been resurrected and turned into impressive boutique hotels.

The first major city south of Tehran is Qom, which contains the second most important religious site in —the Hazrat-i Masumeh, honoring Fatima, the sister of the eighth imam, Imam Reza (AD 765–818). It was in Qom that Ayatollah Khomeini studied and developed his thoughts on religion.

The drive southeast from Qom goes though major towns such as Kashan, Yazd, and Kerman, each with a unique set of shrines and bazaars. This particularly dry area of the country has long struggled with maintaining a water supply, and the people there have developed an impressive irrigation system and maintain a potable water supply. For 2,000 years, they have drawn water from the mountains to the cities using subterranean channels called *qanats*. Outside of the cities, the *qanats* can be identified by their similarity to large molehills.

The area's citizenry have also been ingenious in their efforts at interior climate control. In Yazd, in particular, there are many examples of wind towers known as *badgirs*, which can be described as ecological air-conditioning. Warm air is drawn in and down from the top of a tower on one side of the home and then passes by running water under the house in a *qanat*, whereby the air is cooled. The cool air is then led through the house through holes in the walls of the living quarters, which are often elaborately decorated with beautiful tile work. Across from the holes, outlets lead the air back up and out through the other side of the *badgir*, effectively circulating the air.

In the southern part of central Iran lies Bam, with its adobe complex dating back more than 2,000 years. This UNESCO World Heritage Site suffered major damage in December 2003 from a 6.6 magnitude earthquake, and tens of thousands were killed in the area. The smaller but similarly built adobe Rayan Citadel, 75 miles to the northwest, was spared the brunt of the devastating temblor.

Shiraz, 570 miles south of Tehran, is known as the city of poetry, and here lie the tombs of two of its great poets, Hafez and Saadi. Shiraz is the namesake for the famous grape, which was uprooted for a time after the 1979 Islamic revolution but can still be appreciated as a native fruit. The city is also a major center for the less glamorous but important production of sugar, fertilizer, cement, electronics, textiles, and rugs, and a major oil refinery is also located there.

OPPOSITE
A third-century Sassanid relief at Naqsh-e Rajab depicting the Zoroastrian high priest Kartir with an inscription of his words of devotion to the Sassanian kings.

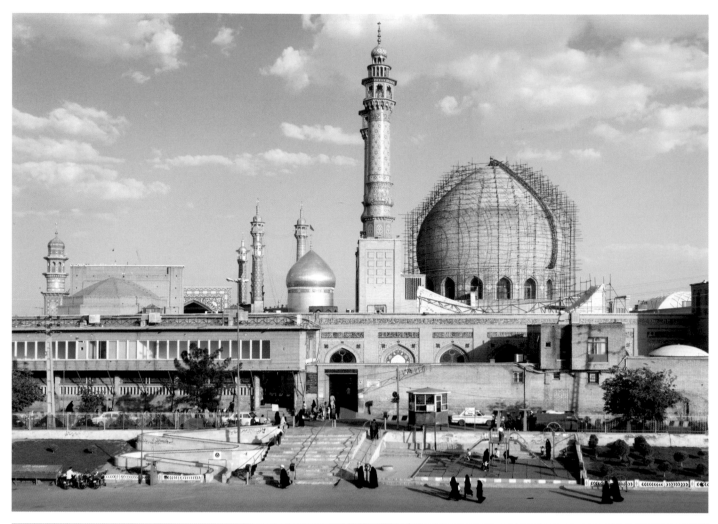

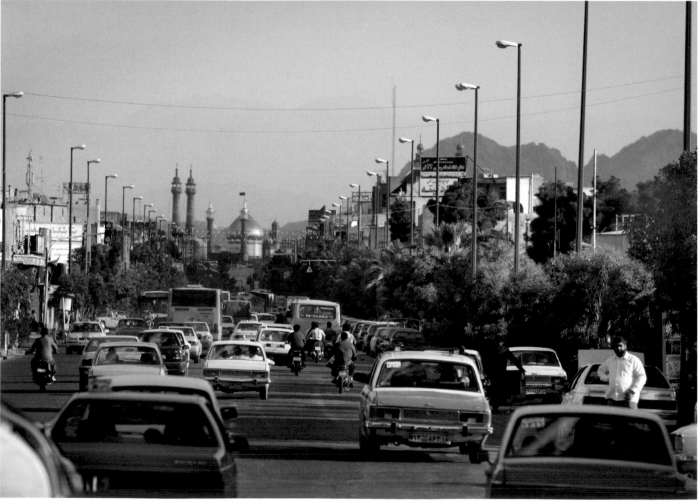

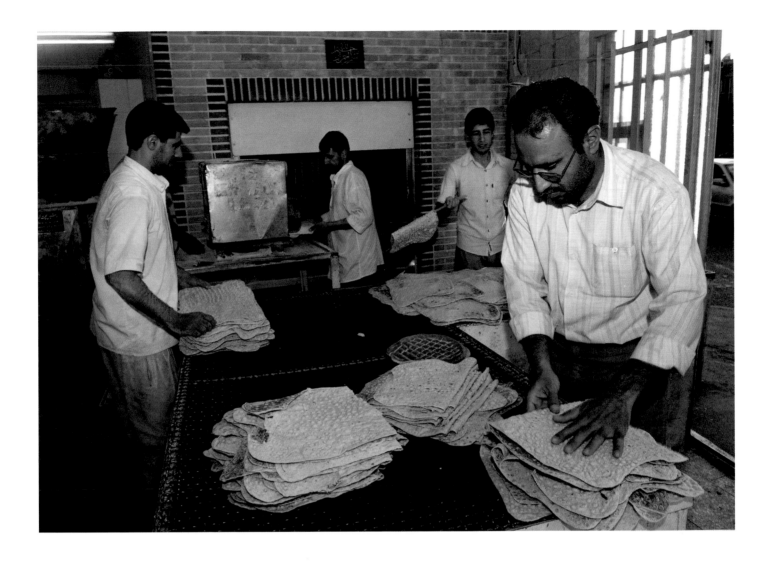

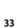

ABOVE
Flatbread in various forms is a very popular staple in Iran.

OPPOSITE, TOP AND BOTTOM
Ninety-seven miles southwest of Tehran is the city of Qom, site of the tomb of Fatima Masumeh, sister of Imam Reza. It is now a city of more than 1 million, with around 60,000 attending its many religious schools dedicated to Islamic teaching. It was here that Ayatollah Khomeini denounced the shah and returned from exile in France to establish his Islamic revolutionary government. Despite the archconservative bent one might expect and observe here—unlike other parts of Iran, nearly all women in Qom wear chadors—there is a notable history of debate among the clerics and sometimes outright challenges to the state of the country's politics.

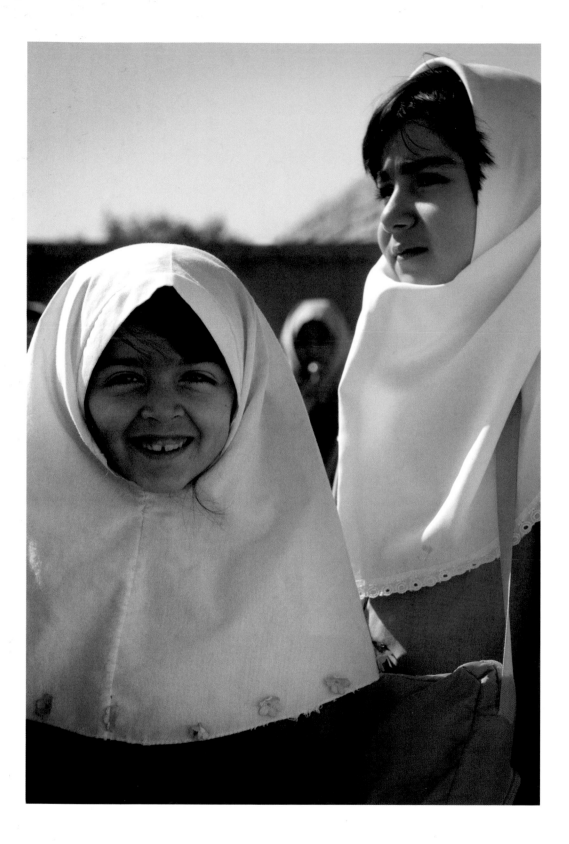

34

ABOVE
Students on a field trip to Tappeh Sialk, an archeological site near Kashan
that contains a ziggurat from the fifth millennium BCE.

OPPOSITE
The dome of the nineteenth-century Agha Bozorg Mosque and madrasa in
Kashan.

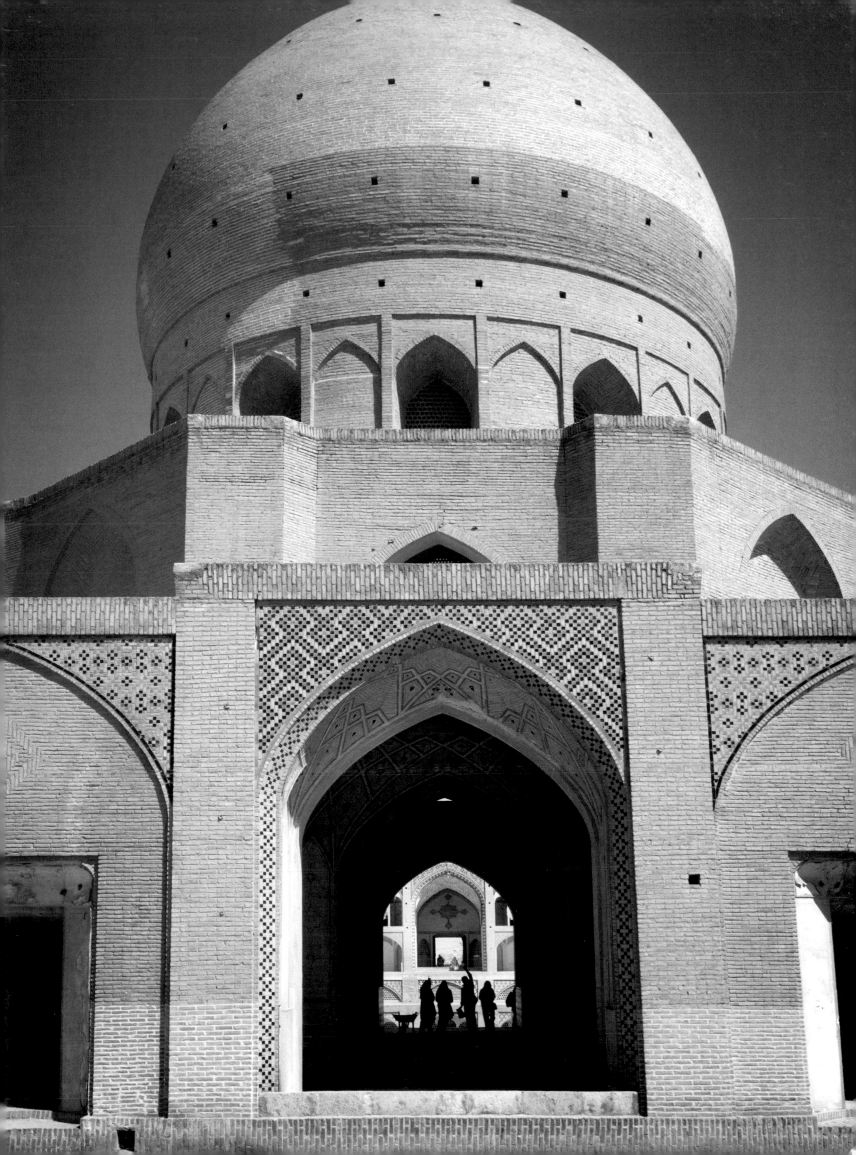

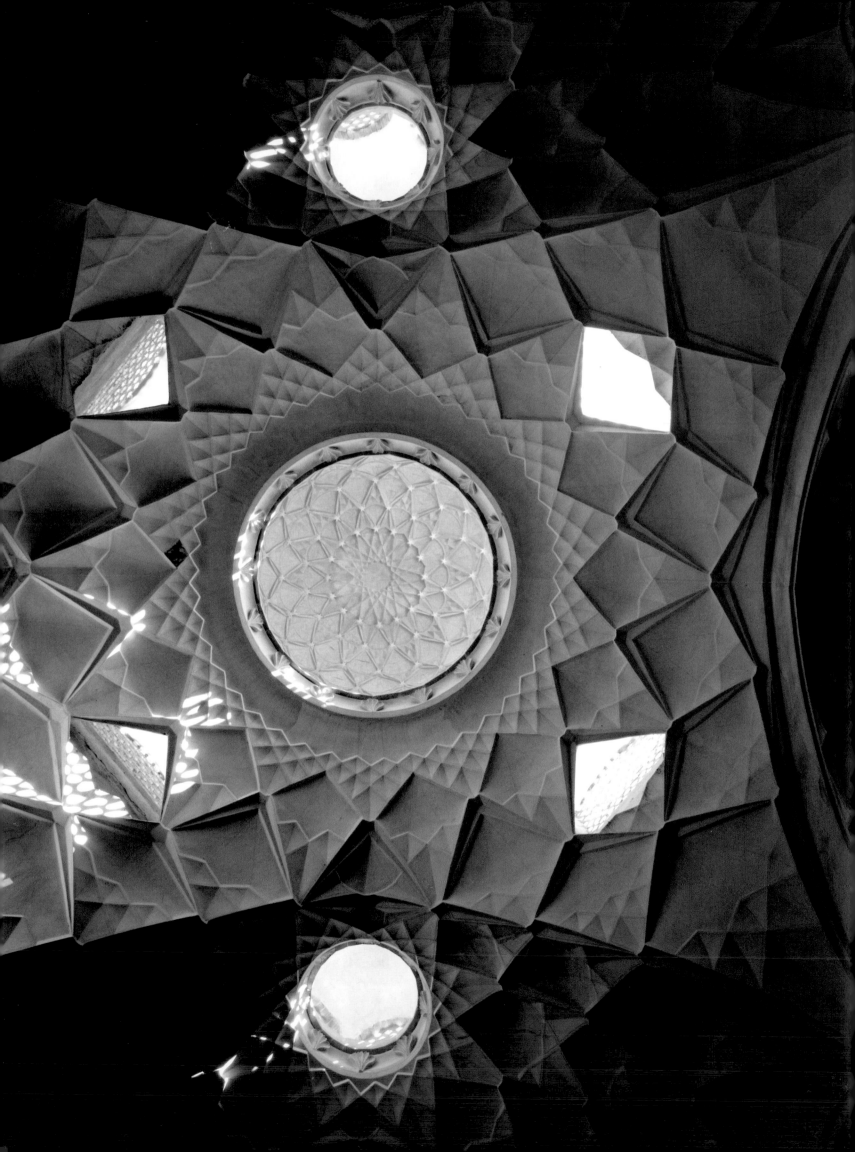

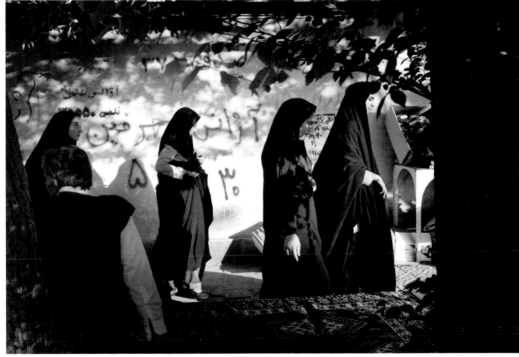

TOP
Sunset over the Zagros Mountains, the largest mountain range in
Iran and Iraq.

ABOVE
A group of women dressed in chadors on their way to the Bagh-i Fin,
a massive garden complex created by the Safavid shahs.

OPPOSITE
The domed ceiling in Kashan's Ameris House, one of a number of
traditional houses open to the public. The property was owned by a
nineteenth-century merchant.

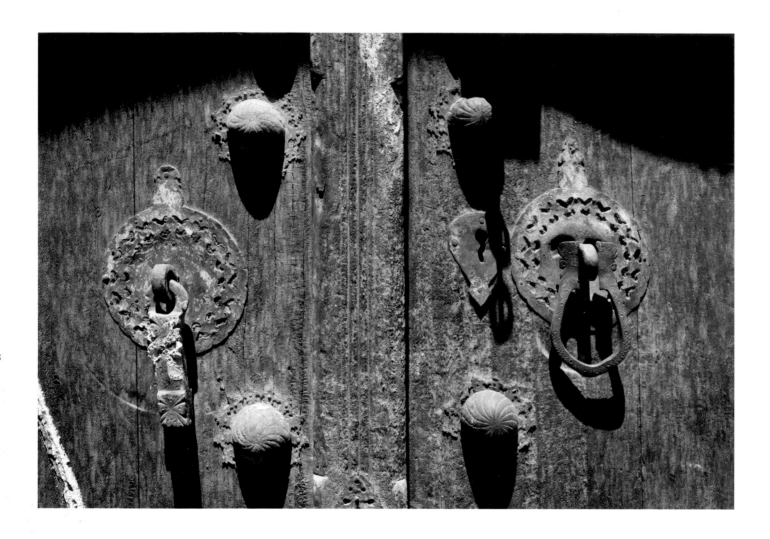

38

ABOVE
Male and female knockers on a door in Abyaneh produce different
sounds and thus alert the occupants as to whether a man or a woman
is at the door.

OPPOSITE
A man in a doorway in the ancient hillside village of Abyaneh, which
dates back to the Achaemenian period, from 559 to 330 BCE.

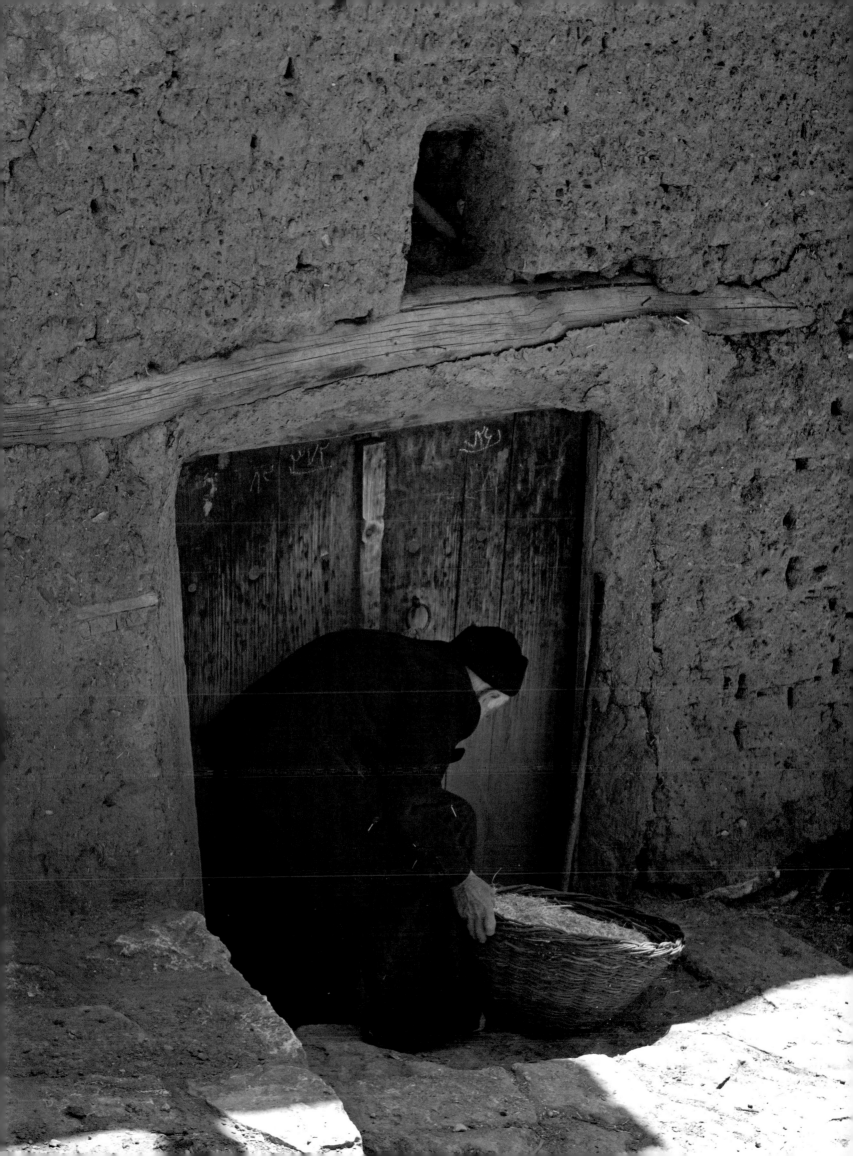

ABOVE, LEFT
An Iranian tourist in the ancient hillside town of Abyaneh protects herself from the sun with a colorful hat.

ABOVE, RIGHT
Graffiti on a wall in the small town of Ahmad Abad.

OPPOSITE
One of two Towers of Silence above the city of Yazd. Ancient Zoroastrian tradition considers a dead body unclean. A code known as the Vendidad has rules for safe disposal of the dead. Bodies were placed at the top of these Towers of Silence so that natural elements—the sun and birds of prey— would aid in decomposition.

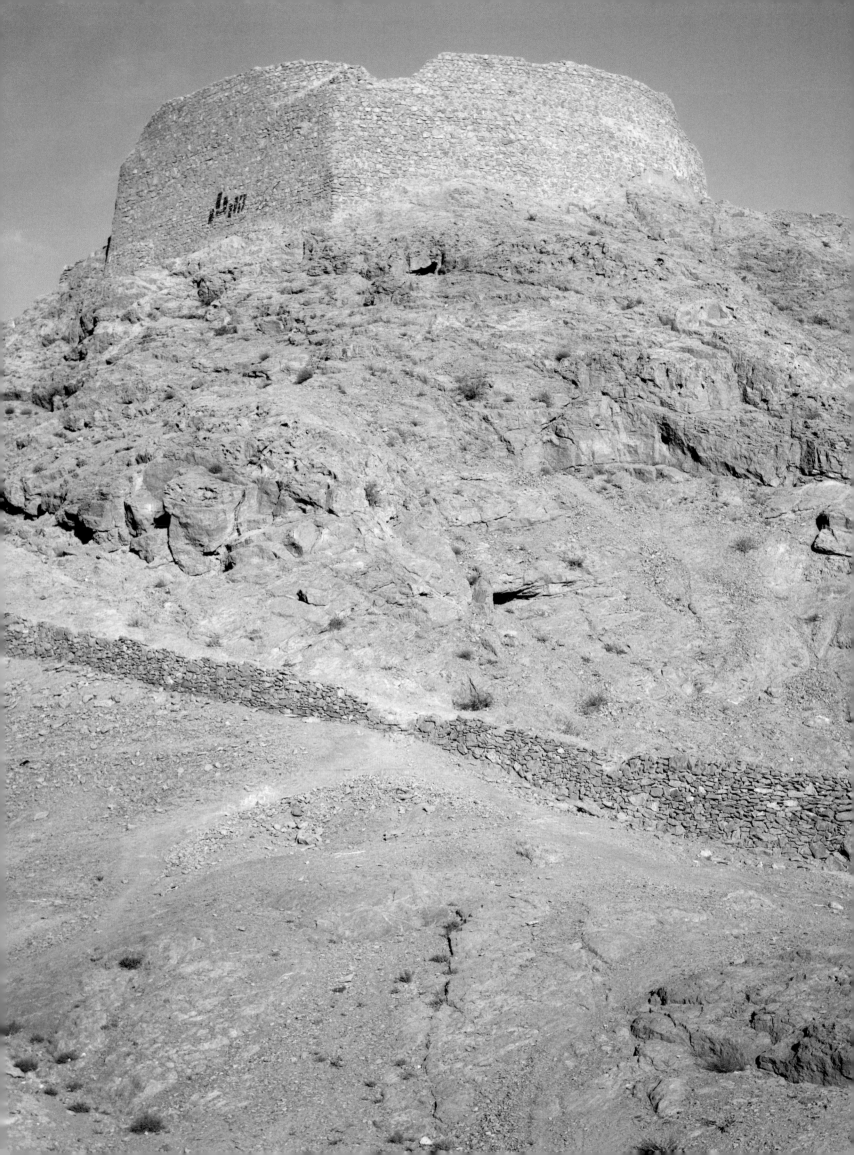

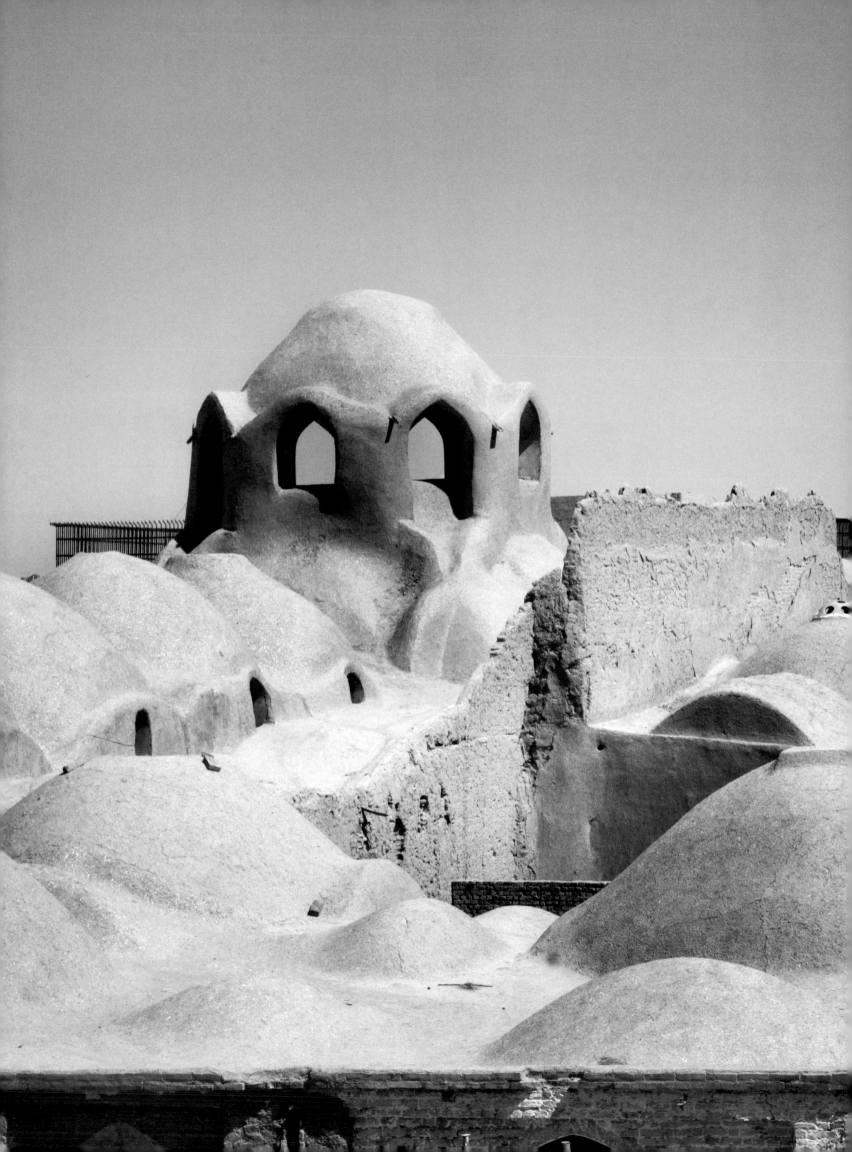

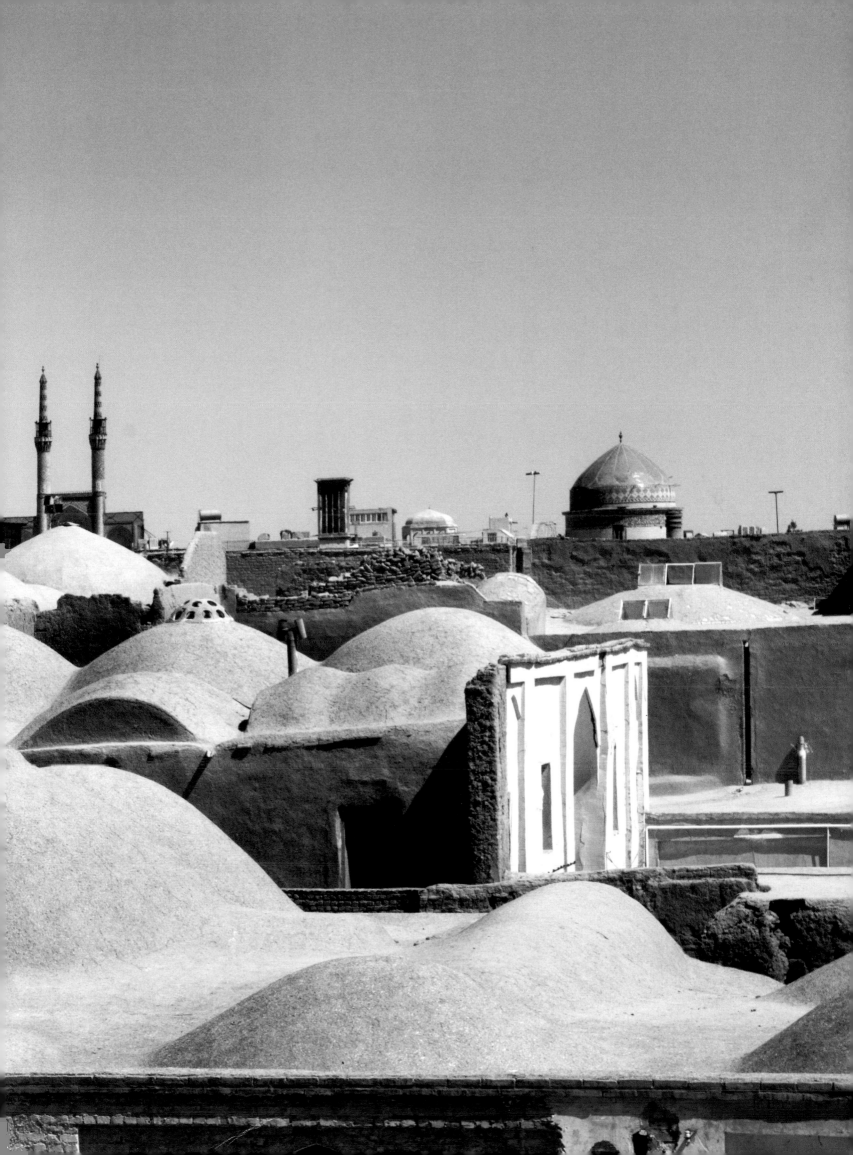

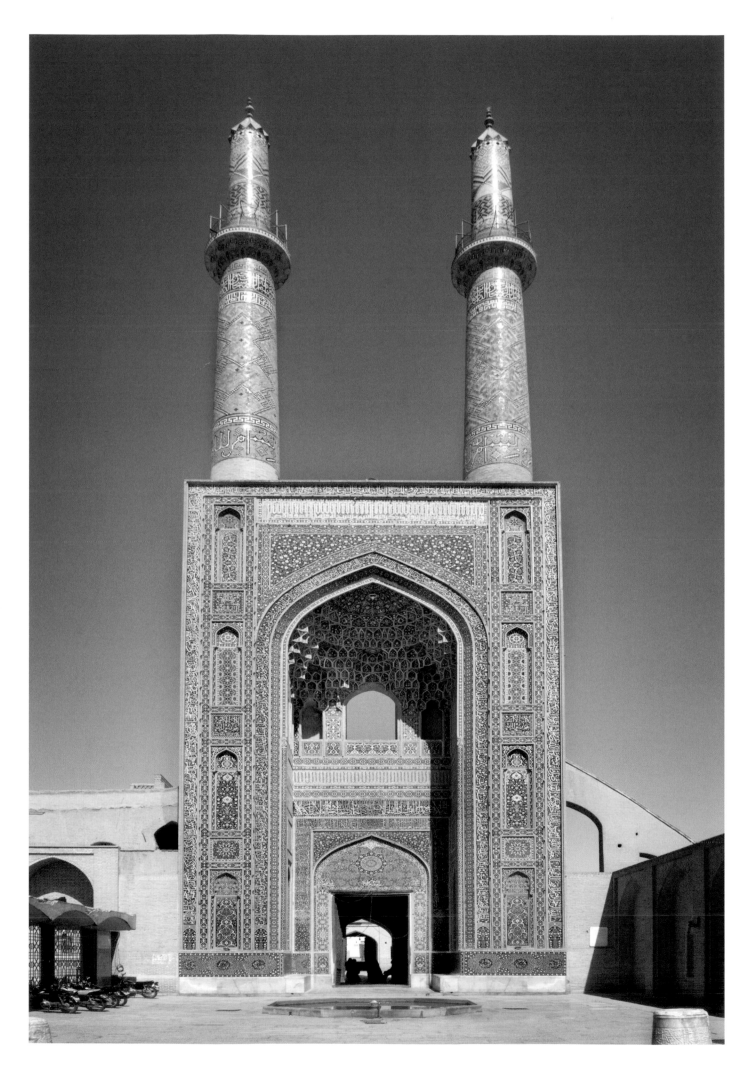

44

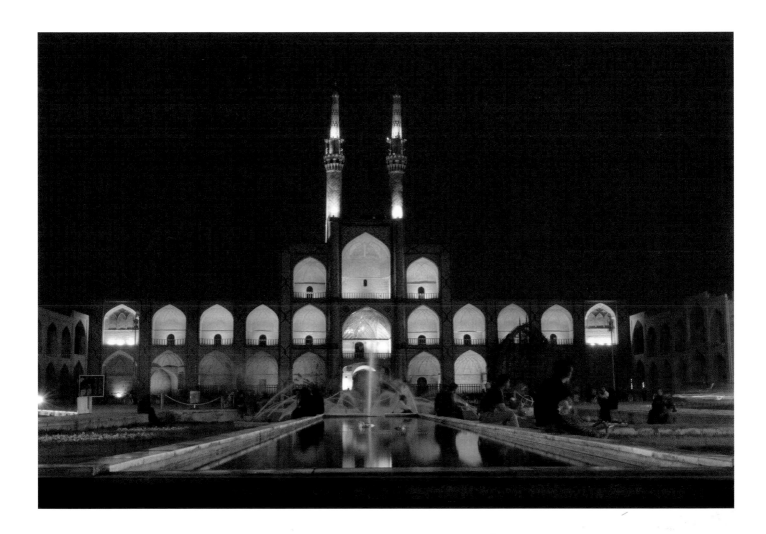

ABOVE
The facade of the fourteenth-century Amir Chakhmaq complex in Yazd.

OPPOSITE
The twelfth-century Friday Mosque (Masjed-e Jameh) in Yazd.

PREVIOUS SPREAD
Rooftops with adobe wind towers and chimneys are part of Yazd's unique
architecture, created specifically for the harsh desert environment of
central Iran.

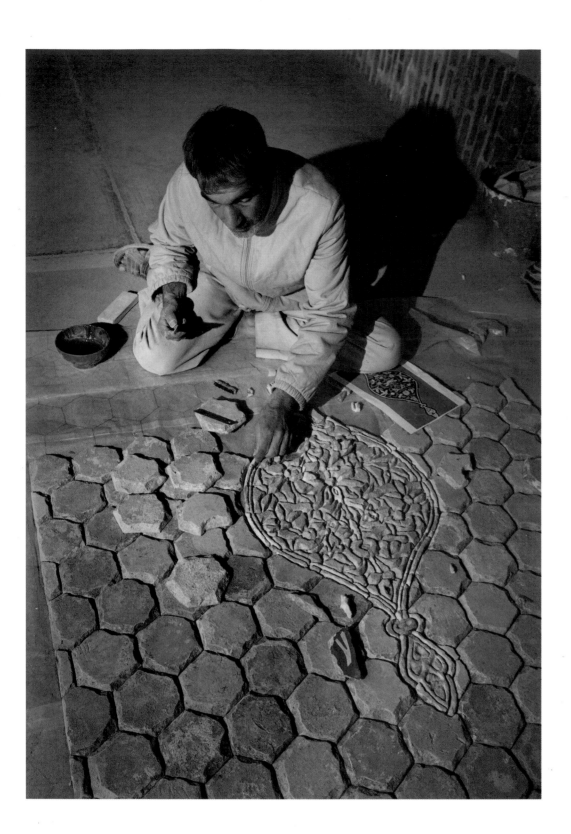

46

ABOVE
A man re-creating tile work at the twelfth-century Friday Mosque in Yazd.

OPPOSITE
A henna mill in Yazd. Henna is a flowering plant that produces a red-orange molecule known as lawsone. Because it bonds well with proteins, it is often used to dye skin, hair, and various fabrics, especially silk and wool. Henna has been used for body art since the Bronze Age.

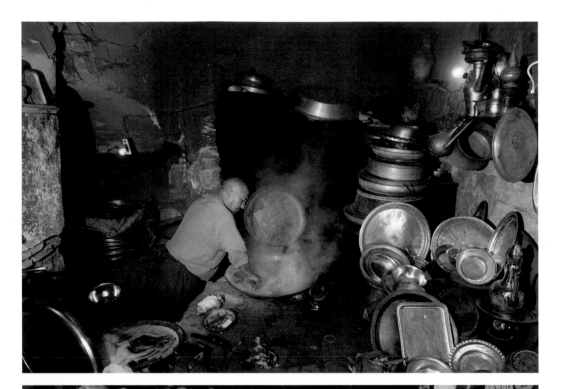

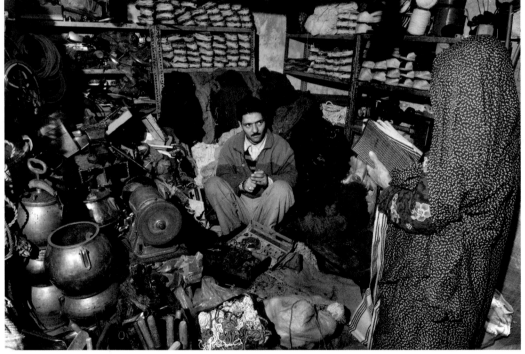

TOP
A craftsman creating pewter pieces in Yazd.

ABOVE
A shop in Yazd.

OPPOSITE
In Yazd, a woman wearing a chador passes a clothing store.

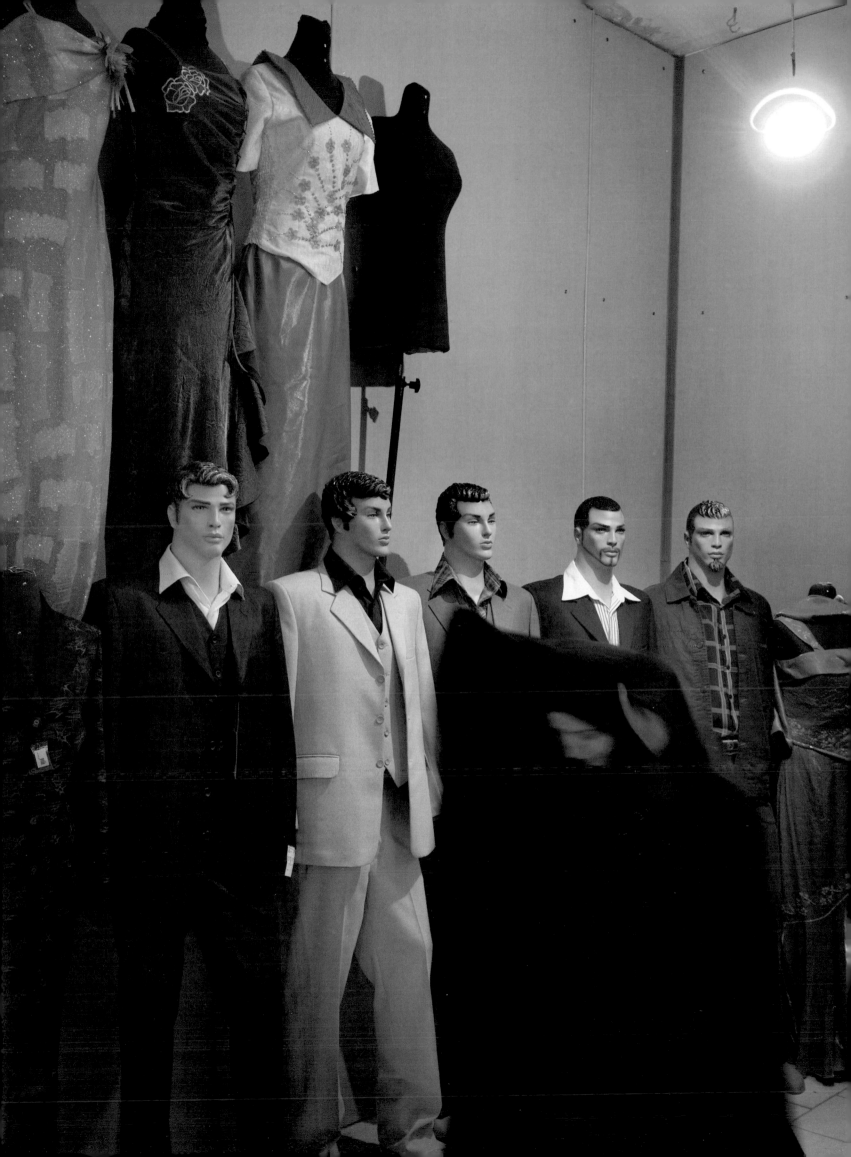

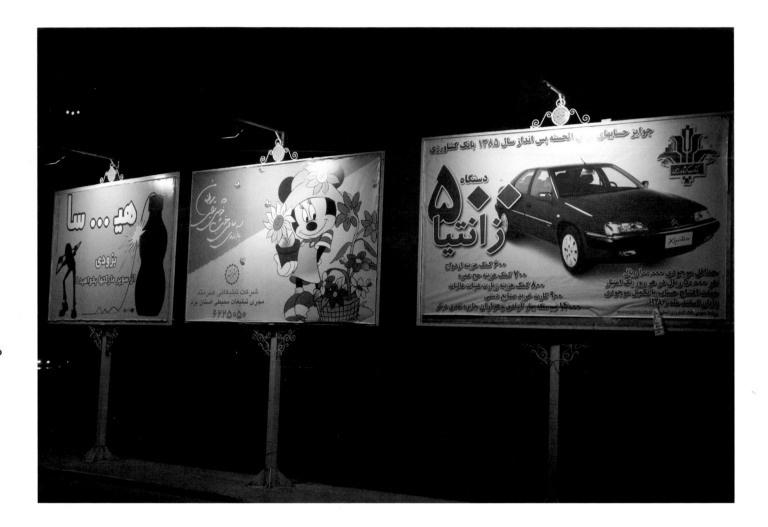

50

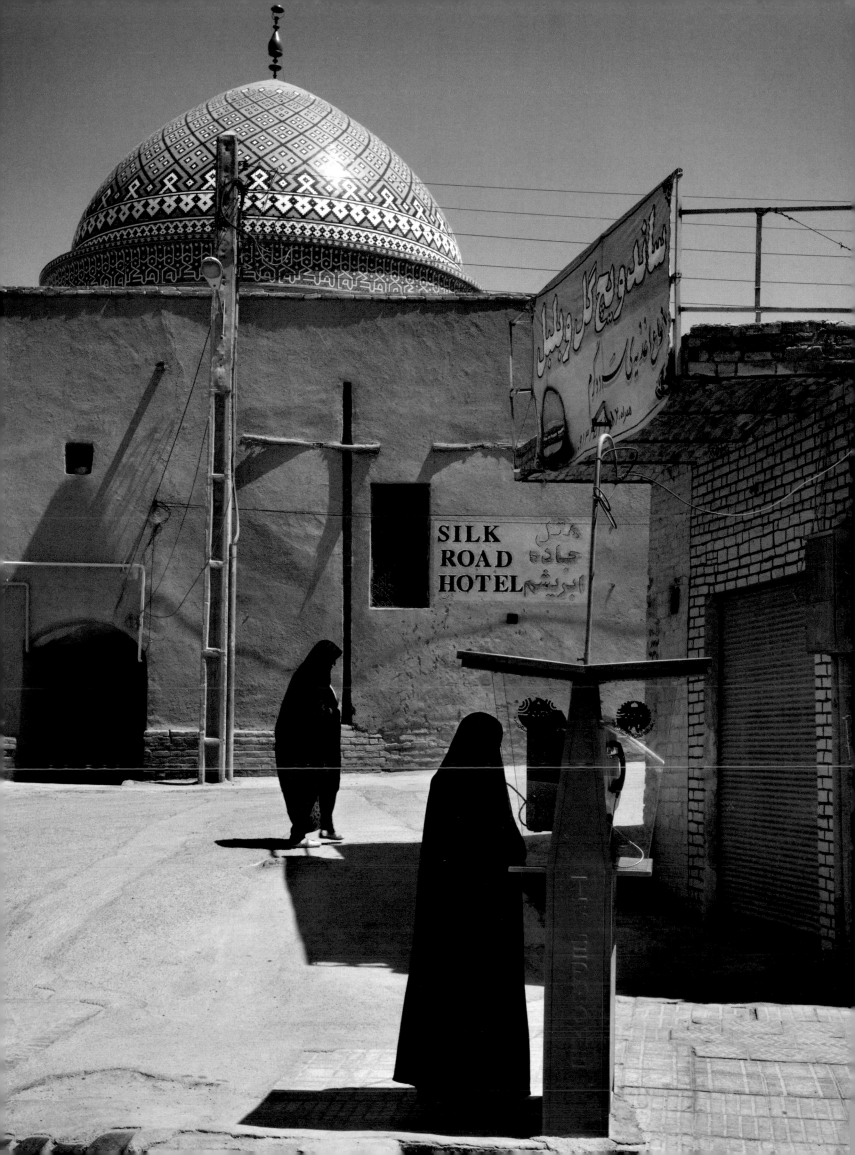

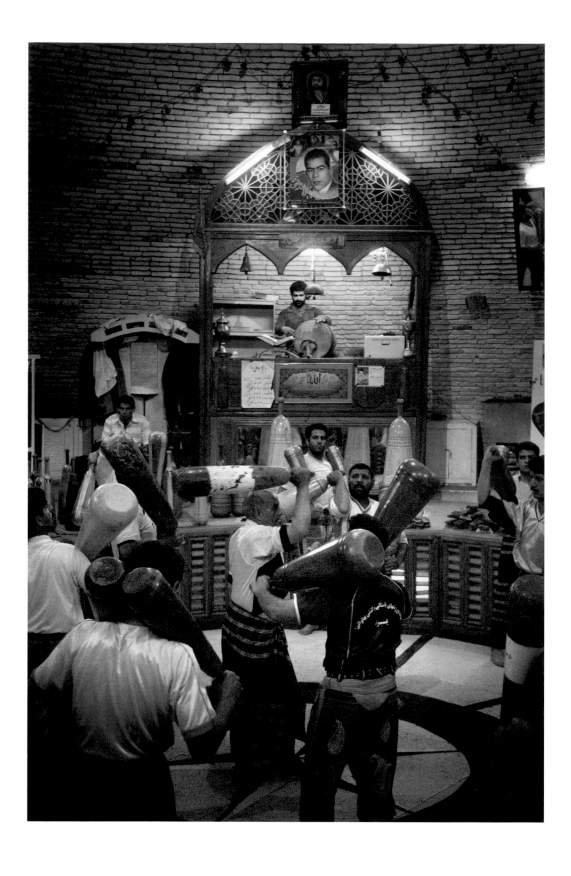

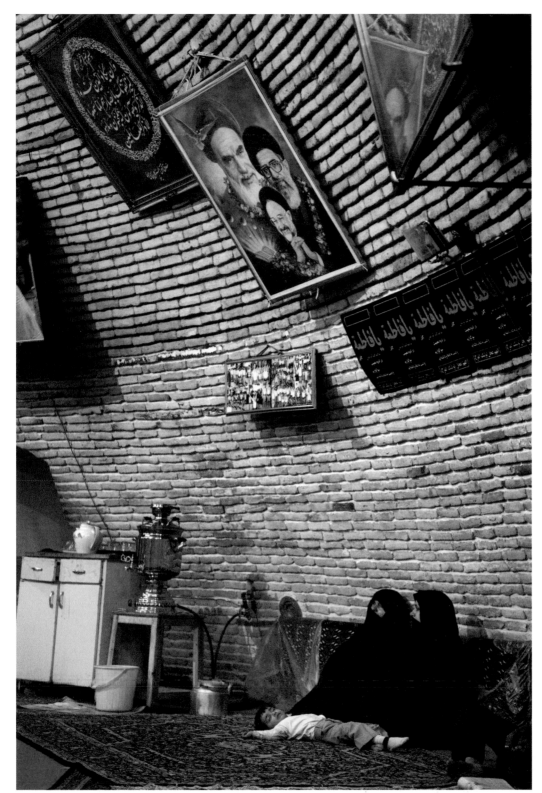

In a *zurkhaneh* (house of strength) in Yazd, an ancient Persian martial art called *varzesh-e pahlavani* (sport of the heroes) is practiced in a circular gym. An energetic beat is provided by a drummer who also recites Sufi poems and praises of Ali. Two of the most important exercises are twirling like a dervish with the arms stretched to the sides and doing calisthenics with a pair of wooden clubs called *mil*.

One of the greatest Sufi poets and mystics was Jalal ad-Din Muhammad Rumi (1207–1273). The Sufi Mevlevi order, the first practitioners of the whirling dervish dance, was founded in his honor after his death. Rumi's six-volume *Masnavi-ye Manavi* is of such importance to Sufis that it is often regarded as a work second only to the Koran and is often referred to as Qur'an-e Parsi (the Persian Koran).

53

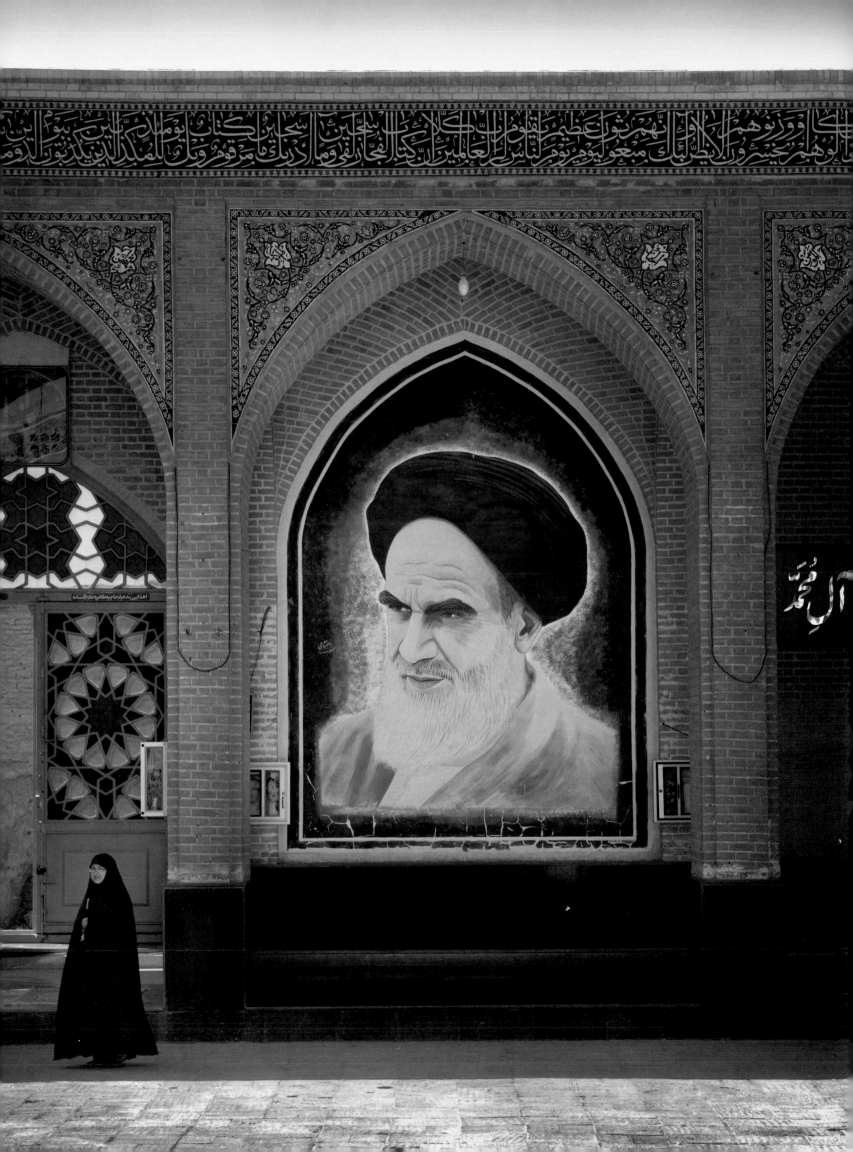

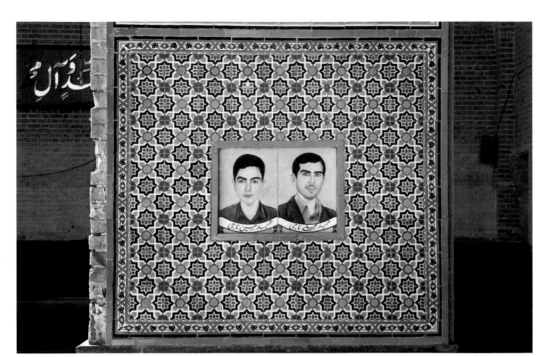

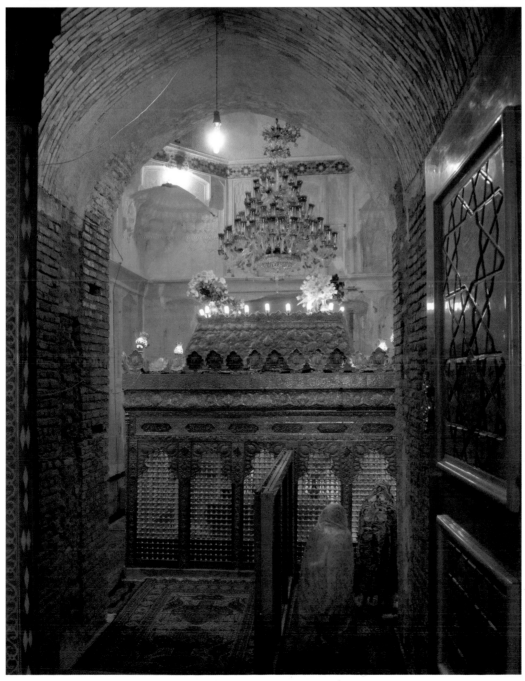

THIS SPREAD
A shrine in Anar, a town on the main road between Yazd and Kerman, pays tribute to the estimated 300,000 Iranians who died in the war with Iraq, which lasted from 1980 until 1988.

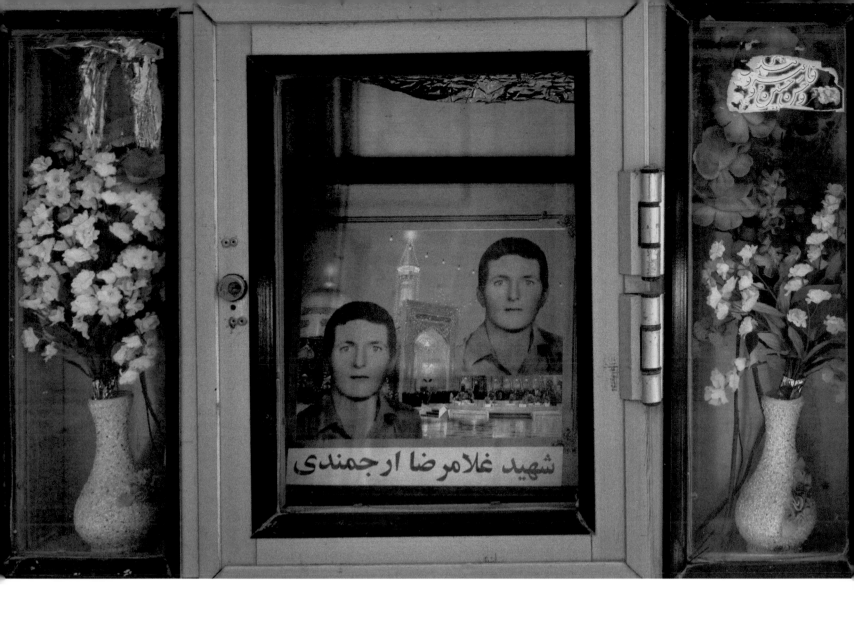

شهید غلامرضا ارجمندی

Photographs of martyrs from the Iran-Iraq War (1980–1988) at
the Anar Shrine.

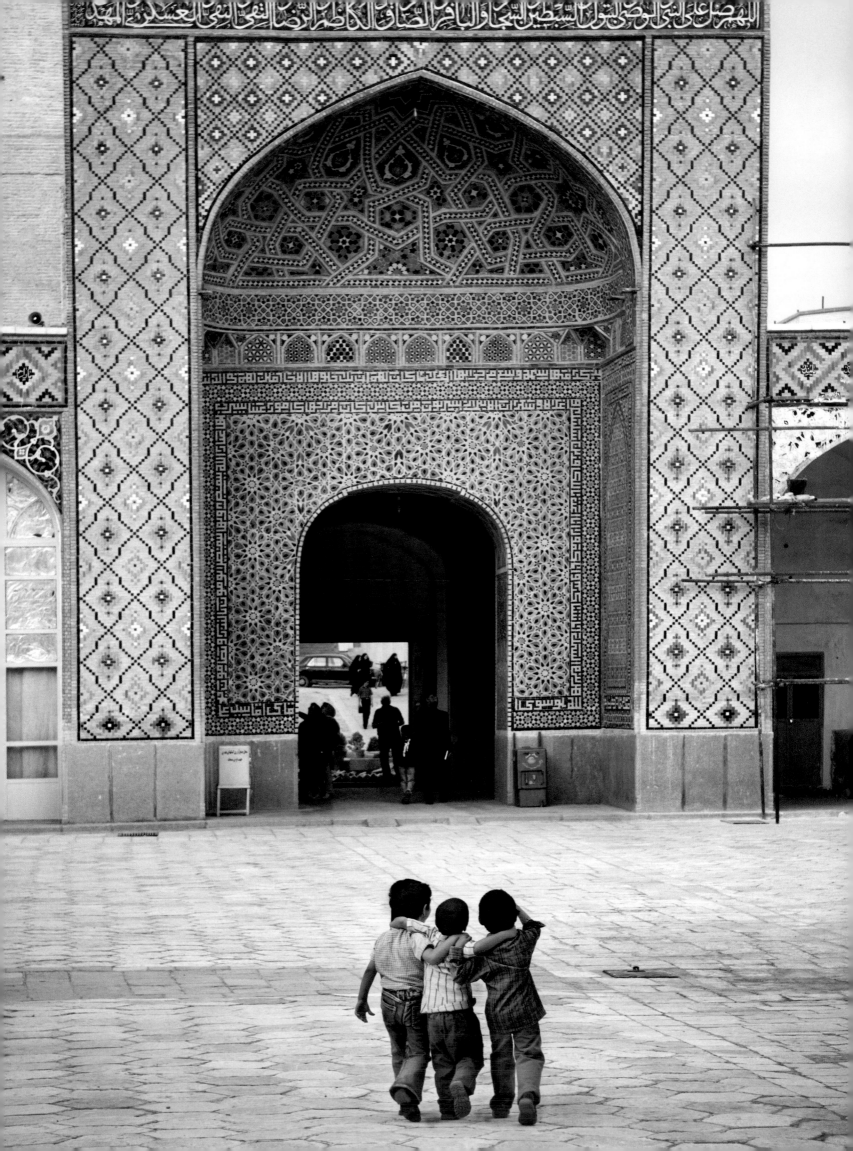

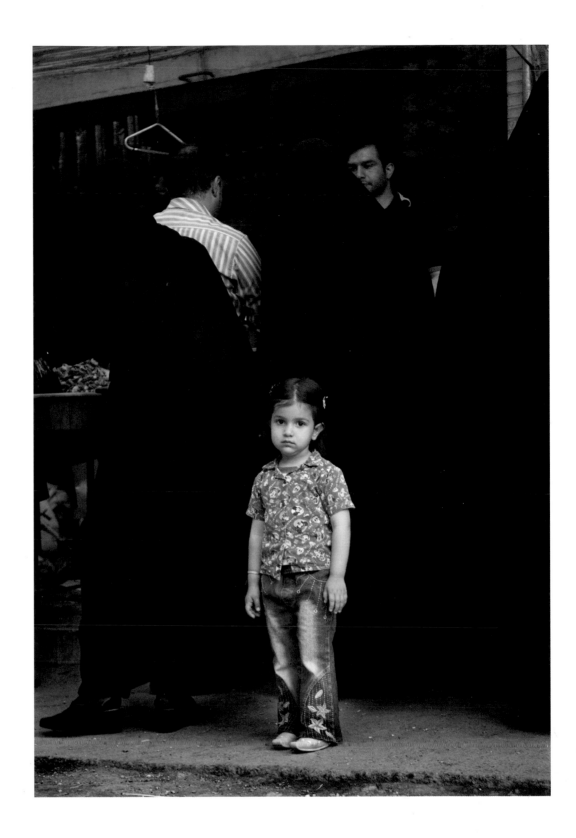

ABOVE
A young girl on a shopping outing with her mother in Kerman.

OPPOSITE
Three boys make their way across the courtyard of Kerman's Friday Mosque.

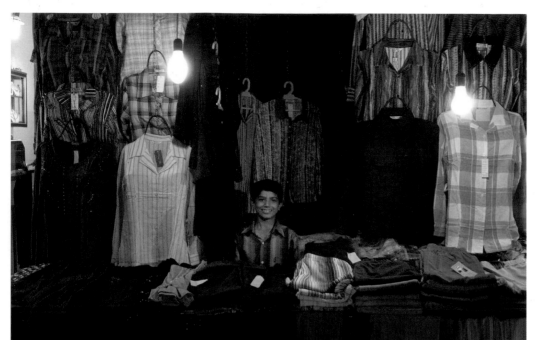

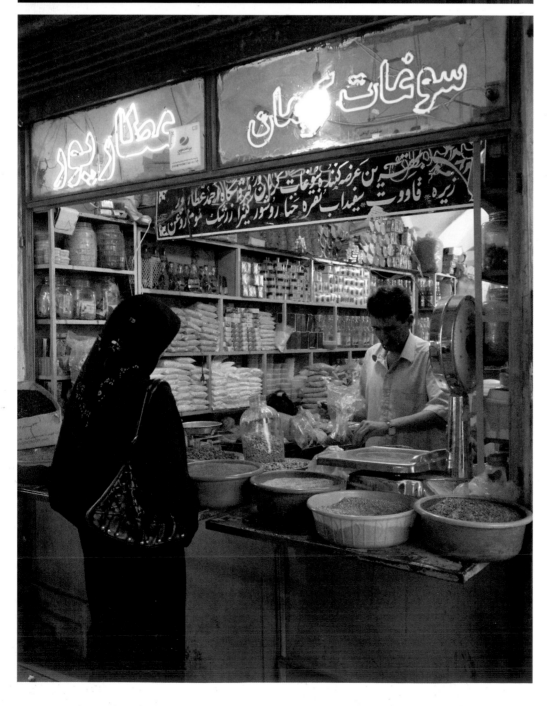

LEFT, TOP
A young clothing salesman at the Bazar Bozorg in Kerman.

LEFT, BOTTOM
Spices for sale at the Bazar Bozorg.

OPPOSITE
A seller of sports bags and athletic gear in Kerman's Bazar Bozorg.

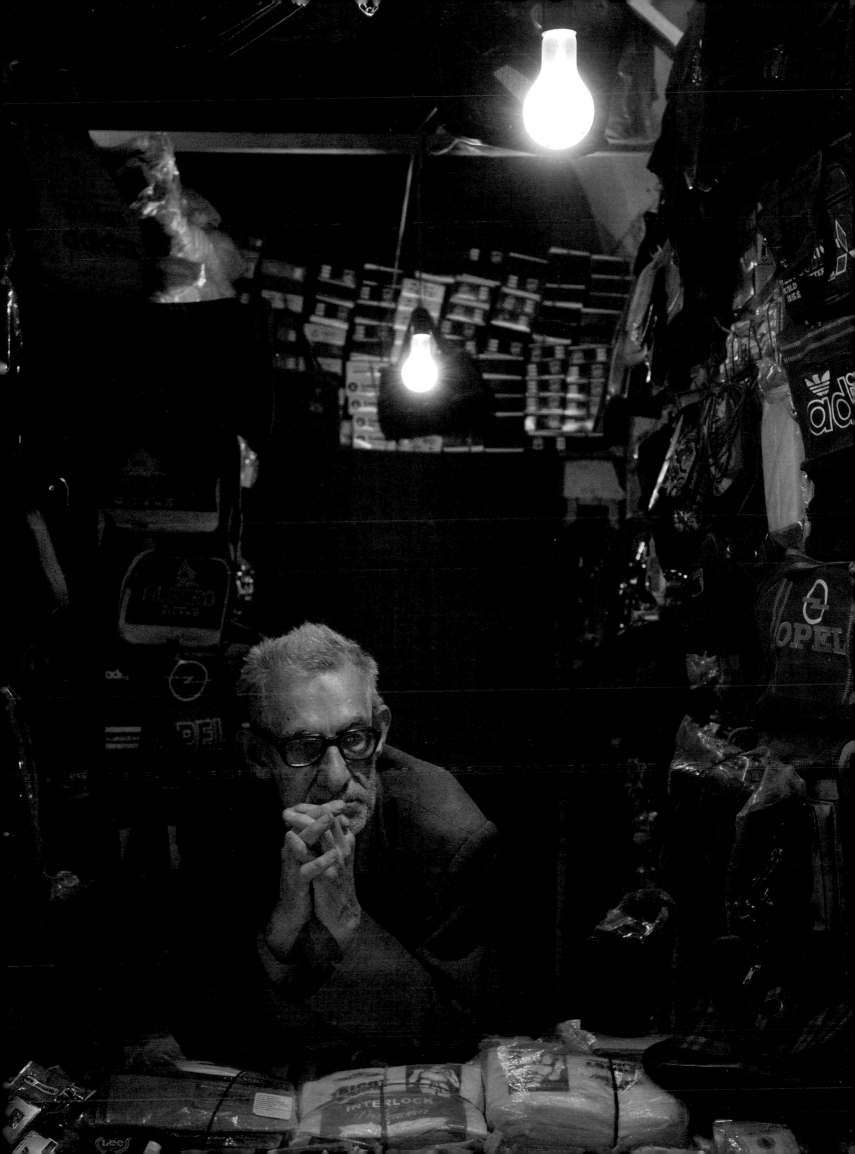

62

ABOVE
Men's suits for sale at the Bazar Bozorg. While suit jackets and pants are
popular, ties are not considered appropriate Islamic dress in Iran.

OPPOSITE
Hijabs (head scarves) on display at the Bazar Bozorg. Covering the head is
mandatory for all women in Iran. Many women wear chadors, while some,
especially the younger and better off, choose to go with a manteau and a
head scarf. A common term for the working class is "chador class."

LEFT, TOP
Schoolchildren at Shahzadeh Garden near Kerman.

LEFT, BOTTOM
A view of Shahzadeh Garden from its teahouse.

OPPOSITE
A portrait of a young woman in Shahzadeh Garden.

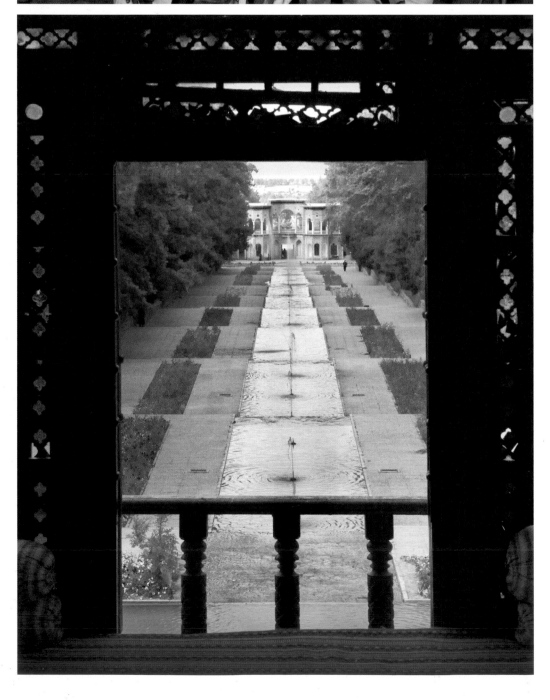

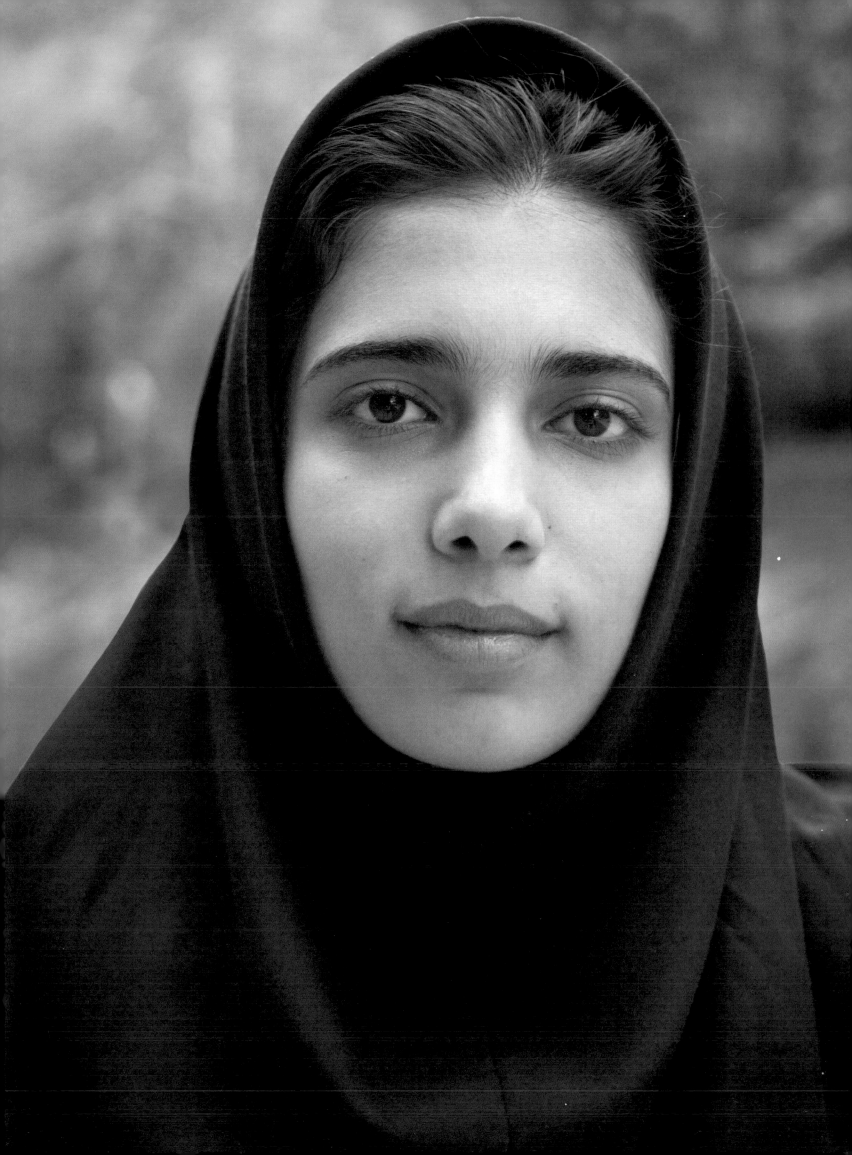

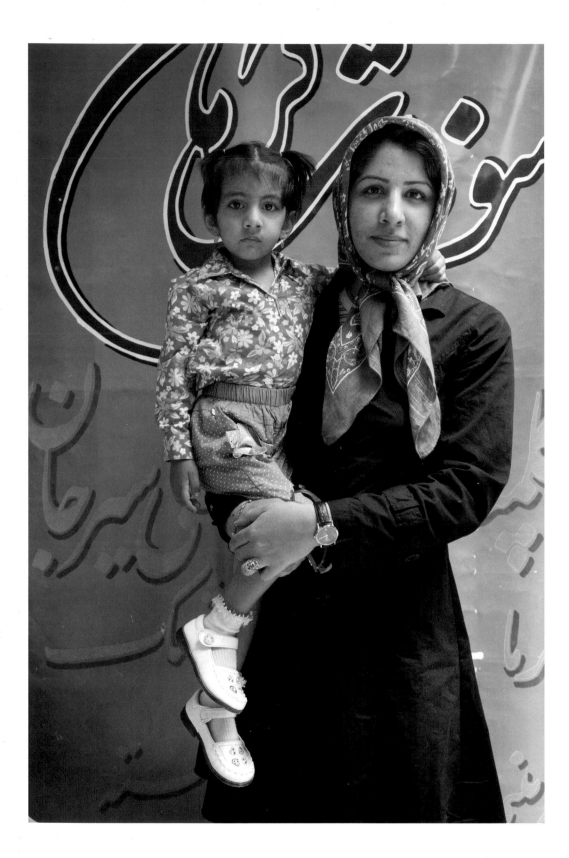

ABOVE
A mother and daughter in Mahan.

OPPOSITE
A gift store near the Shah Nur-eddin Nematollah Vali shrine in Mahan
displays sports equipment and a rug adorned with a portrait of Ali.

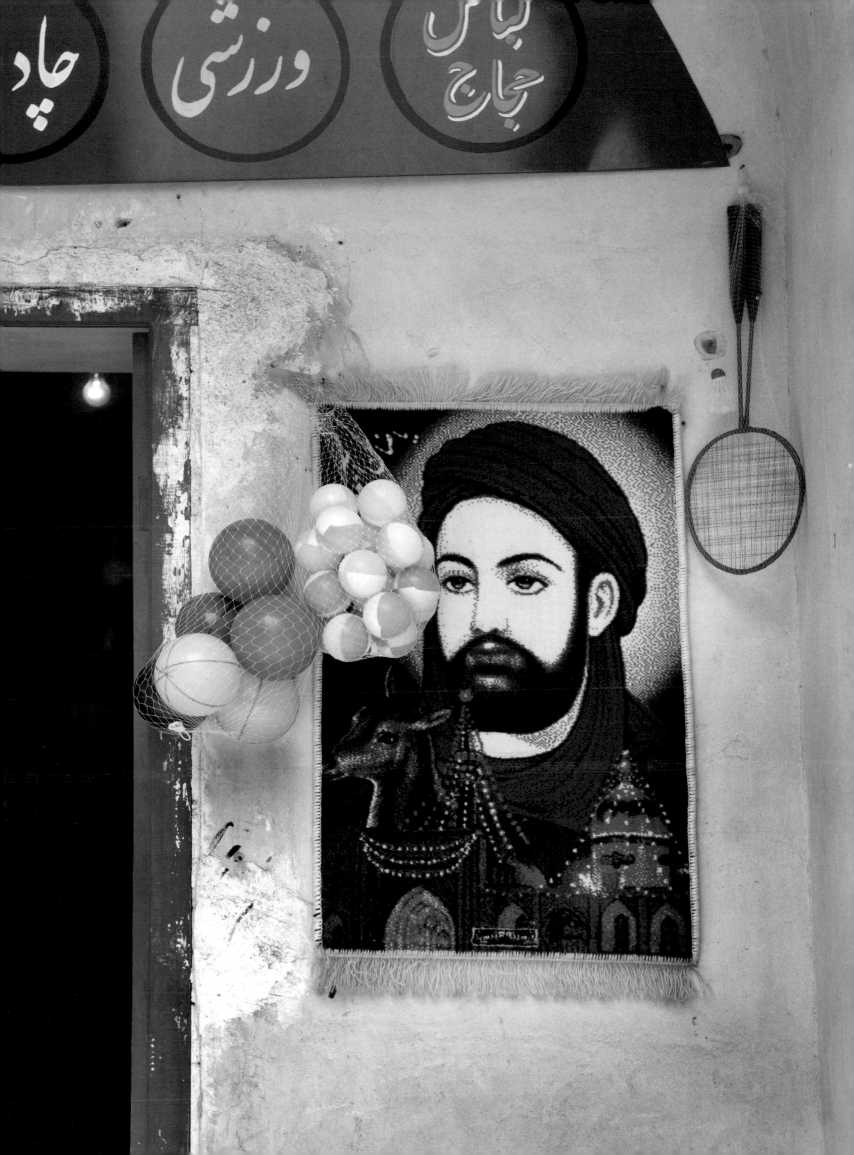

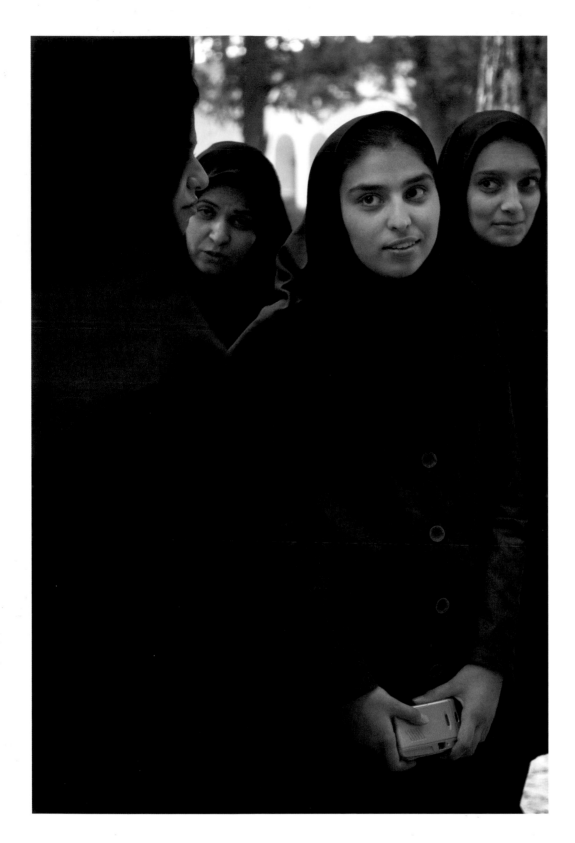

68

ABOVE
Visitors dressed in *magnae* (a fitted hood) and manteau at the Shah
Nur-eddin Nematollah Vali shrine.

OPPOSITE
A turquoise-tile minaret at the tomb of Shah Nur-eddin Nematollah Vali
in Mahan, southeast of Kerman.

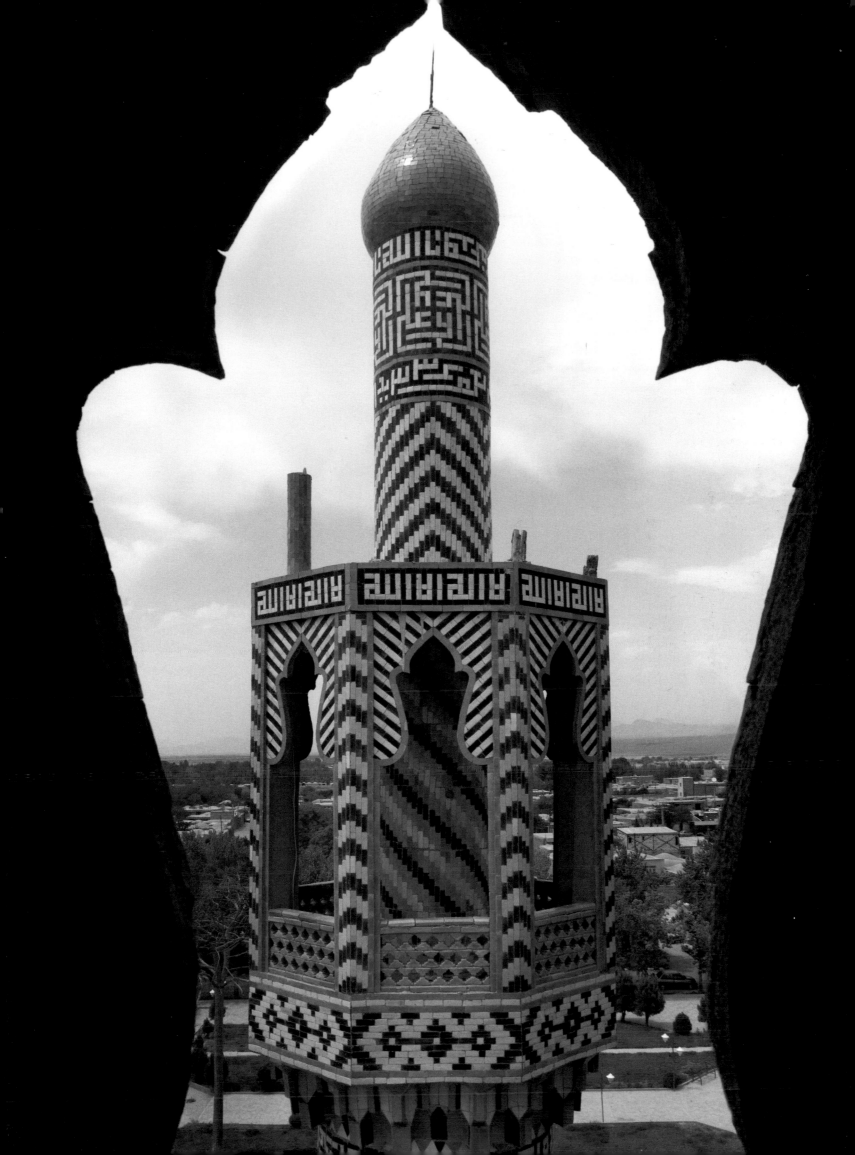

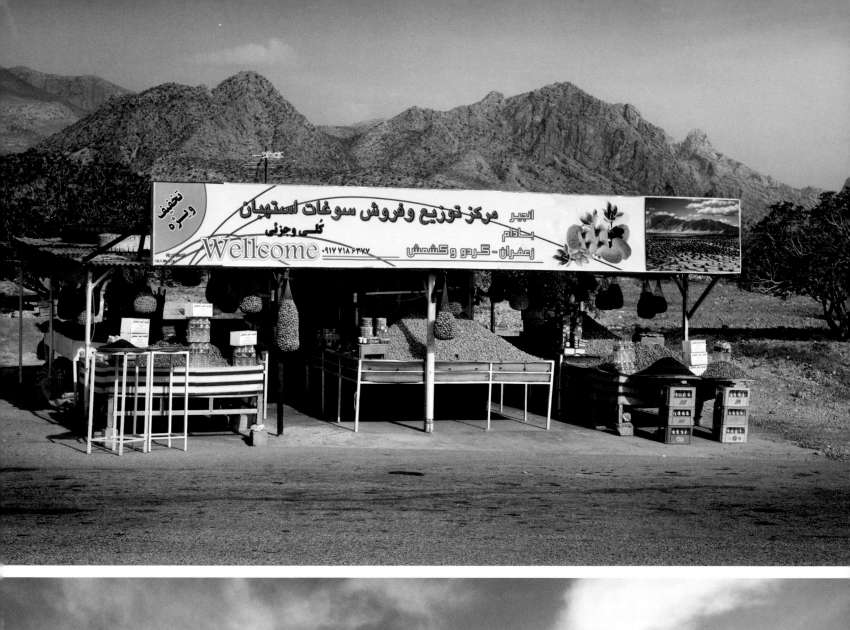

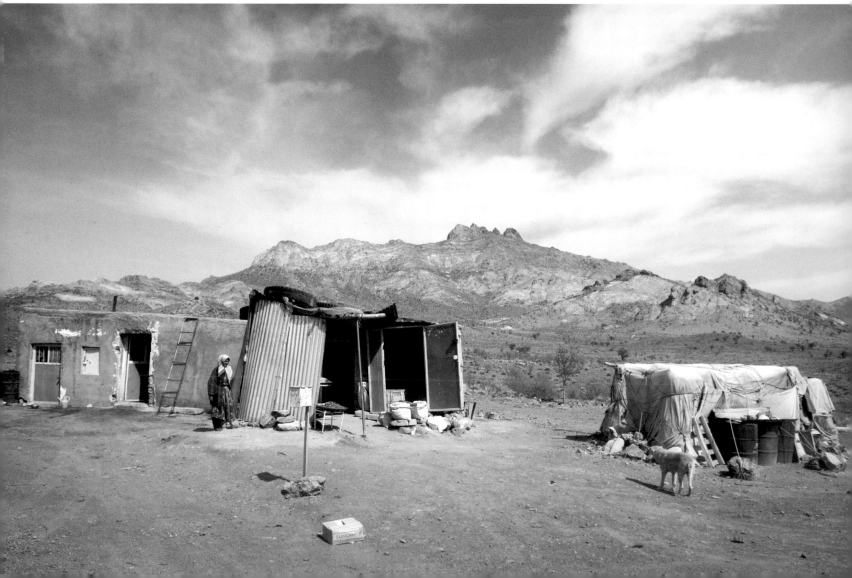

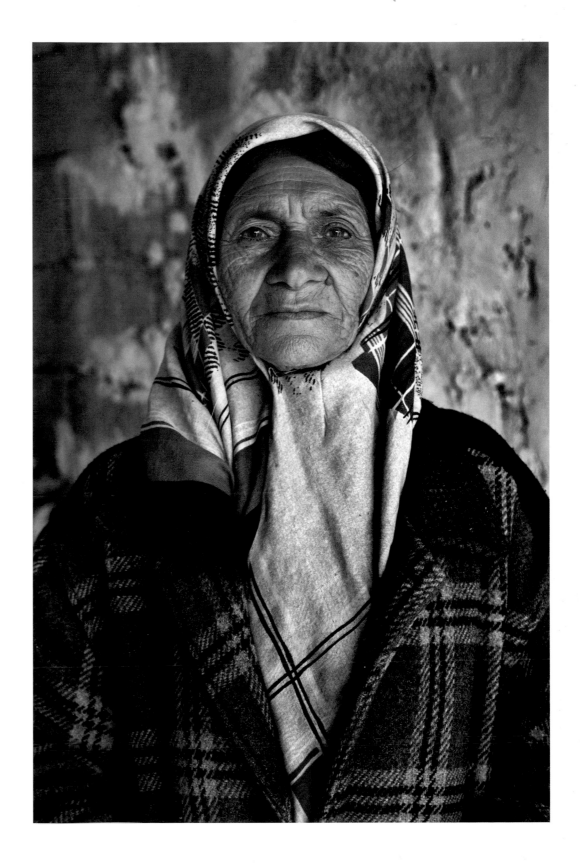

ABOVE
A woman who runs a small shop on the road near Taj Abad.

OPPOSITE, TOP
A fruit and nut stand on the road between Kerman and Shiraz.

OPPOSITE, BOTTOM
A rural scene on the road between Kerman and Shiraz.

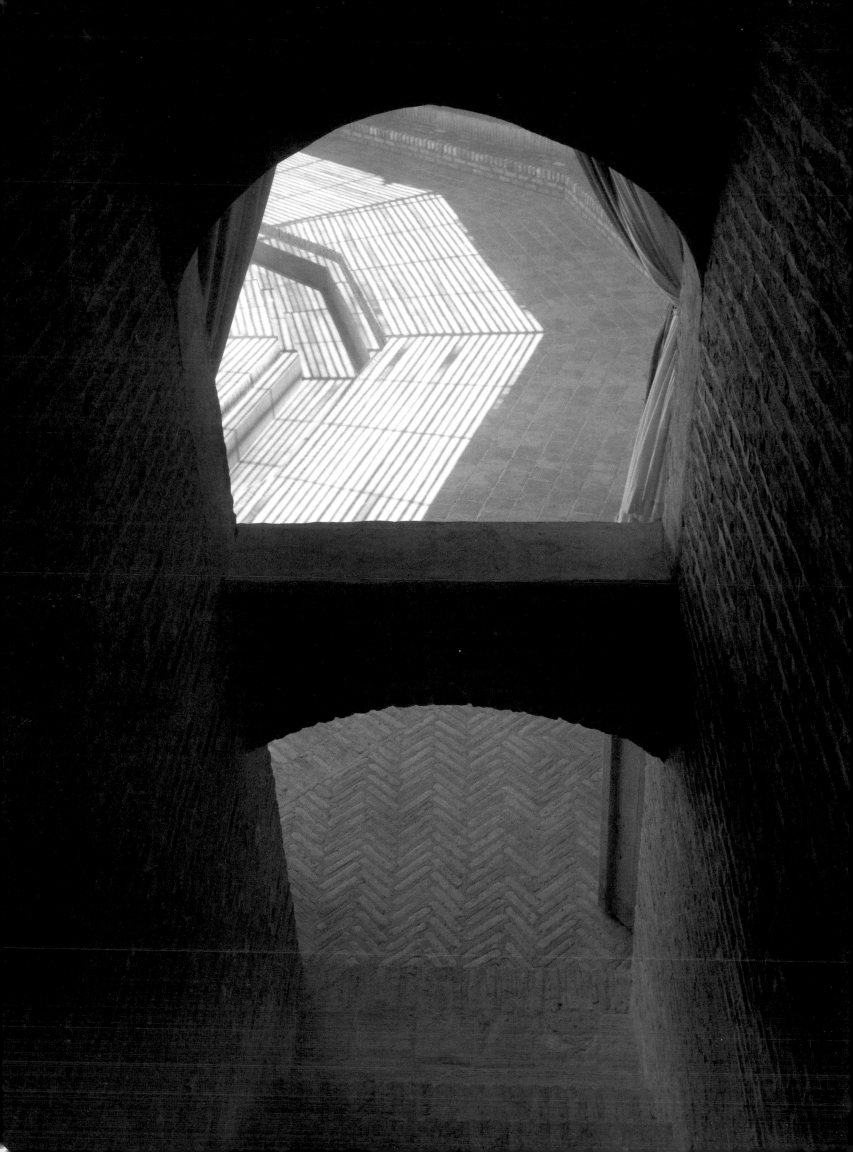

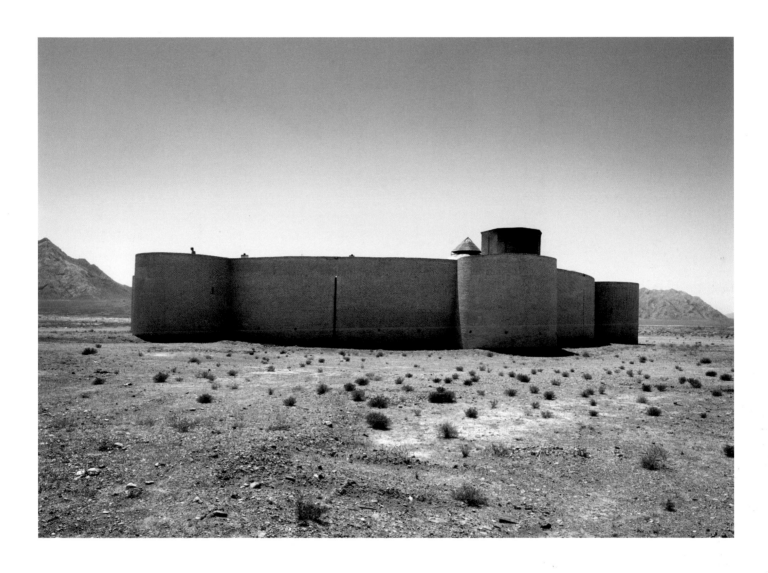

73

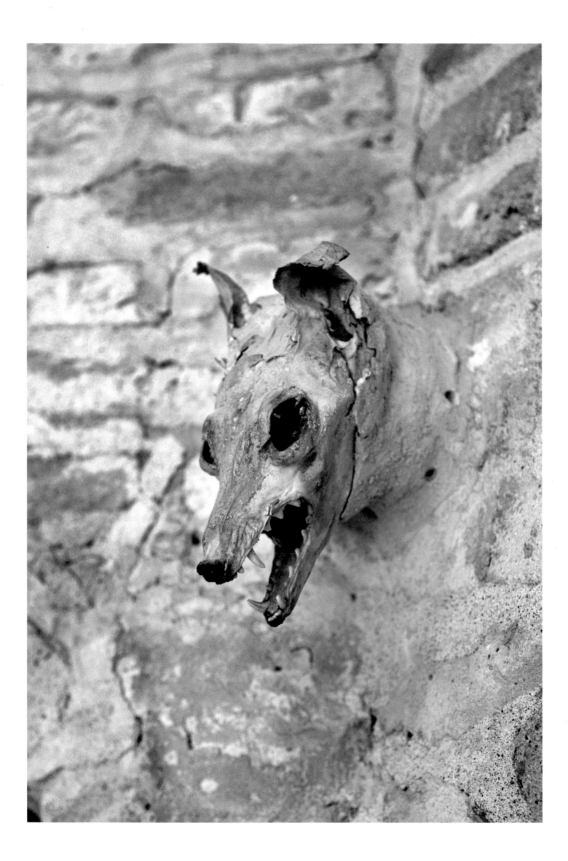

74

OPPOSITE
The Rayan Citadel is about one-quarter the size of but similar in construction to the citadel at Bam, which was severely damaged by a 6.6 earthquake on December 26, 2003.

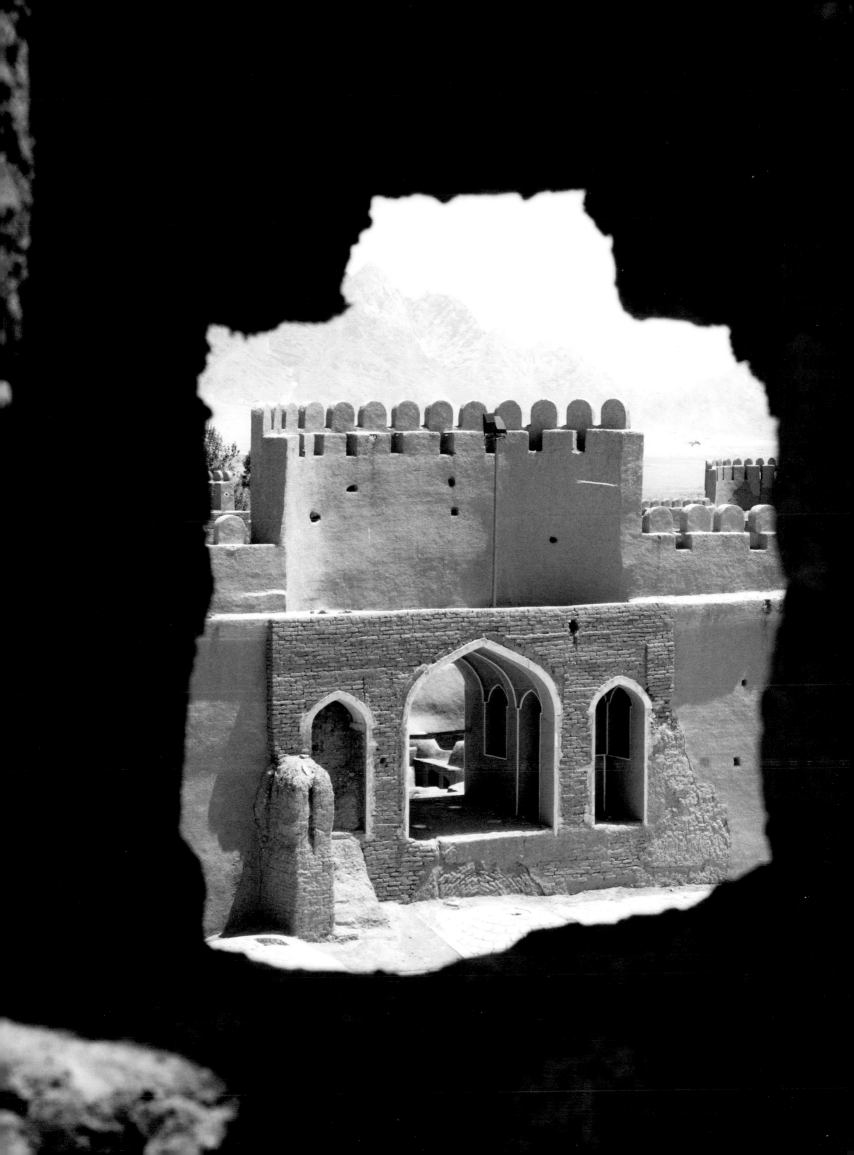

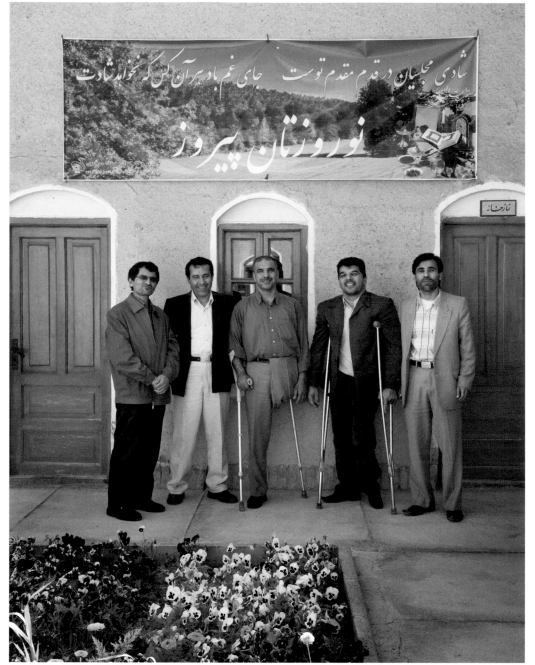

LEFT, TOP
Members and coaches of the Iranian Paralympics basketball team in Na'in.

LEFT, BOTTOM
Two miles from Na'in is Moham-mediyeh, a textile manufacturing town where winding streets and ancient houses have changed little in hundreds of years.

OPPOSITE
Portrait of a schoolgirl in Neyriz.

76

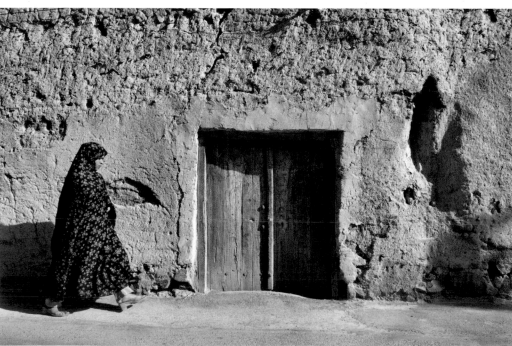

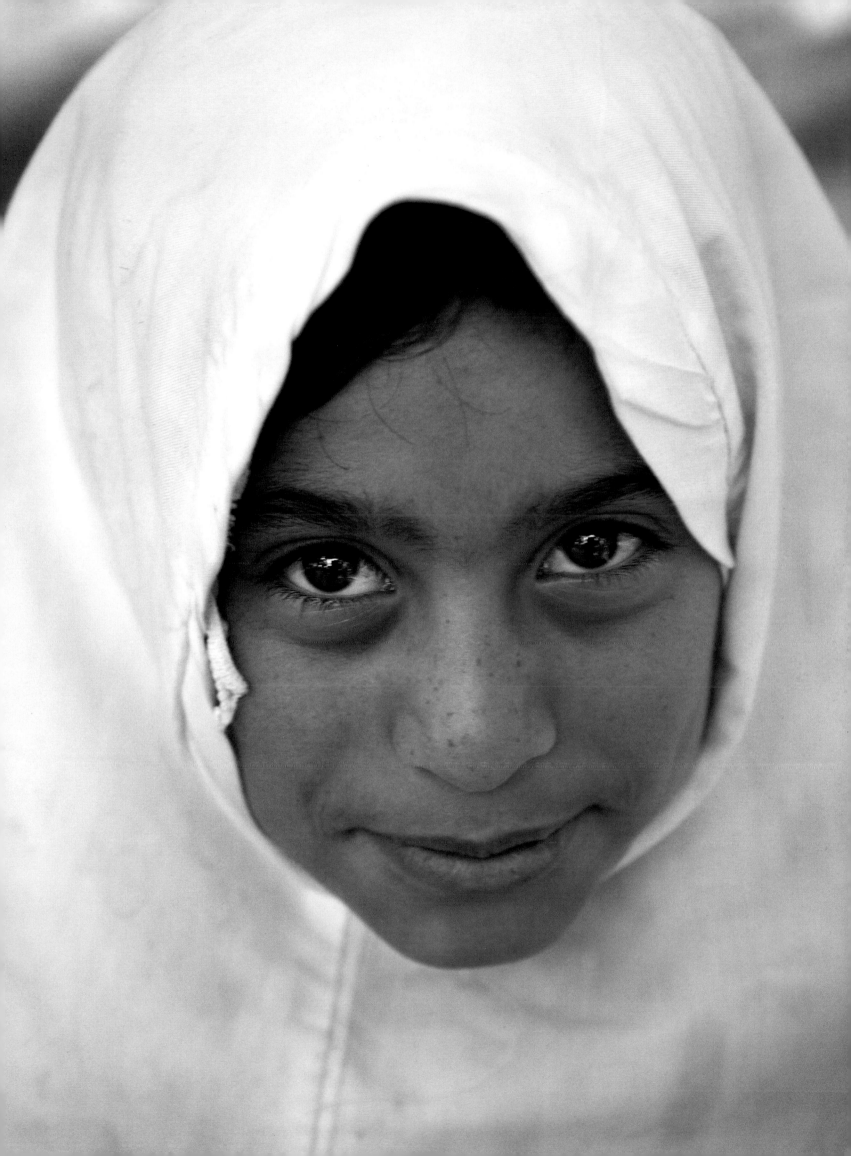

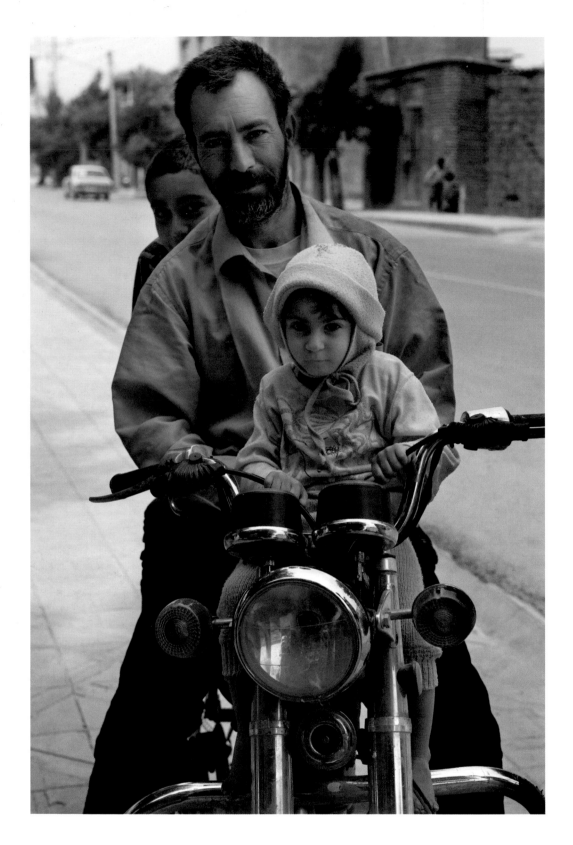

ABOVE
A father, son, and daughter on their motorcycle in Neyriz.

OPPOSITE, TOP
Friends hanging out in the park in Neyriz. Closeness between men in Iran
has a different connotation than it does in the West.

OPPOSITE, BOTTOM
Gentlemen on a bench in Sirjan.

FOLLOWING SPREAD
An ancient icehouse known as a *yackchal* on the outskirts of Kerman.

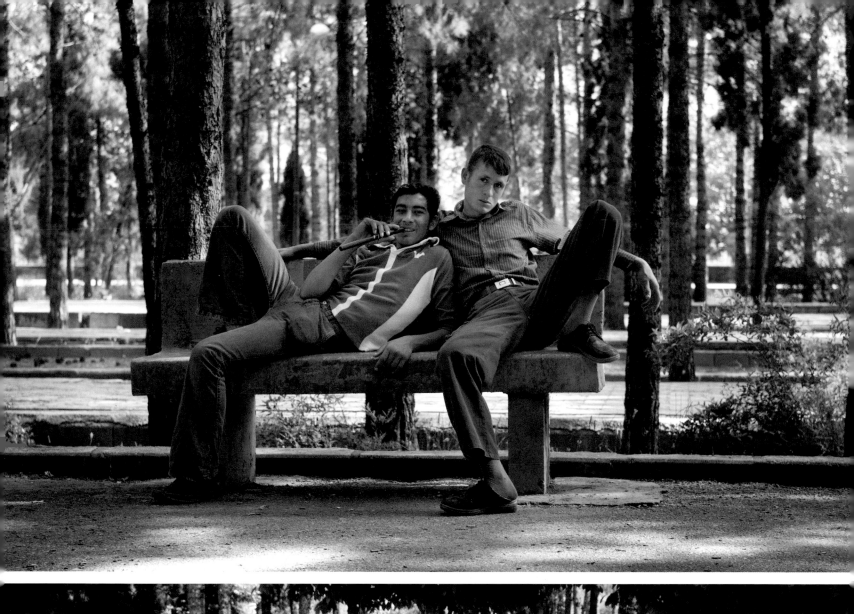
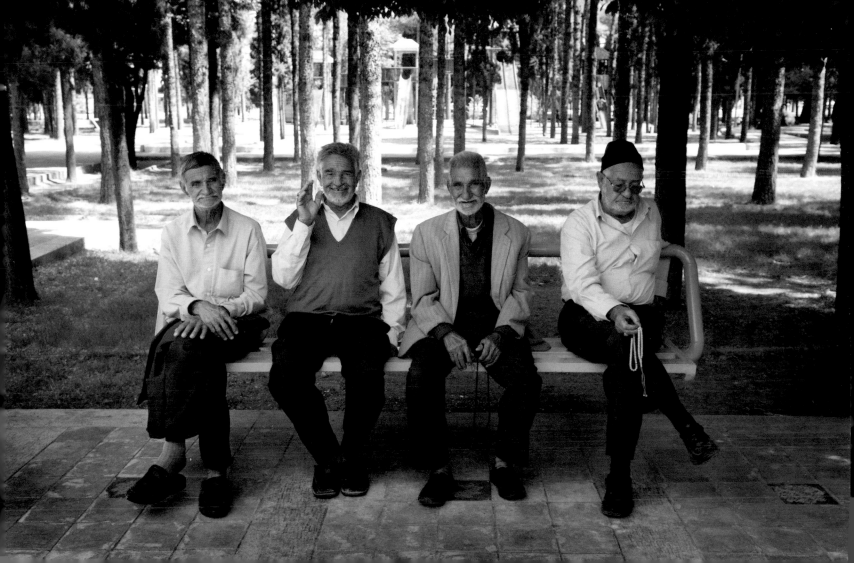

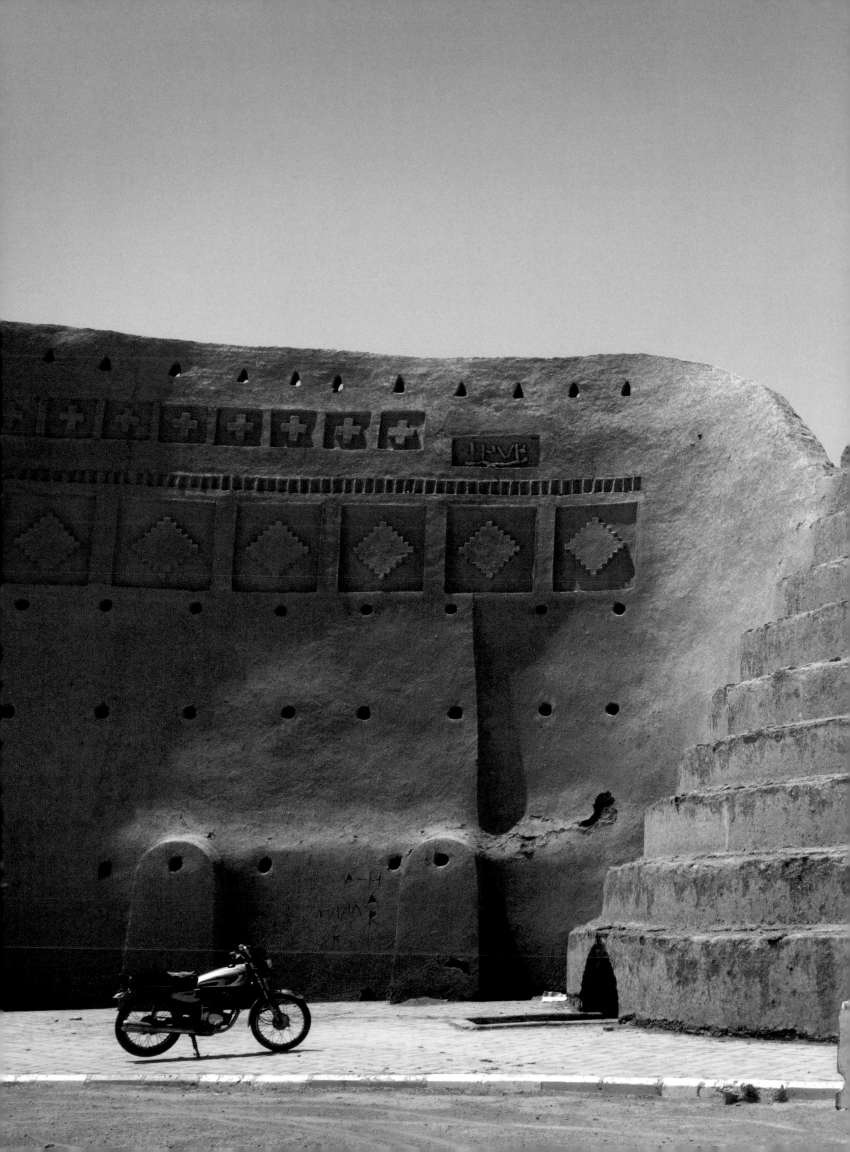

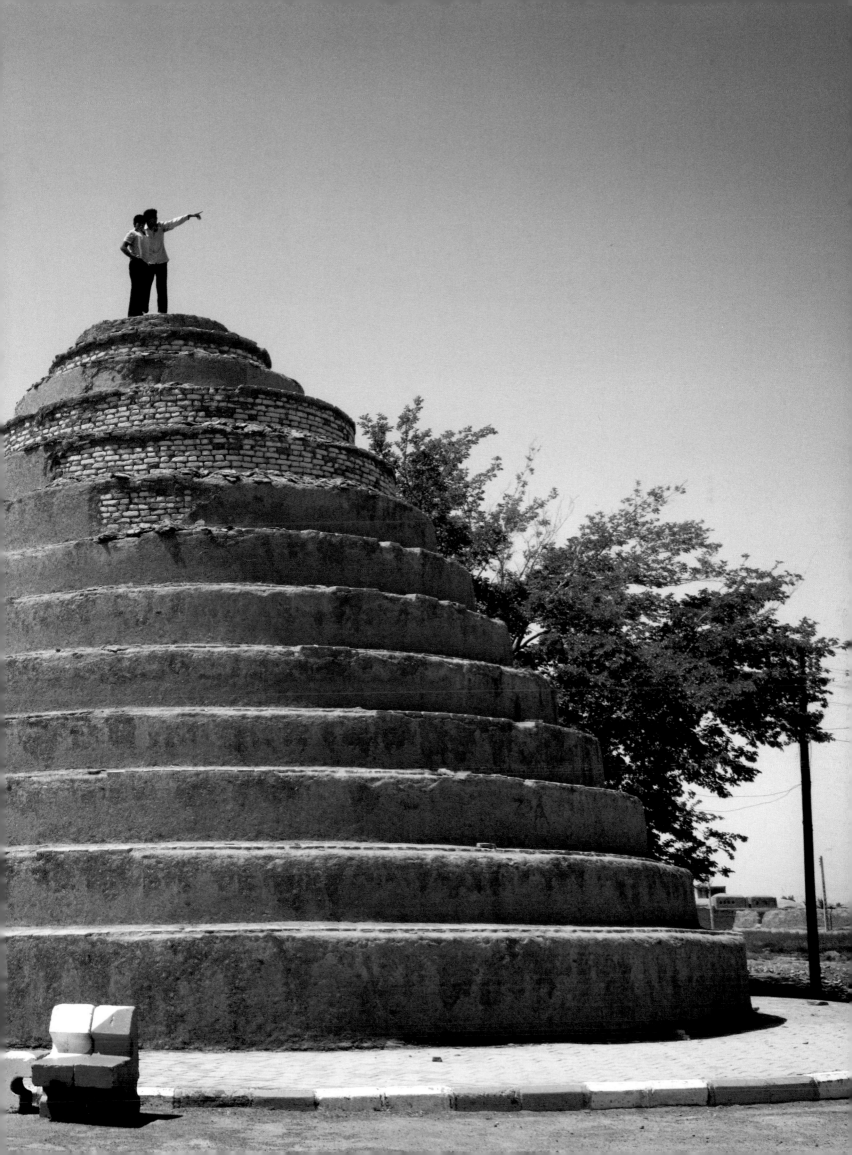

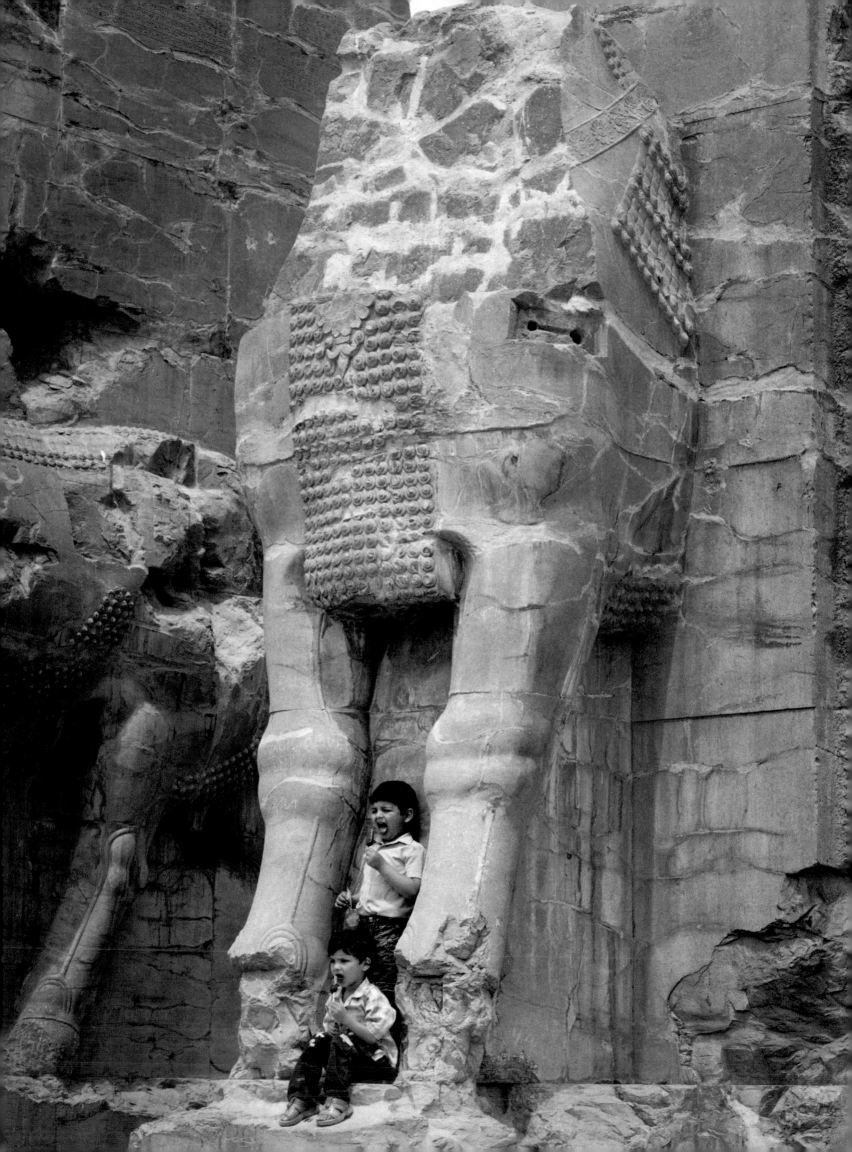

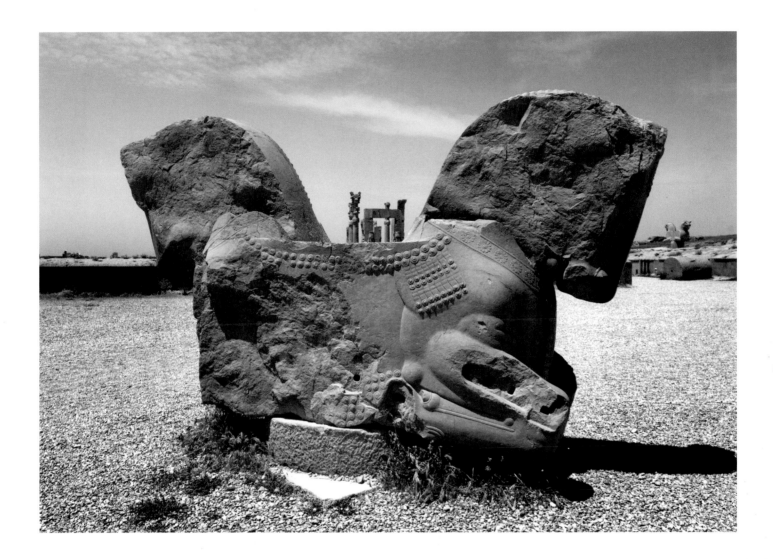

ABOVE
A griffin *(homa)* with the Gate of All Nations in the background at Persepolis.
The earliest ruins in Persepolis date from around 518 BCE.

OPPOSITE
Children take an ice-cream break at the feet of a Lamassu at the Gate of All
Nations, Persepolis. The city of Persepolis, known in ancient Persia as Parsa
and in present-day Iran as Takht-e Jamshid (Throne of Jamshid), was a capi-
tal of the Achaemenid Empire. Persepolis is the name of the city rendered in
Greek: *Perses* (Persian) and *polis* (city).

Alexander the Great took over the city in 333 BCE when he invaded Persia.
A few months into the occupation, a fire broke out in the city and soon
destroyed it. The true cause of the fire is not known, but the two most likely
scenarios are that Alexander's troops started it by accident, or set the fire in
revenge for the Persians having burned the Acropolis in Athens.

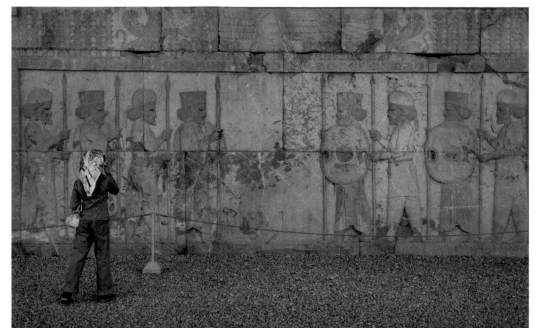

Front views of the palace built by Darius the Great were embossed with pictures of the Immortals, the king's elite guards. When I was in Persepolis, several Iranians asked me if I had seen the movie 300. Several of them had watched black-market DVDs of the movie and were not happy with the way their ancestors—Xerxes (the son of Darius the Great) in particular—were portrayed.

Iranian sightseers in Persepolis.

A relief at Nash-e Rustam depicts Ardashir I, the founder of the Sassanid Empire, being handed the ring of kingship by Ahura Mazda, the deity of the Zoroastrian religion.

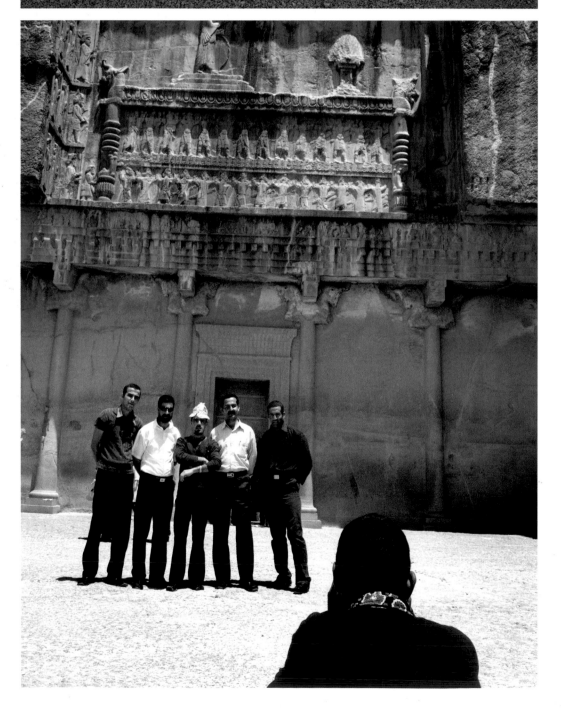

84

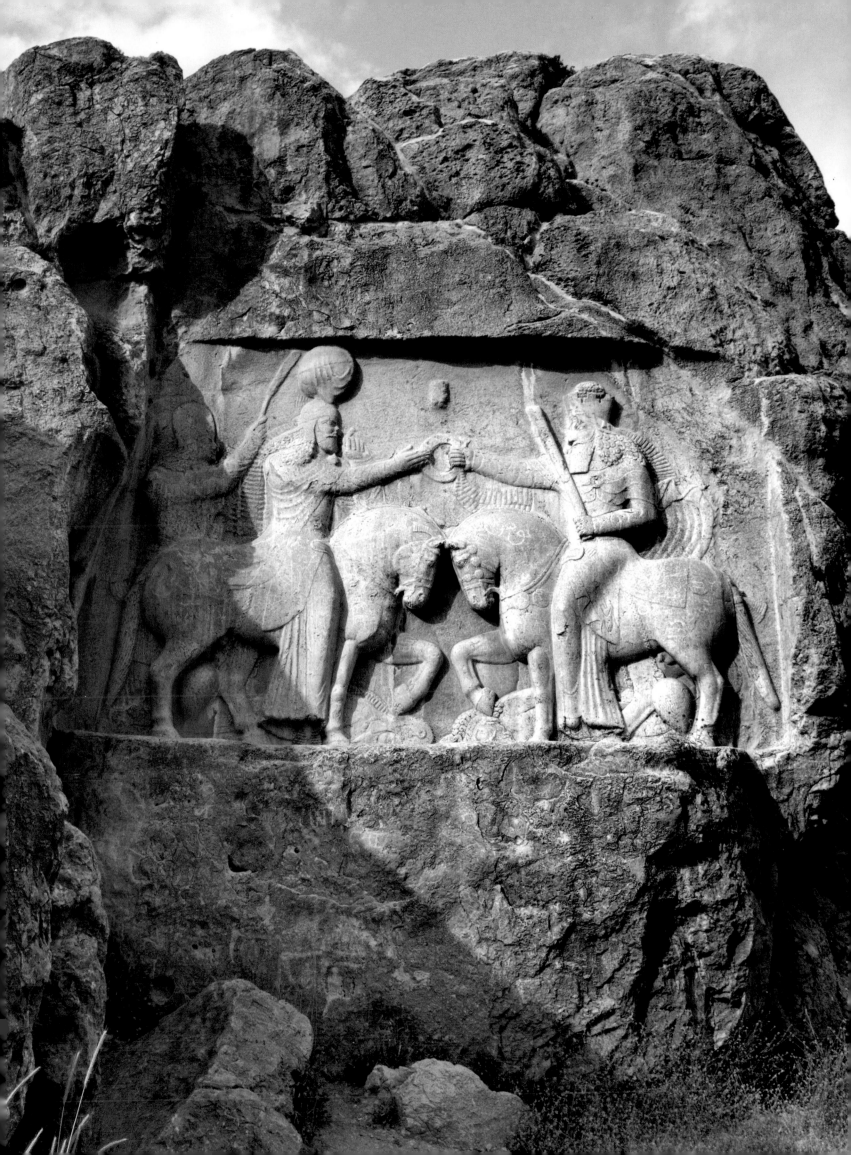

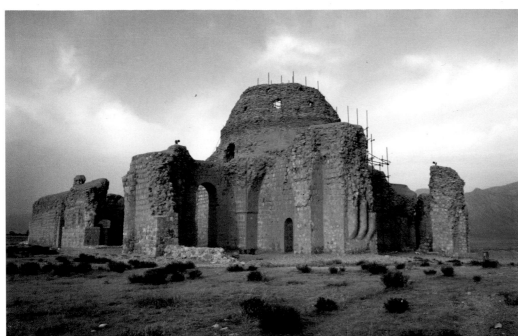

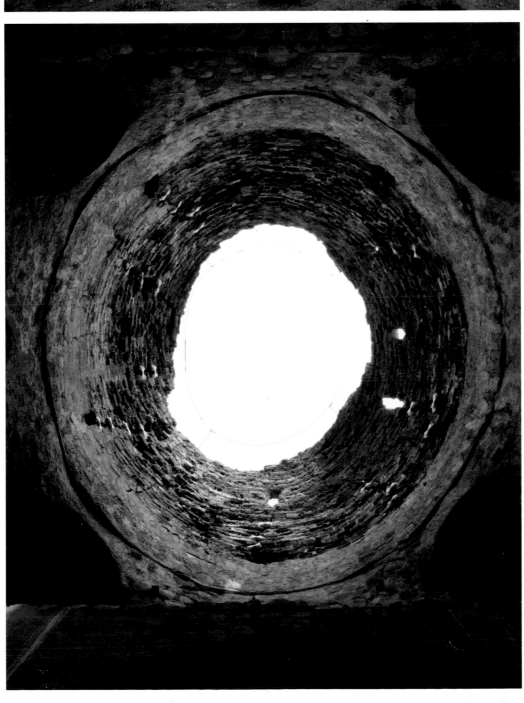

OPPOSITE
Iranian tourists pose in front of a relief of two victories by Bahram II below the tomb of Darius the Great at Naqsh-i Rustam.

LEFT, TOP
The Sassanid Palace in Sarvestan. The state religion of the Sassanians was Zoroastrianism. The Sassanid Empire lasted from AD 226 to 651.

LEFT, BOTTOM
An interior view of the Sassanid Palace dome in Sarvestan.

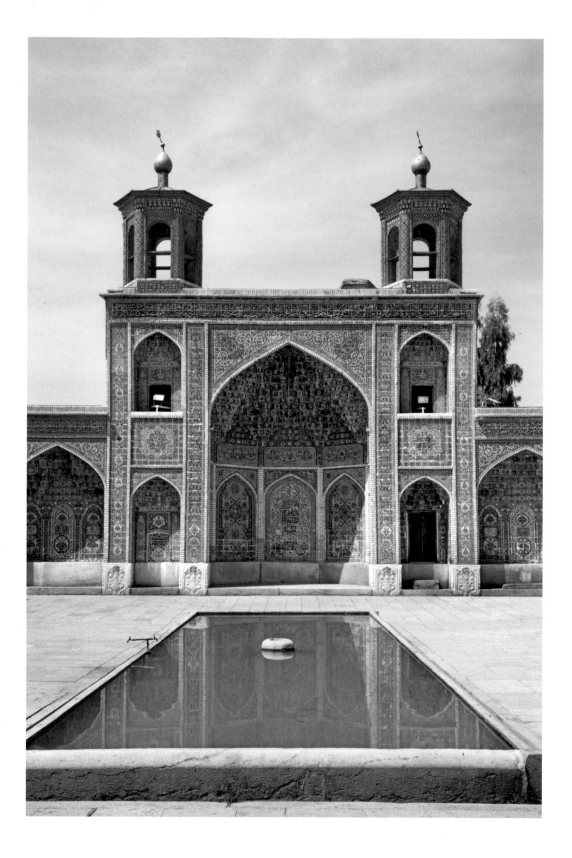

ABOVE
The interior courtyard of the Nasir al-Mulk Mosque.

OPPOSITE, TOP
Stained glass in the Nasir al-Mulk Mosque in Shiraz. Construction of the mosque began in 1876 and finished in 1888.

OPPOSITE, BOTTOM
Schoolgirls prepare to enter the Jameh-ye Atigh Mosque in Shiraz, which was first built in the ninth century and rebuilt and expanded in the mid-fourteenth century.

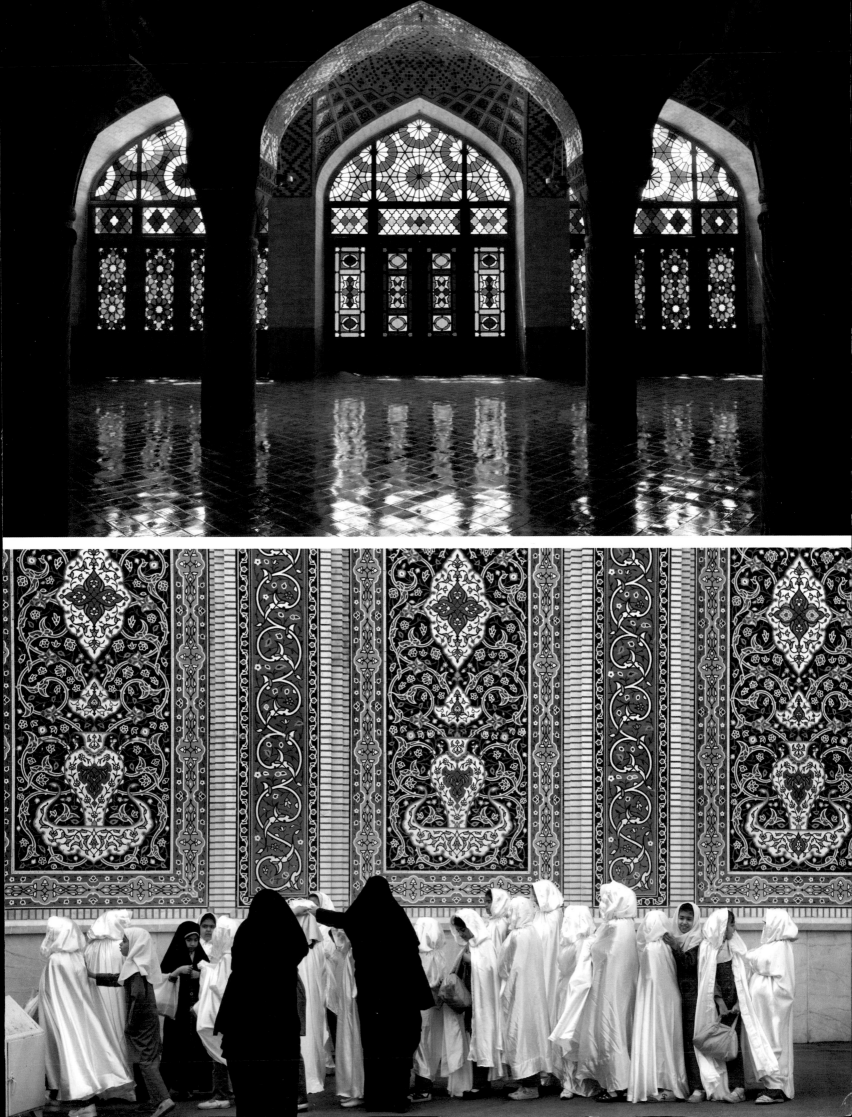

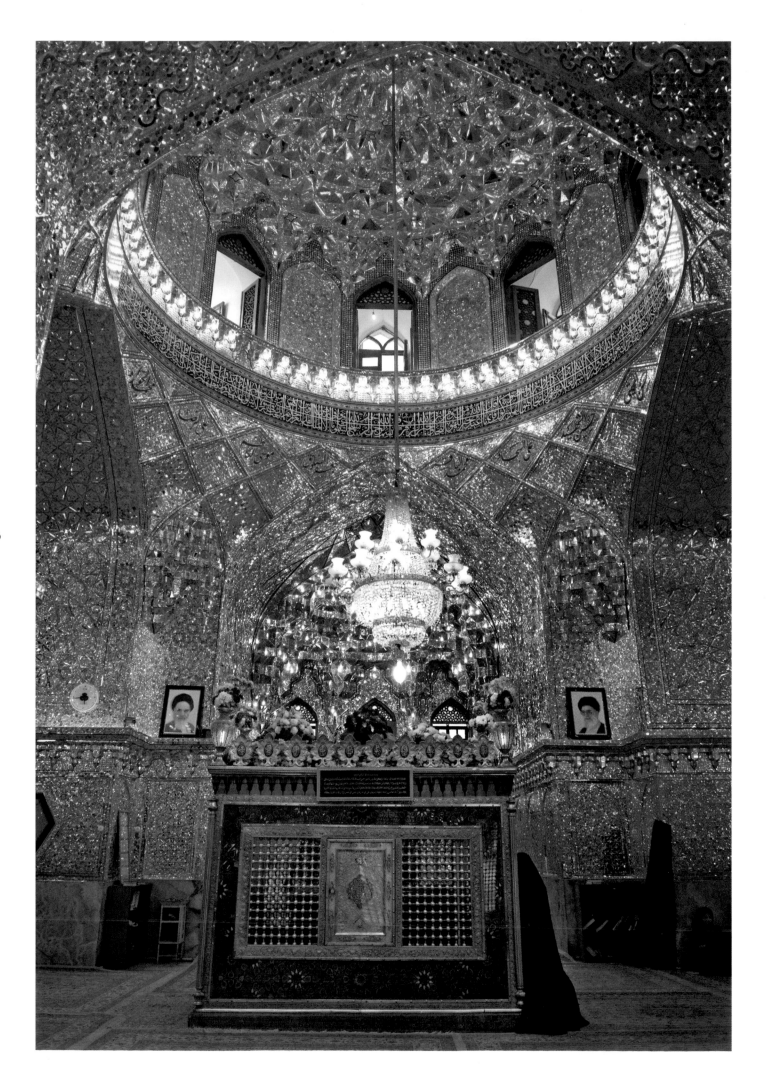

90

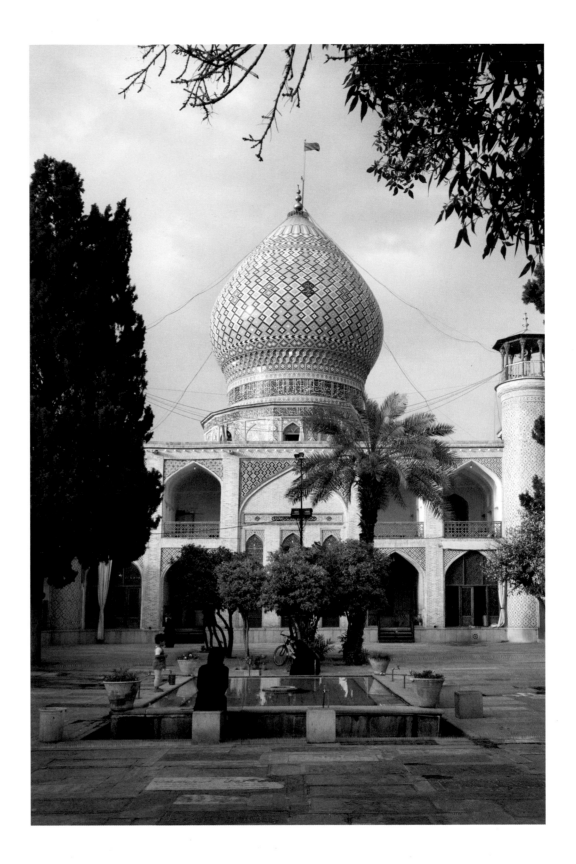

ABOVE
The courtyard and dome of the Shah-e-Cheragh mausoleum.

OPPOSITE
A woman prays at the Shah-e-Cheragh mausoleum in Shiraz.

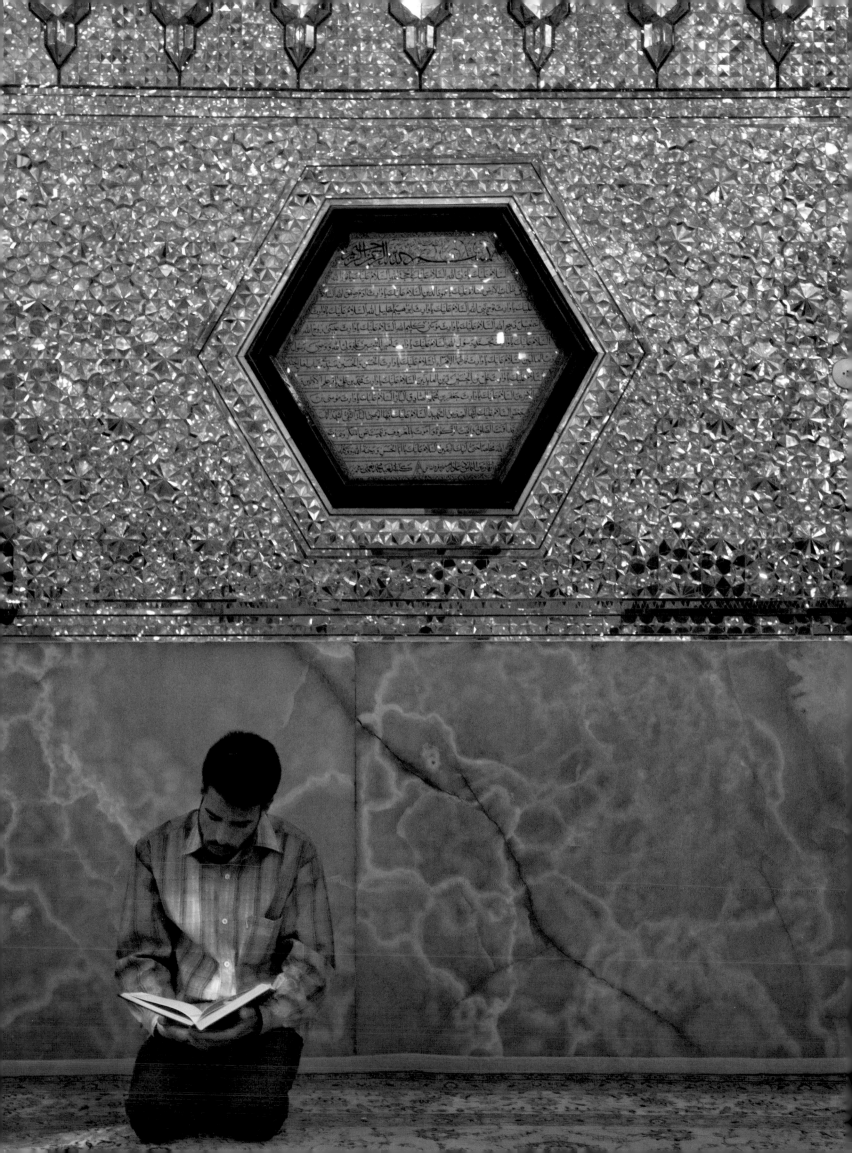

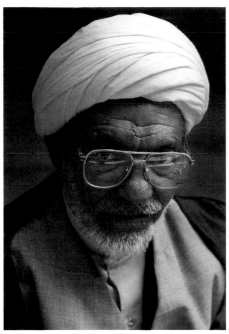

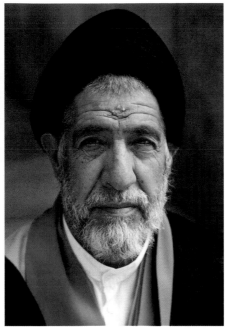

OPPOSITE
Inside the Shah-e-Cheragh
mausoleum in Shiraz.

TOP, LEFT AND RIGHT
Mullahs at the Madrassa-e Khan
in Shiraz.

BOTTOM
A mullah outside the entrance to
the Madrassa-e Khan.

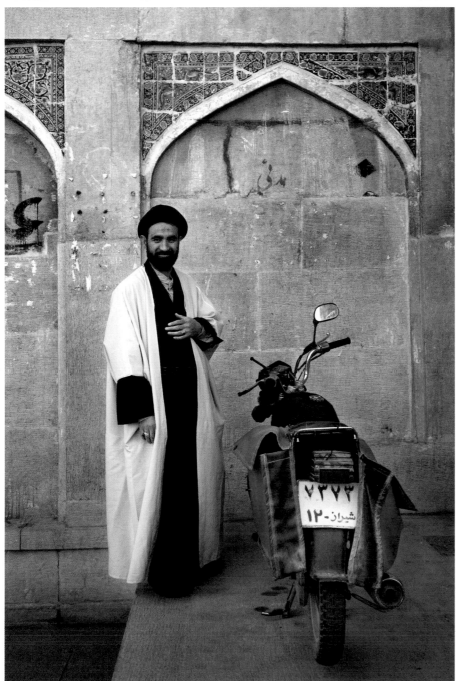

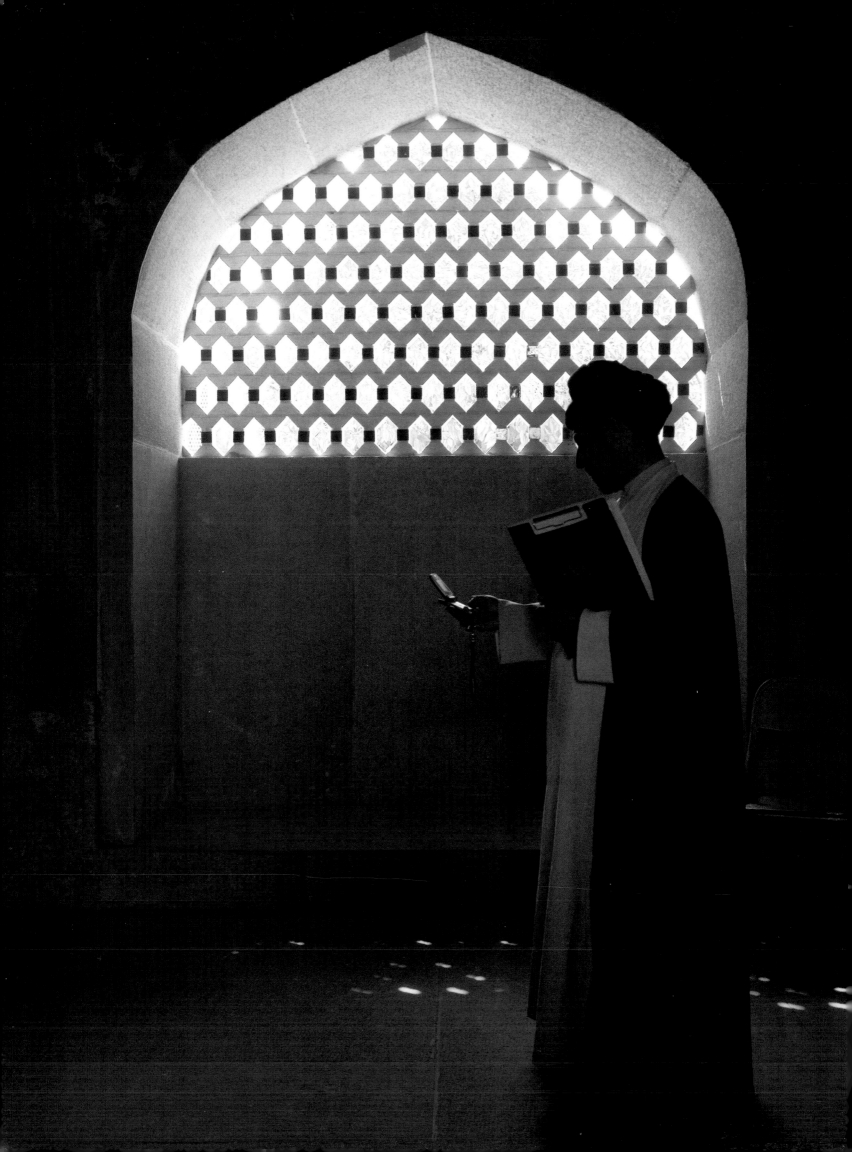

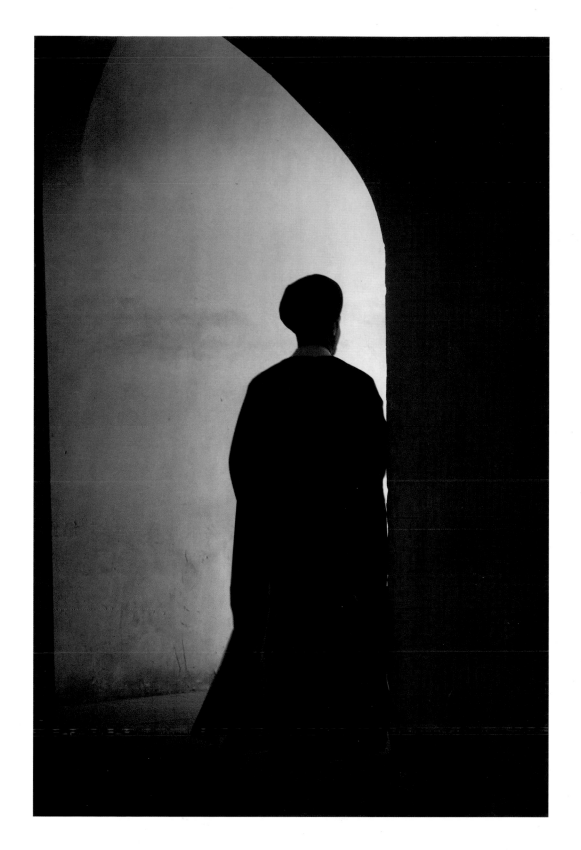

THIS SPREAD
A mullah at Madrassa-e Khan, Shiraz.

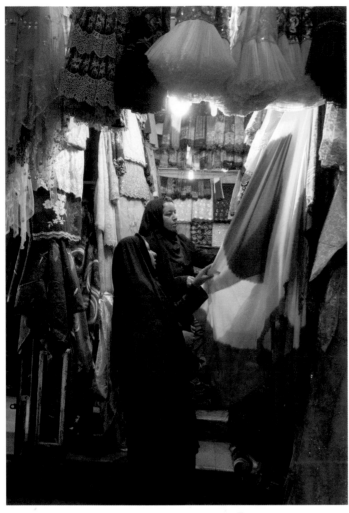

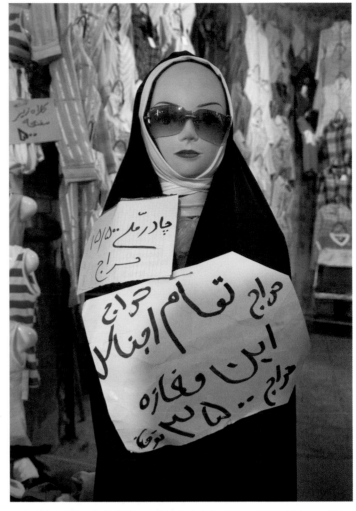

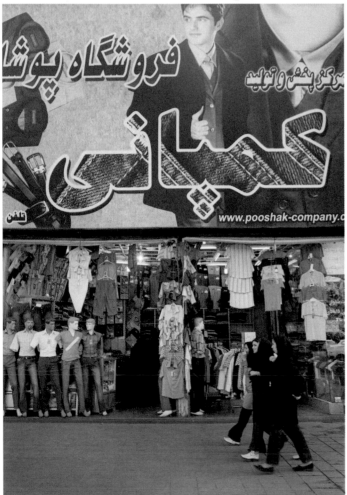

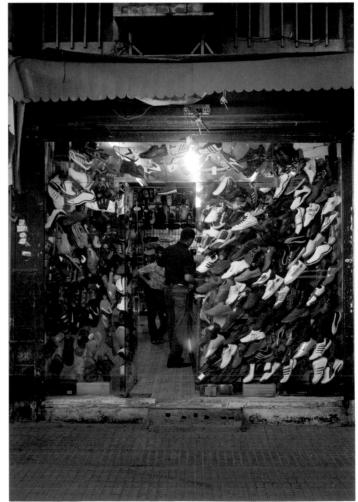

THIS SPREAD
Shopping and entertainment in Shiraz.

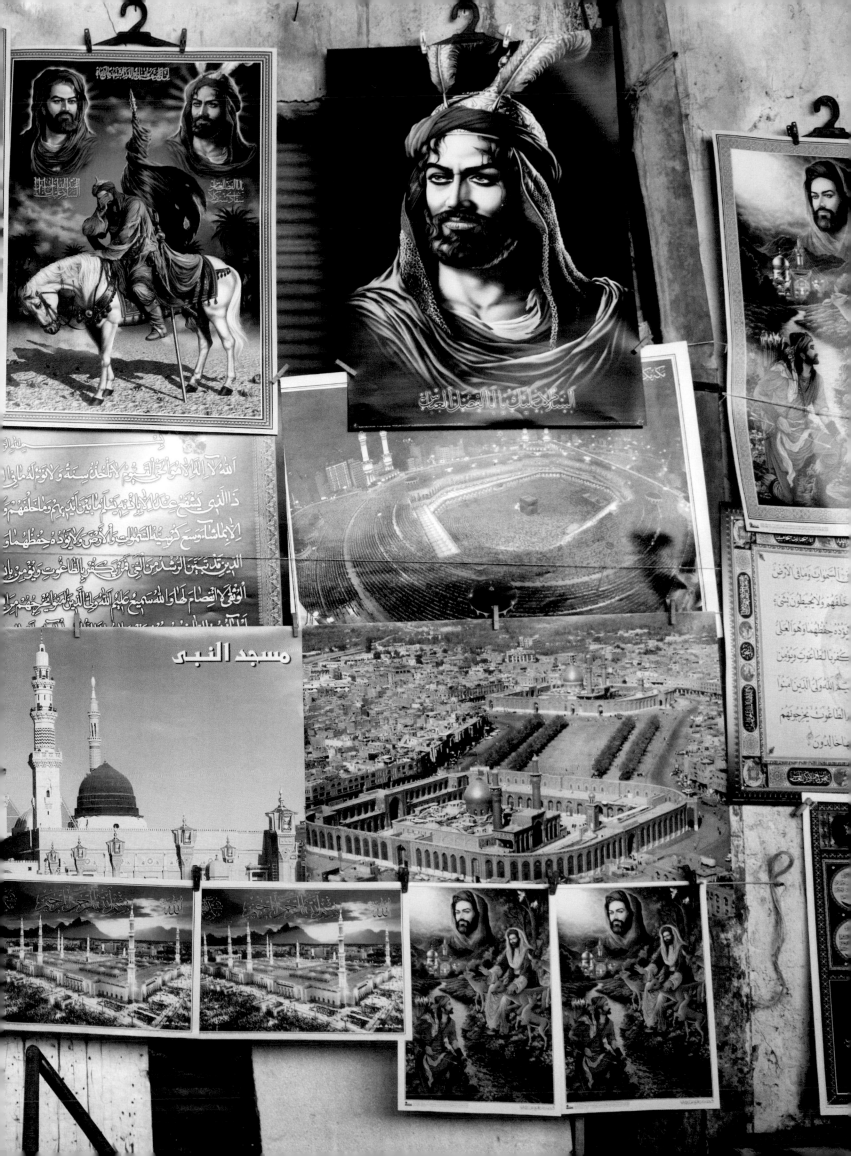

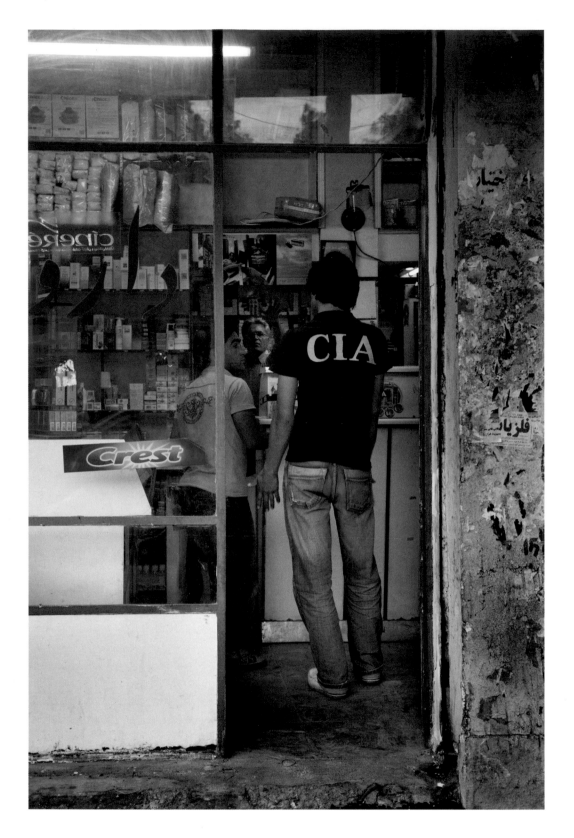

ABOVE
A customer at a pharmacy in Shiraz sports a CIA T-shirt. In June 2007, young men who were wearing T-shirts deemed too tight or sporting hairstyles that seemed too Western were paraded bleeding through the streets of Tehran and forced by uniformed police officers to suck on plastic containers used by Iranians to wash their bottoms. The photographs were distributed by the official news agency Fars, who called the young men riffraff. The move was part of a larger "spring cleaning" against clothing considered unIslamic that Iranian police said resulted in the detention of 150,000 people.

OPPOSITE
A drawing on the wall opposite Shiraz's Shah-e-Cheragh shrine.

PREVIOUS SPREAD
Religious artwork for sale at the Bazar-e Vakil in Shiraz.

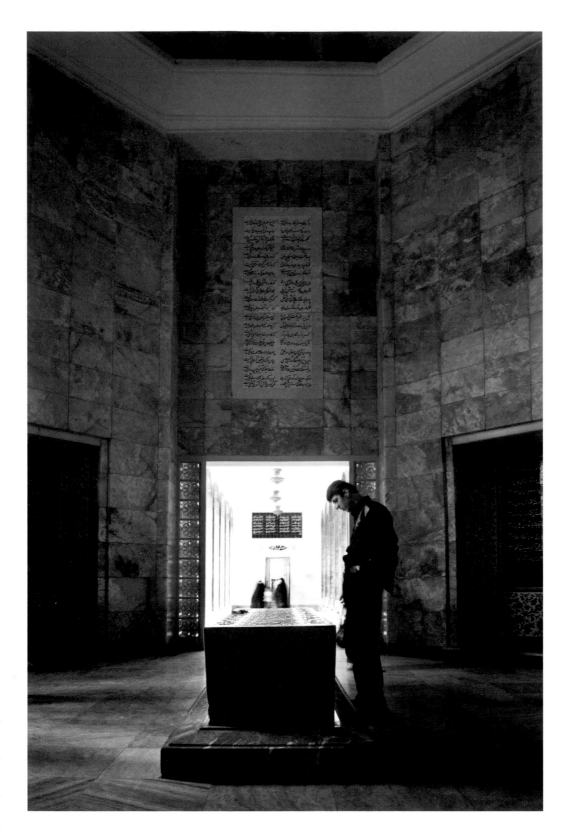

ABOVE
The tomb of Saadi in Shiraz was built in 1952 to replace an earlier one of
simple construction. The thirteenth-century poet traveled extensively
throughout the Middle East and during one trip was said to have been taken
prisoner by a group of Crusaders. Saadi's most famous works are *Bustan* (The
Orchard) and *Golestan* (The Rose Garden).

OPPOSITE
The tomb of Hafez was built in 1953 with a marble lid inscribed with several
of the poet's verses.

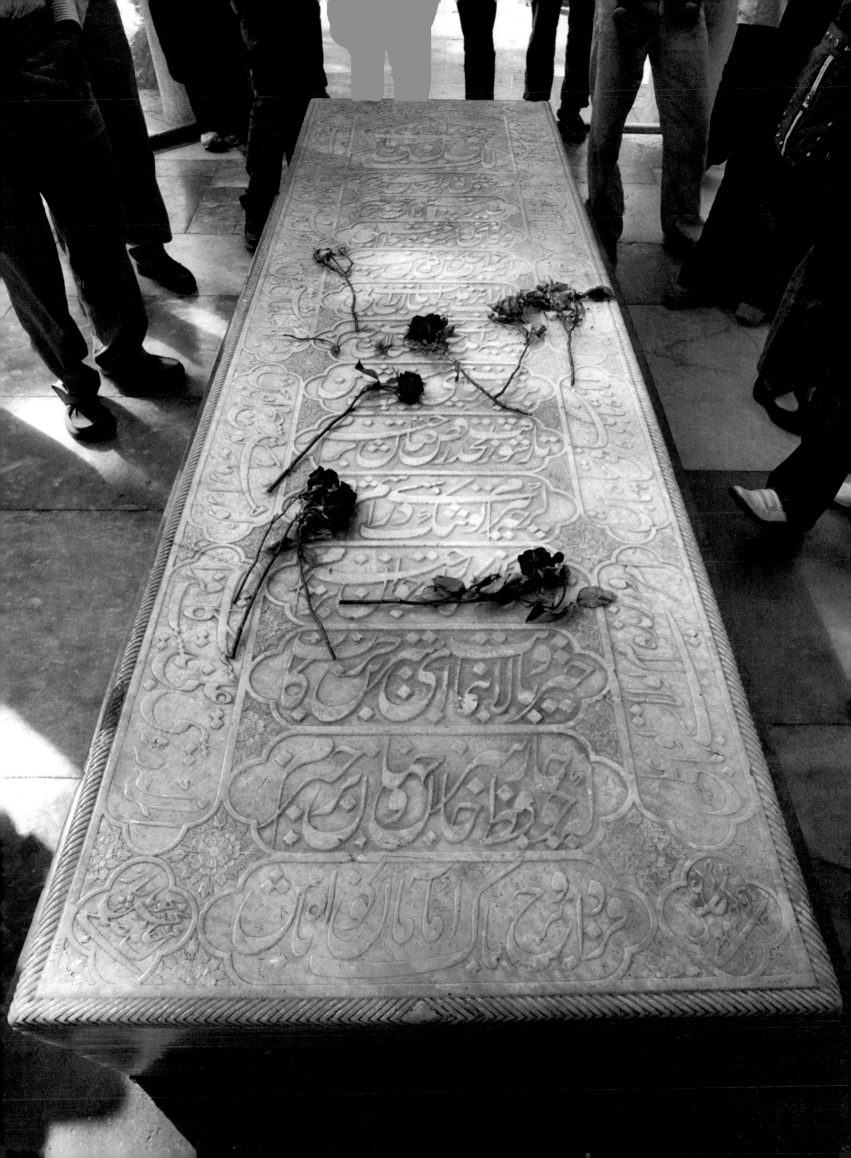

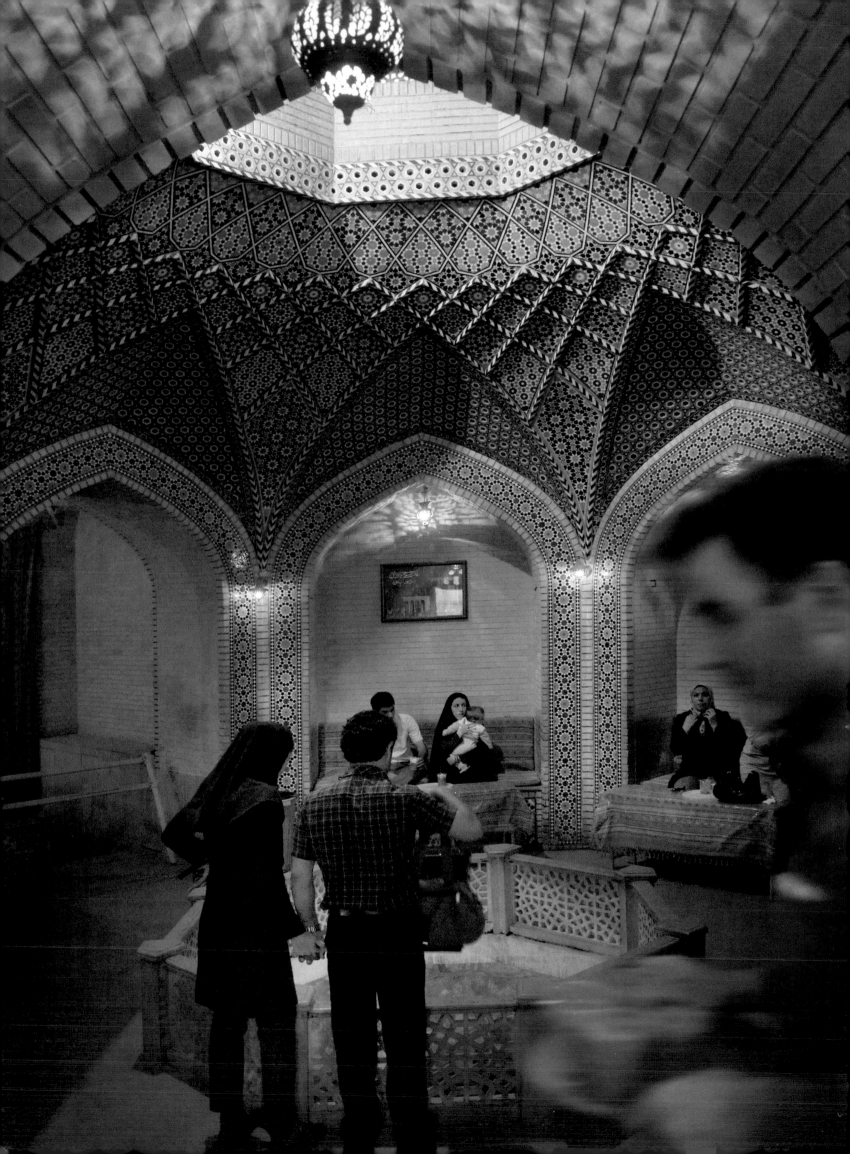

OPPOSITE

One of the nicest teahouses (*chai-khaneh*) in Shiraz can be found at the tomb of Hafez. The fourteenth-century poet is considered the undisputed master of the *ghazal*, a lyrical poem with a single rhyme.

LEFT, TOP

Shiraz's Eram Garden (Bagh-e Eram) dates from 1823.

LEFT, BOTTOM

A young couple studies Saadi's writings at his tomb in Shiraz. Poems and phrases by Saadi and the other great Iranian lyrical poet Hafez are still used in daily conversation by Farsi-speaking people around the globe.

FOLLOWING SPREAD

The small mountain town of Natanz is now well known as the site of one of several once-secret nuclear facilities in Iran, revealed by a dissident group in 2002, which were built by the Iranian government without notifying the International Atomic Energy Agency, a protocol it should have followed as a signatory to the Nuclear Non-Proliferation Treaty. Iran has always maintained that its nuclear program is meant for civilian purposes only, and the Iranian government claimed that the United States would have blocked even a nonmilitary nuclear program. The Iranian government also believes that having such a program is an "inalienable right." The United States contends that Iranian nuclear activities include a secret nuclear weapons program. Iran suspended enrichment activities in 2003 following international negotiations but resumed them in 2005 with the inauguration of President Mahmoud Ahmadinejad. A National Intelligence Estimate (NIE), which coordinates the assessments of United States intelligence organizations on specific topics, was released to the public in December of 2007. The report stated that Iran stopped the weapons side of its nuclear program in 2003. Many top American officials question the report's findings.

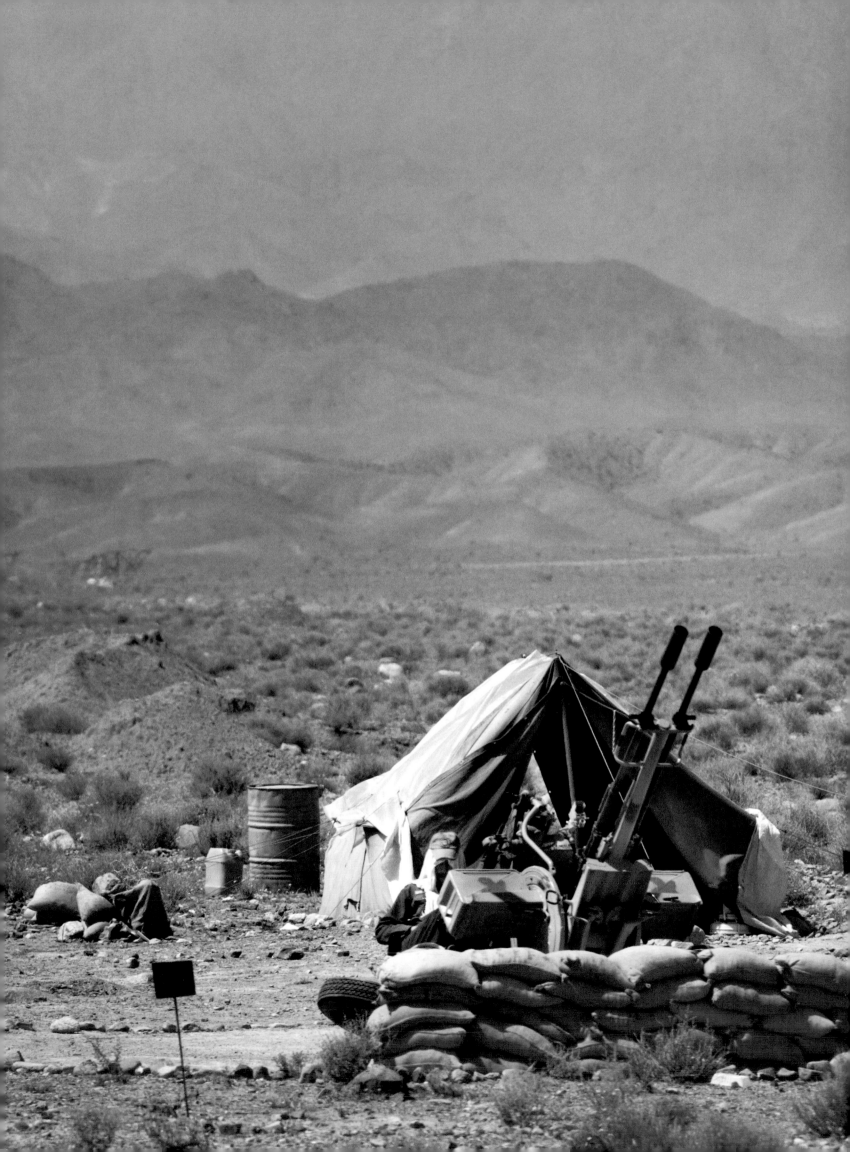

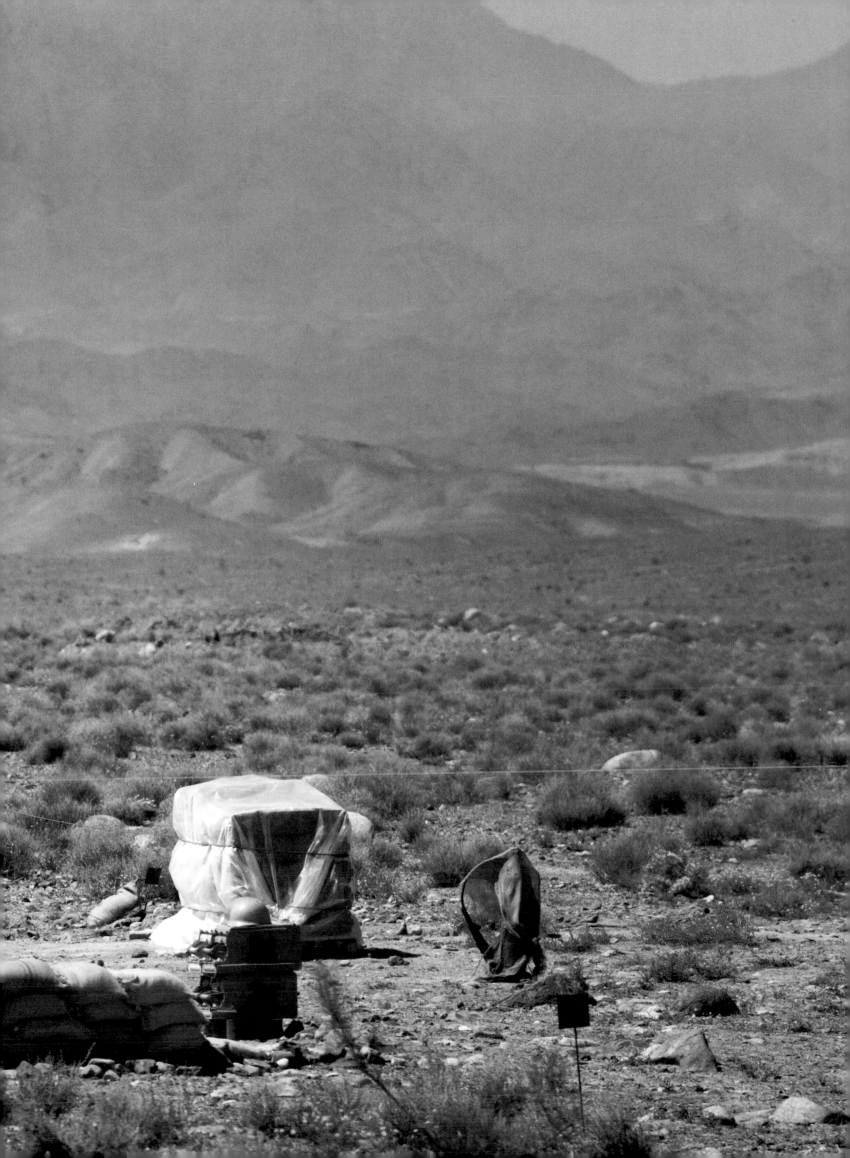

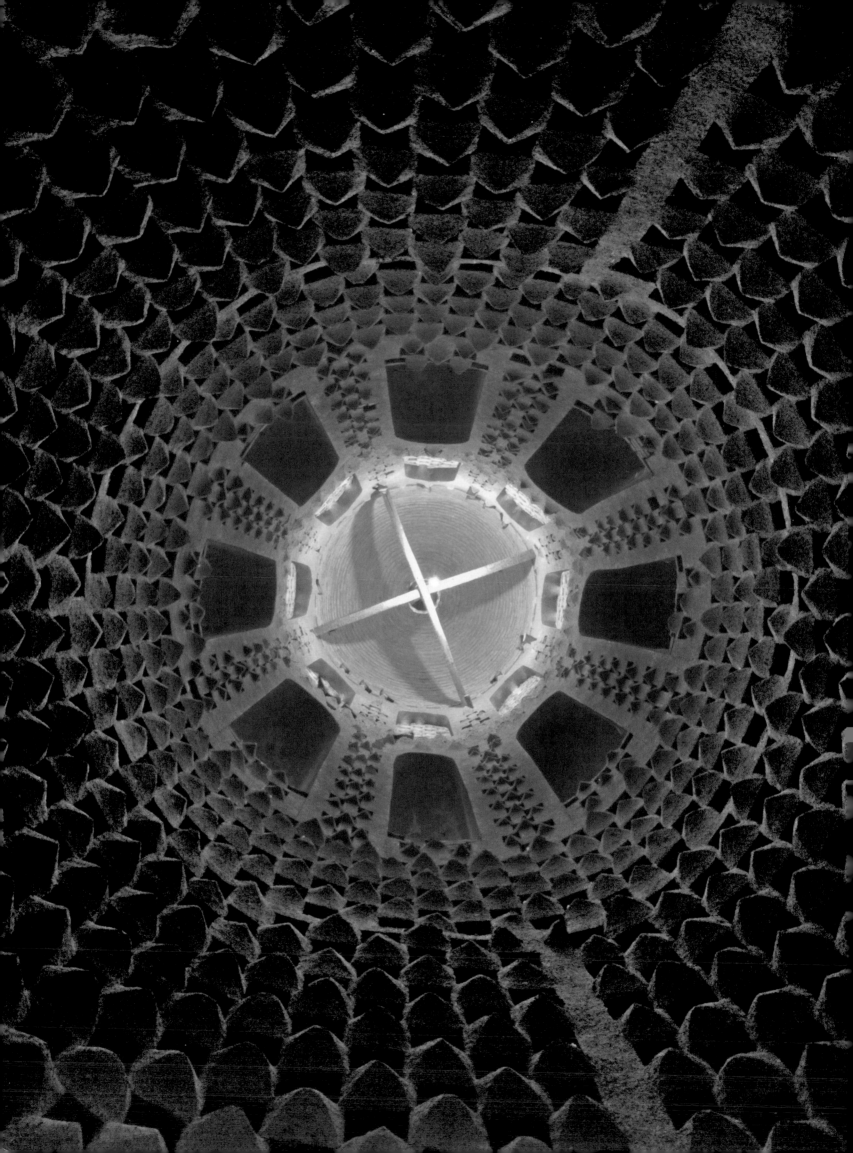

ISFAHAN: HALF THE WORLD

A CROWN JEWEL OF IRAN IS ISFAHAN (OR ESFAHAN), A CITY RICH IN BEAUTIFUL ANCIENT PALACES, MOSQUES, GARDENS, MUSEUMS, AND PERSIAN CULTURE. PRIDE OF PLACE IS REFLECTED IN THE PERSIAN SAYING *"ESFAHAN NESF-E JAHAN AST"* (ESFAHAN IS HALF OF THE WORLD). MUCH OF IT WAS DEVELOPED DURING THE SIXTEENTH CENTURY, CONSIDERED THE CITY'S GOLDEN AGE THANKS TO SHAH'ABBAS I (1571–1629), WHO CONQUERED THE CITY AND ESTABLISHED IT AS THE CAPITAL OF THE SAFAVID DYNASTY AND PURPOSEFULLY SET ABOUT TO MAKE ISFAHAN ONE OF THE GREAT ISLAMIC CITIES OF THE WORLD.

Today it is the country's third largest city (with around 1.5 million residents) and is a major metropolitan area, industrialized at the outskirts, that hosts numerous universities, a major oil refinery, and Iran's Khatami Air Base. For hundreds of years, the city has also produced magnificent rugs and textiles.

In more recent times, the city has been host to the Uranium Conversion Facility at Isfahan, which processes uranium concentrate (yellowcake) to produce uranium hexafluoride (UF6), used in uranium enrichment. (There are other Iranian nuclear facilities located at Arak and Natanz.) Low-level enrichment can yield fuel for nuclear power generation, while a high level of enrichment can make uranium suitable for use in nuclear weapons. Iran claims that it wants to develop nuclear technology for peaceful purposes, and it asserts that it has a right to do so. The visitor of Isfahan of course does not come in contact with the realities of modern-day nuclear issues. Rather, they are immersed in the magnificence of the city's grand architecture and cosmopolitan lifestyle.

OPPOSITE
The ceiling of a pigeon tower, or dovecot, one of many in the vicinity of Isfahan.

ABOVE
An Armenian Bible from AD 1472 on display in the museum at Kelisa-e Vank.

OPPOSITE
Safavid rulers received foreign envoys in Isfahan's seventeenth-century
Chehel Sutūn Palace. Several of the palace's frescoes show the influence of
European art.

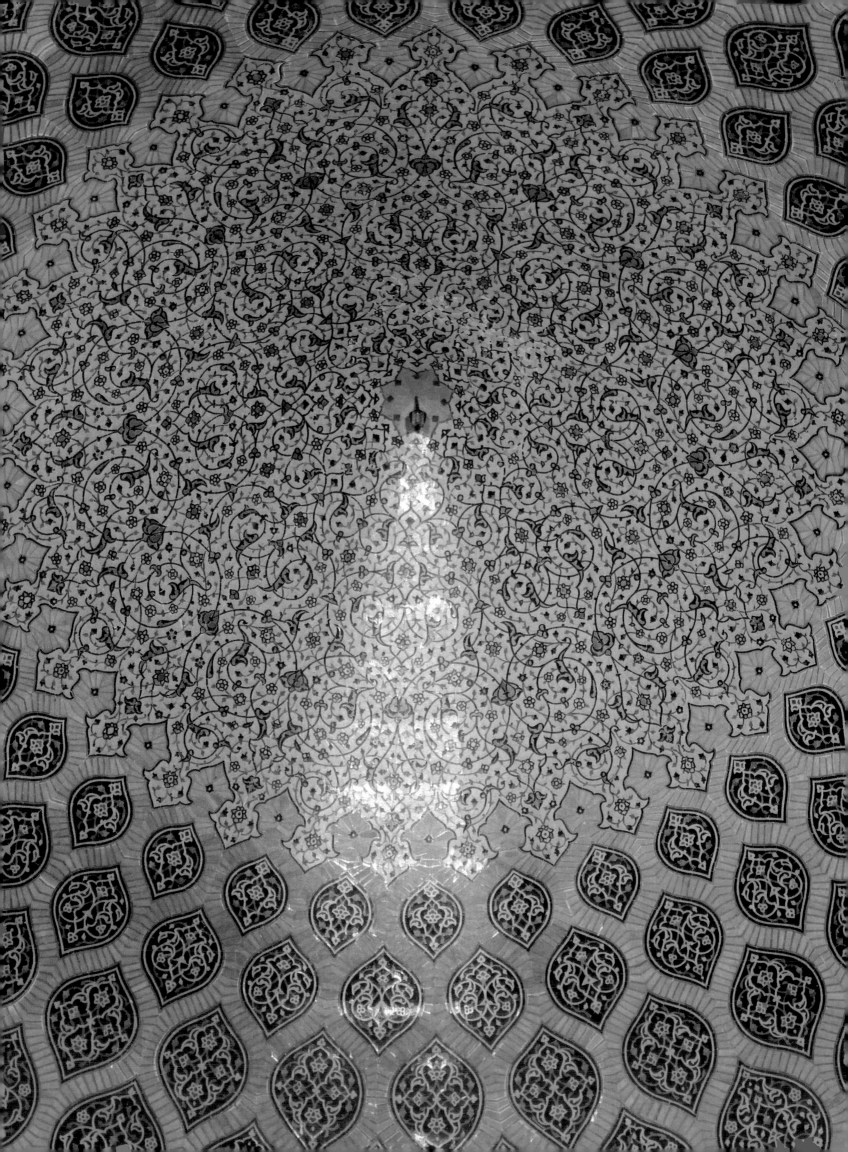

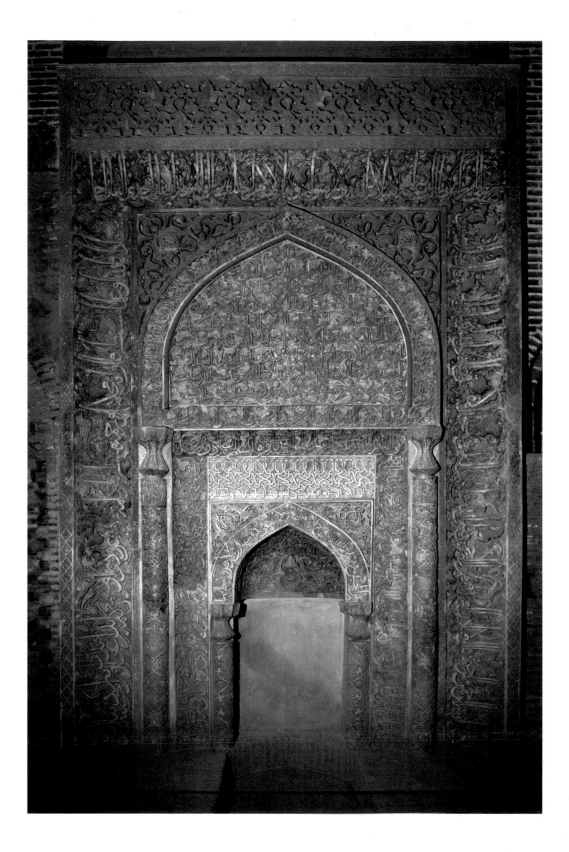

ABOVE
A stucco mihrab constructed by Ostad Heydar during the reign of the
Mongol ruler Oljaytu (Oljeitu) in AD 1310 at the Friday Mosque, Isfahan.

OPPOSITE
The "tail of a peacock" formed by light coming through the top of the dome
of Isfahan's Shaykh Lutfallah Mosque.

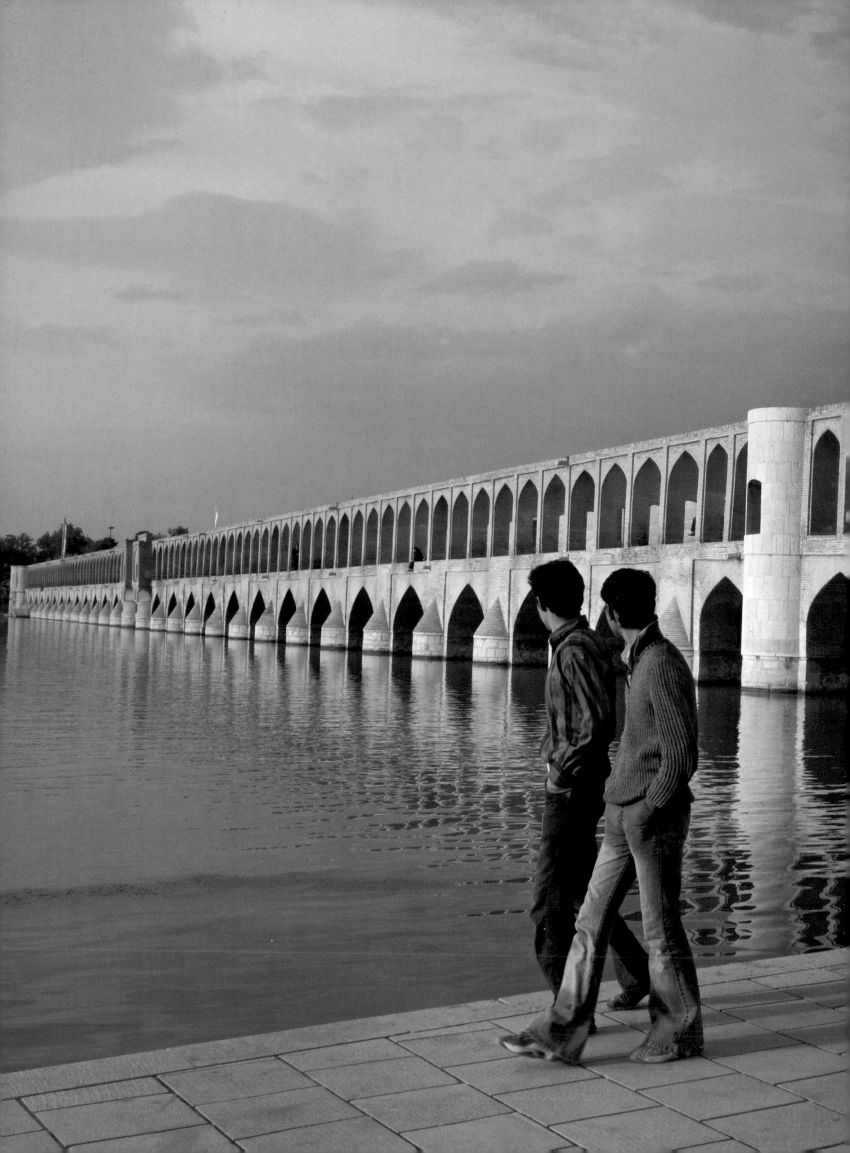

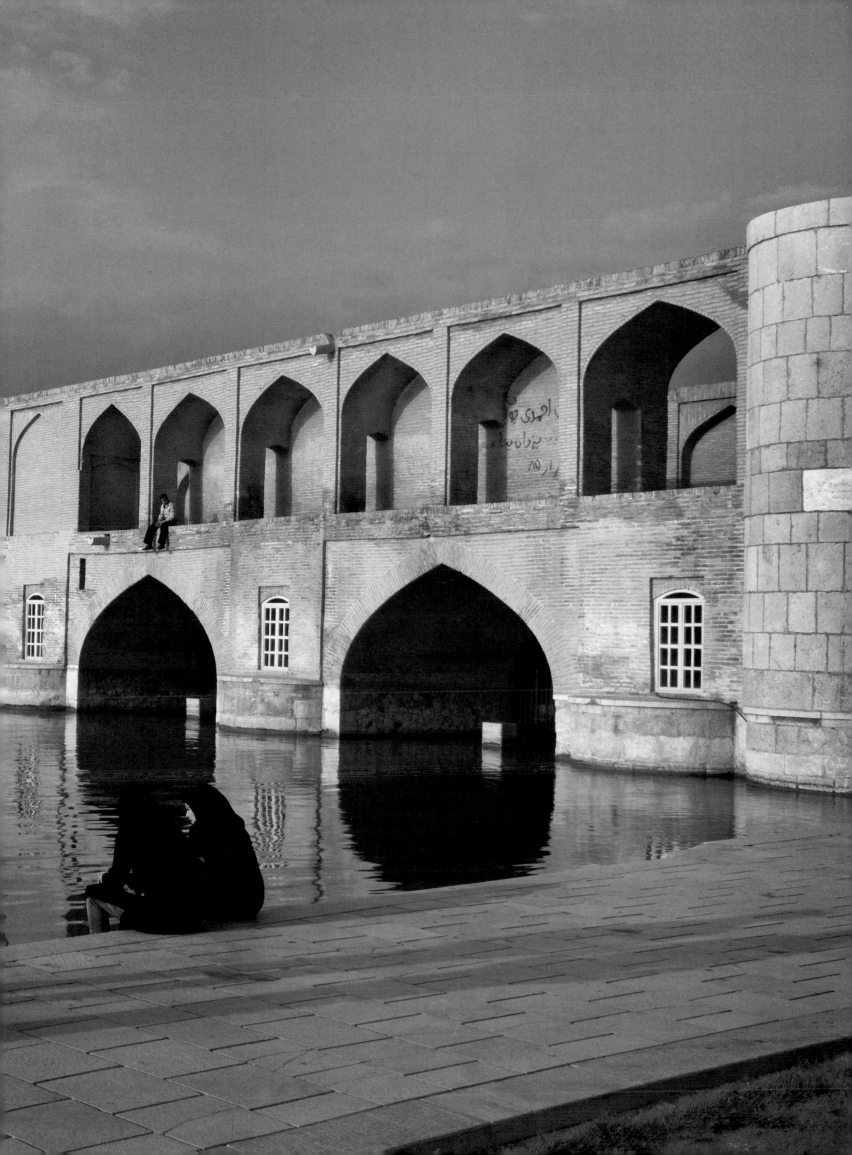

116

ABOVE

Women in Iran are required to wear either a chador or a manteau and a *hijab* (head scarf) in public. Some express their individuality in public with designer head scarves and shoes, makeup, hair color, and nail polish.

PREVIOUS SPREAD AND OPPOSITE

The Allah-Verdi Khan Bridge was commissioned in 1602 by Shah Abbas I. It is also called Si-o-Se Pol (thirty-three bridges) because its lower level is made up of thirty-three arches.

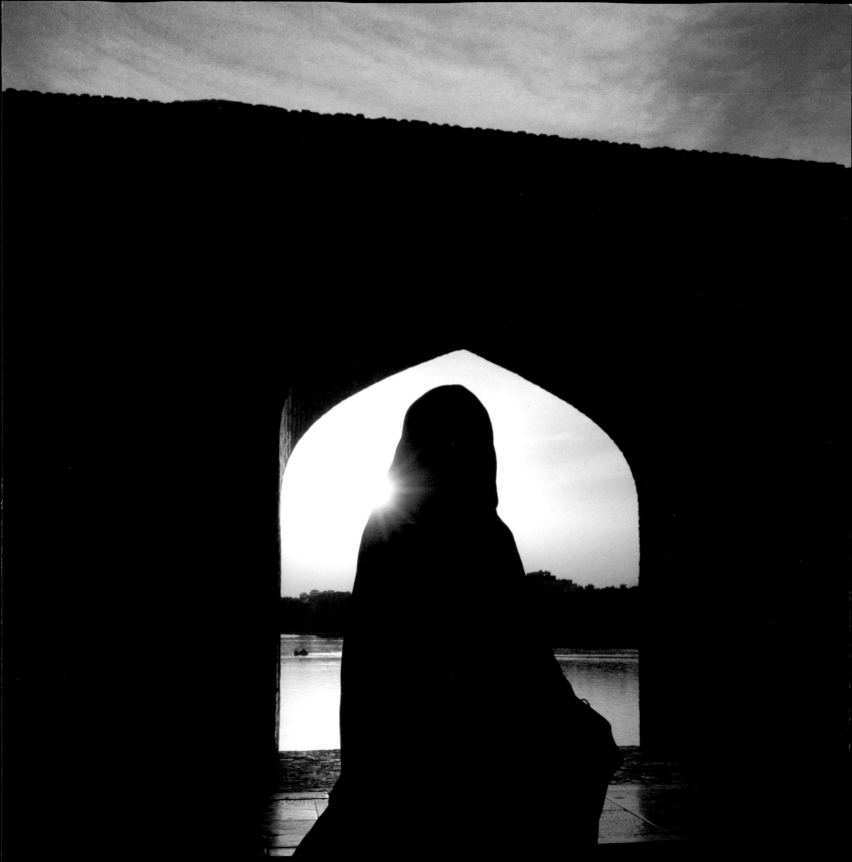

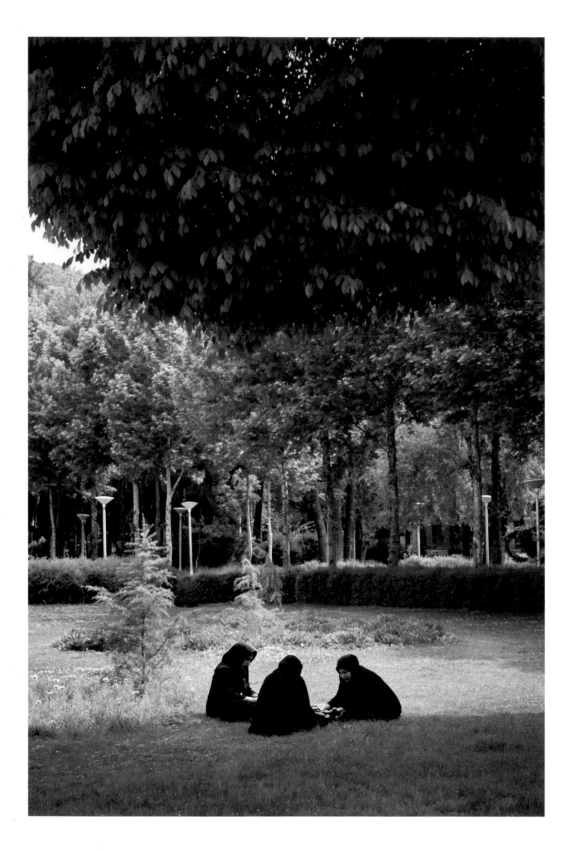

118

ABOVE
Women in a park behind the Hasht Behesht (Eight Paradises) pavilion.

OPPOSITE
An Isfahan street scene from the top of the pigeon tower. In the distance
pedestrians take their lives into their own hands with a dash across traffic,
a scene that is repeated countless times throughout the country every day.

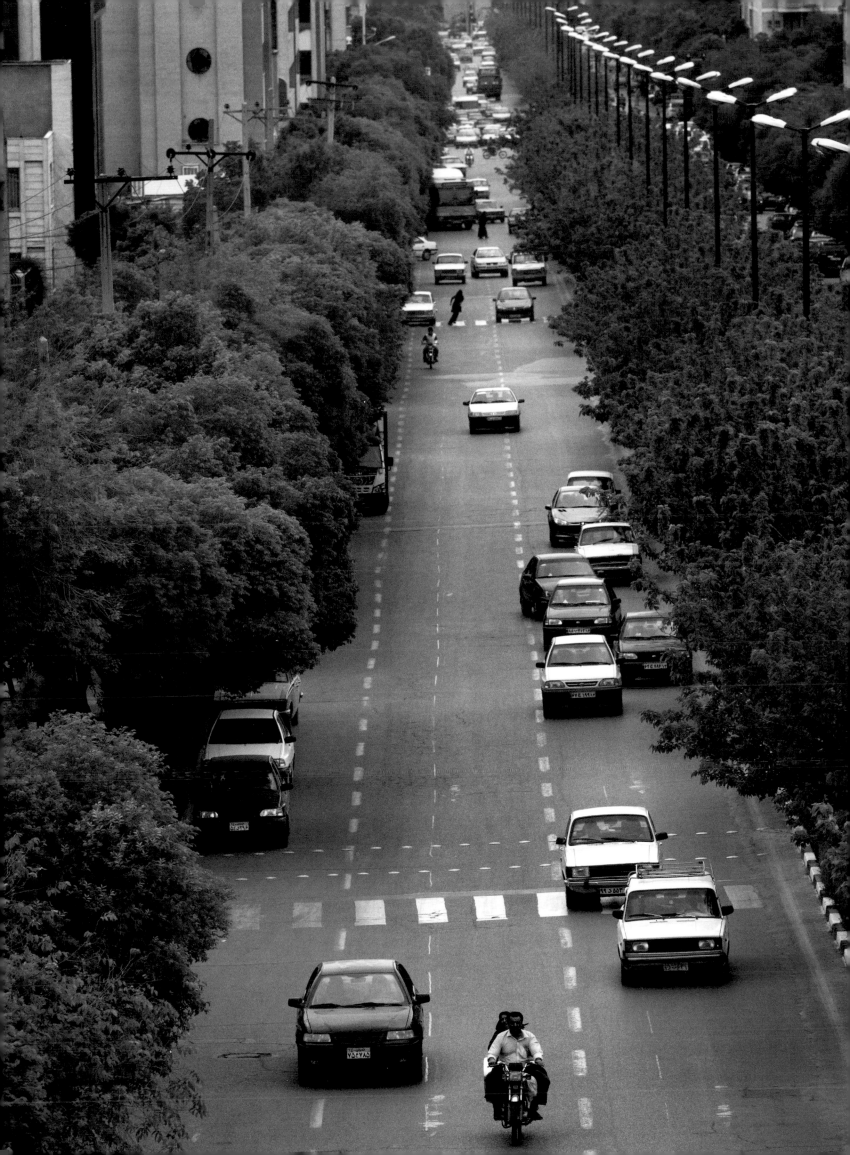

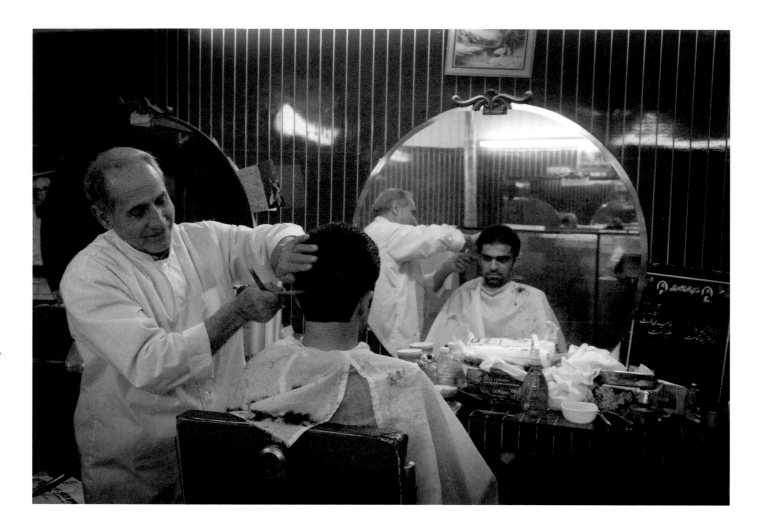

ABOVE
A barbershop in Isfahan.

OPPOSITE
A shop for wedding dresses in Isfahan.

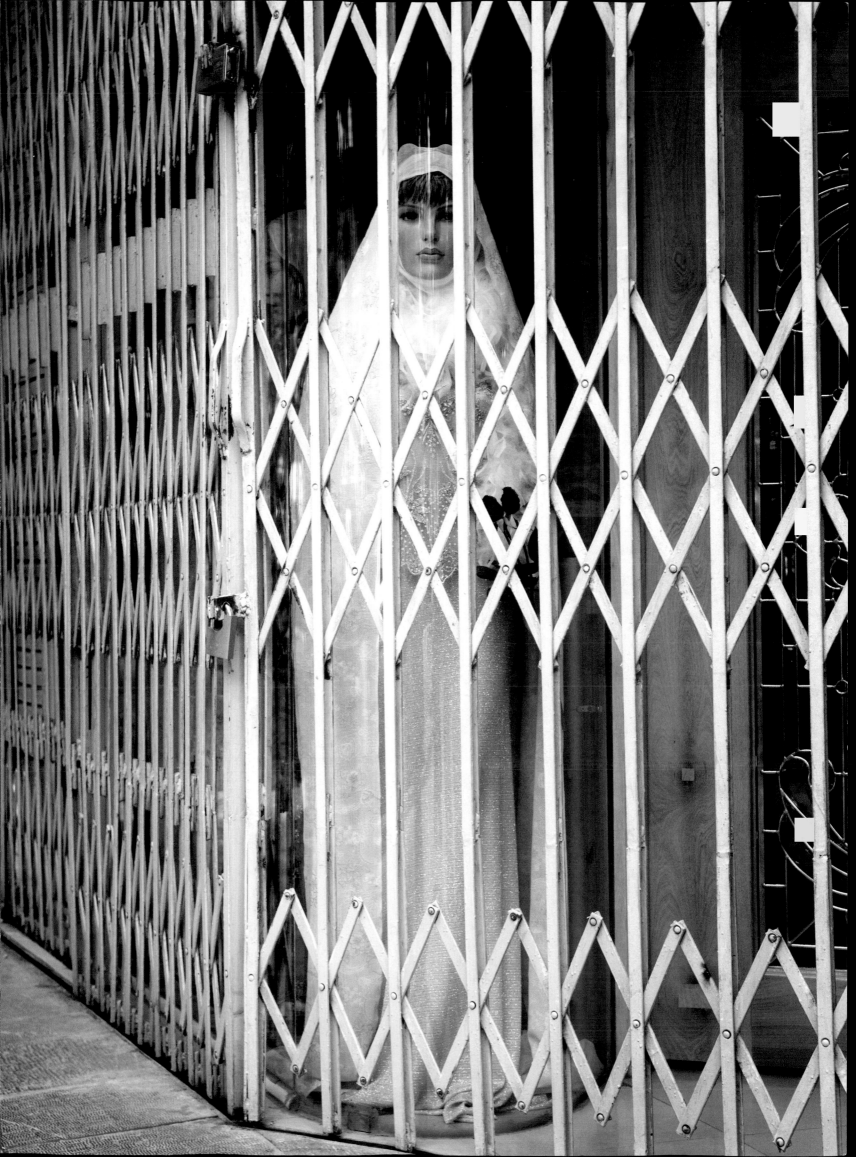

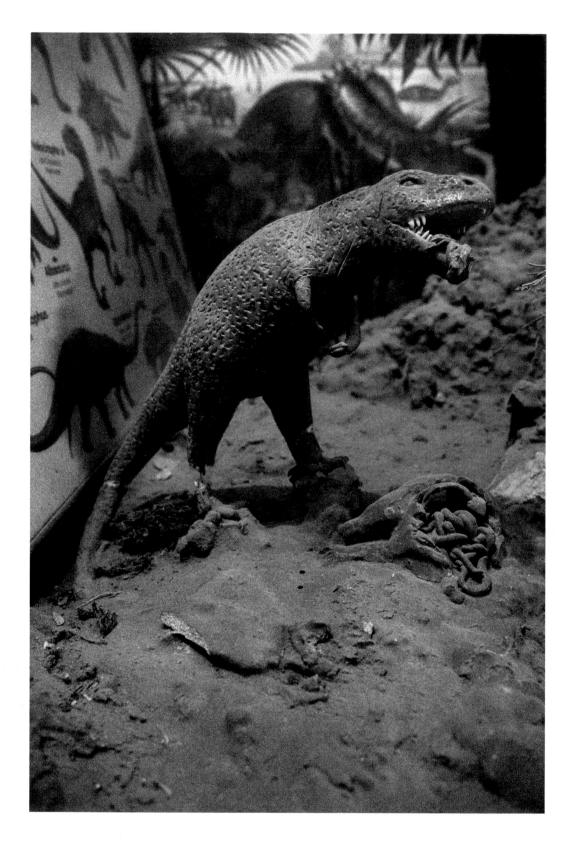

122

ABOVE
A display at Isfahan's Natural History Museum.

OPPOSITE
Children play on the tail of a prehistoric animal model in front of the Natural
History Museum in Isfahan.

FOLLOWING SPREAD
Two couples watch the Menar Jonban, or "shaking minarets," so called
because grabbing and shaking one of the two small towers on the roof of
the building will cause the other to sway and, alarmingly, to reveal cracks
in the building.

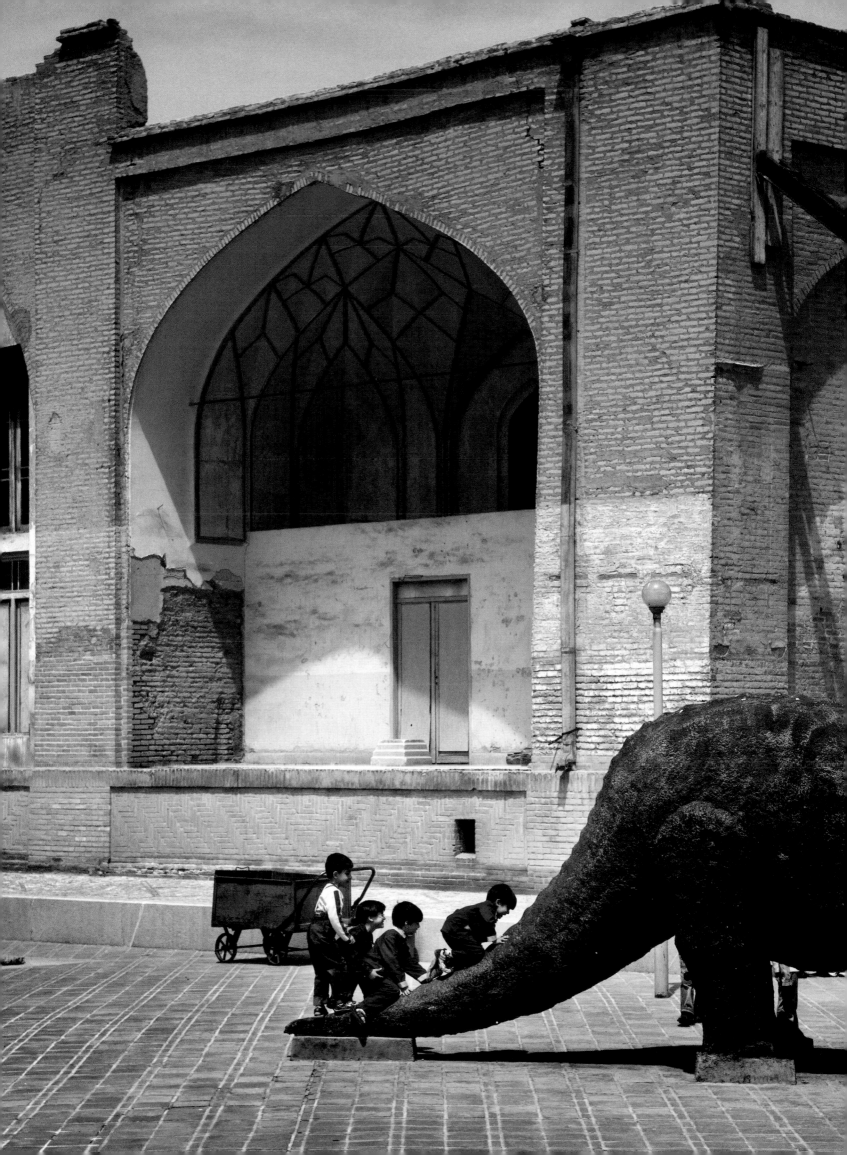

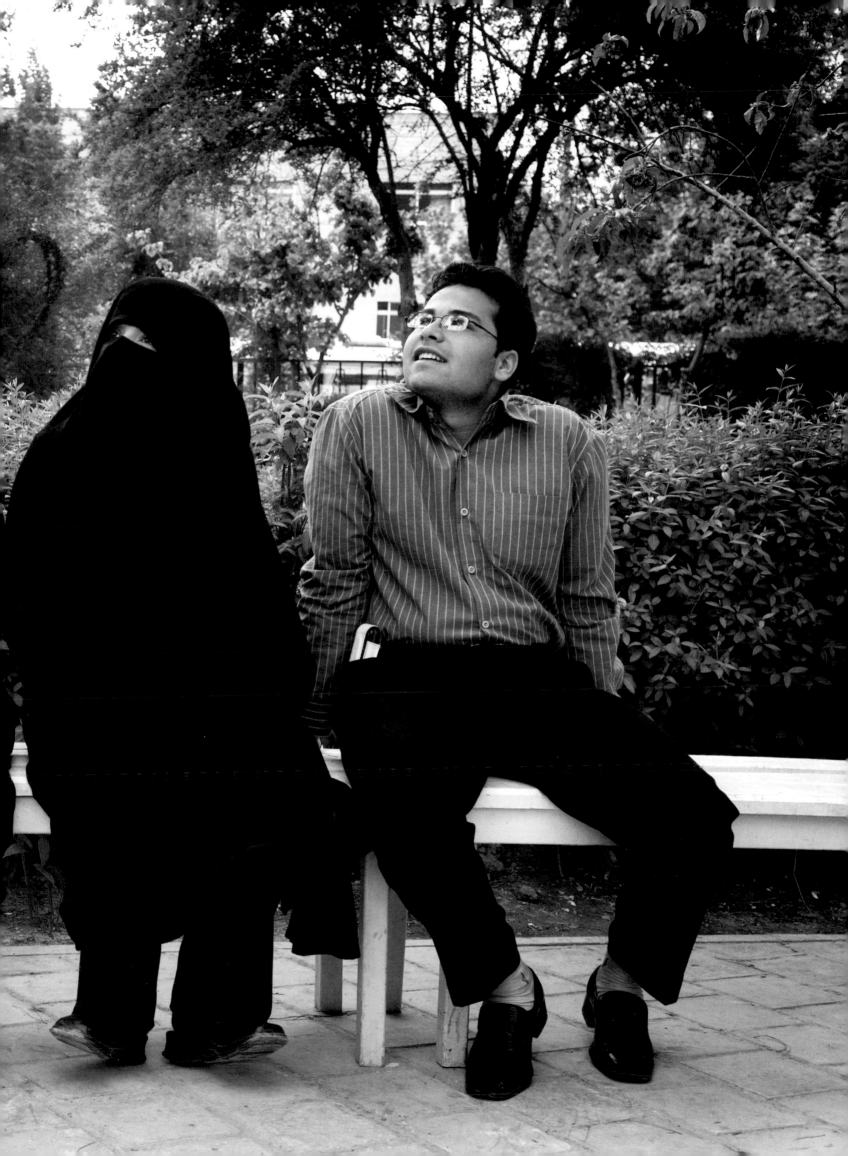

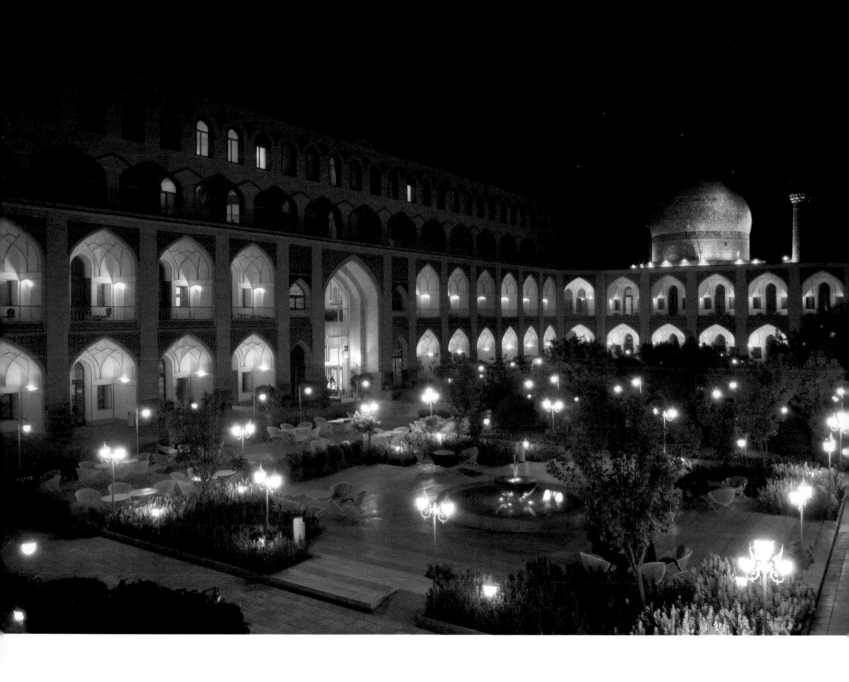

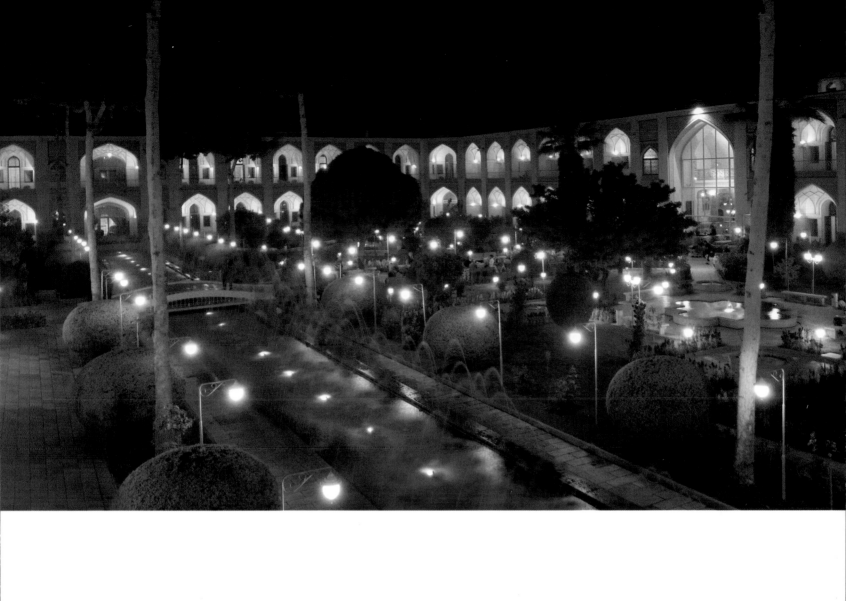

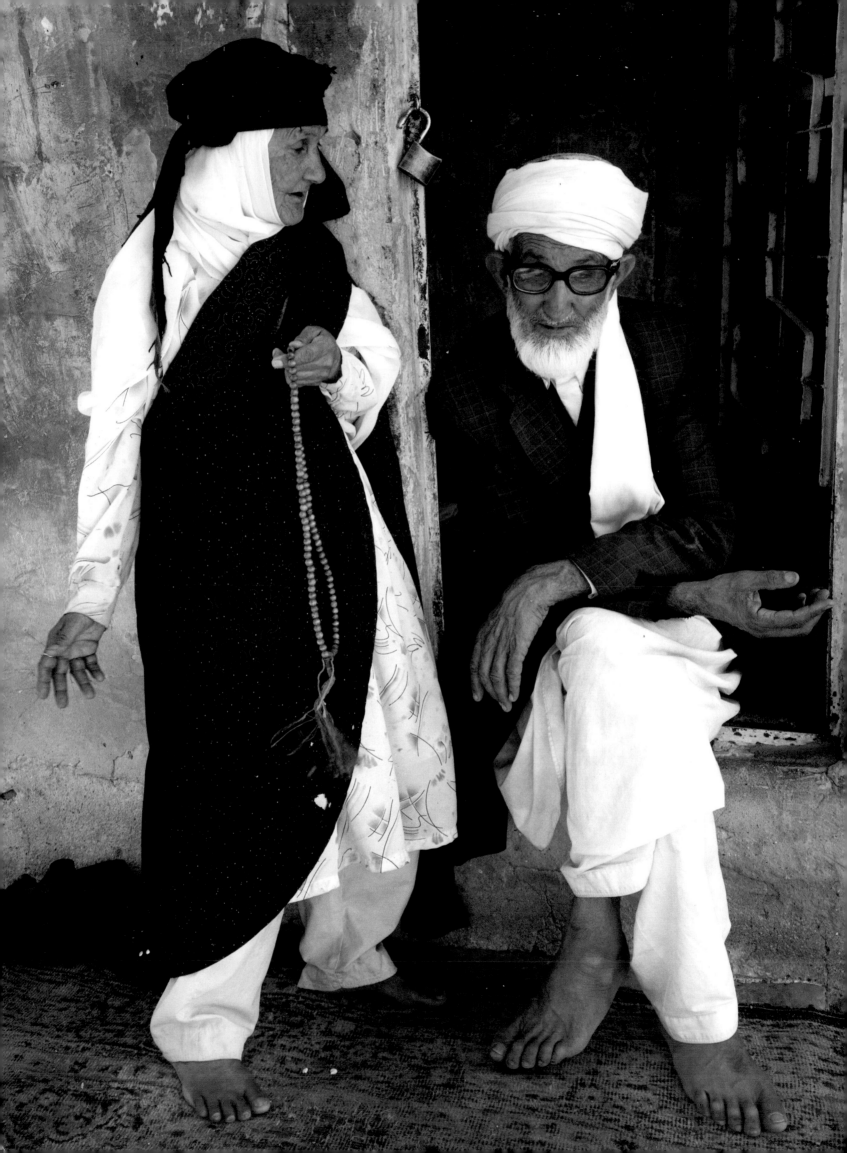

MASHHAD AND EASTERN IRAN

MASHHAD IS 500 MILES NORTHEAST OF TEHRAN. IT IS BOTH THE CAP-ITAL AND LARGEST CITY (MORE THAN 2 MILLION PEOPLE) OF IRAN'S EASTERN PROVINCE, AND IT IS ALSO THE COUNTRY'S HOLIEST CITY. MASHHAD (PLACE OF MARTYRDOM) IS THE FINAL RESTING PLACE OF THE IMAM REZA, A DIRECT DESCENDANT OF THE PROPHET MUHAMMAD AND EIGHTH IN THE LINE OF TWELVE IMAMS, OR SPIRITUAL LEADERS. THE TWELFTH IMAM, THE MAHDI, IS SAID TO HAVE DISAPPEARED IN THE NINTH CENTURY AND ACCORDING TO BELIEVERS IS DUE TO RETURN TO GUIDE THE WORLD TO A RIGHTEOUS PEACE.

Although Mecca and Medina in Saudi Arabia and Najaf and Karbala in Iraq are seen by Shiites as the holiest cities, Mashhad has gained in importance for Iranian pilgrims since it is much more accessible, especially in light of the turmoil taking place across the country's western borders. Those who complete the pilgrimage to Mecca receive the title of *haji*; those who make the pilgrimage to Mashhad are known as *mashtee*. It is said that the rich go to Mecca but the poor journey to Mash-had. With thousands of pilgrims in the city at any given time, Mashhad has a much more religious feel to it than Tehran, with many more women cloaked in black chadors (women are only admitted to the shrine of the imam if wearing the chador).

While approximately 15 percent of Muslims world-wide are Shia, with 85 percent being Sunni, Iran is the only officially Shia country. Its populace is roughly 89 percent Shia, 10 percent Sunni, and the rest made up of Christians, Jews, and those of other faiths. The Shia-Sunni split in the Muslim faith stems from a disagree-ment over who is held to be the true successor of the prophet Muhammad. Further, Iranians are Persian, not Arab, though there is an Arab population in Iran. Iran has never been an Arab country and was known as Per-sia until 1935. Additionally, the predominant language is Farsi, not Arabic. These distinctions are a source of pride for Iranians and sometimes a source of tension and separation within the Middle East.

In 1994, a terrorist bombing at the holy shrine of Imam Reza in Mashhad killed twenty-five people, resulting in a policy, continued today, of strict security searches for visitors to the shrine. While the shrine and the religious pilgrims that it draws have been impor-tant for Mashhad's development, the city also attracted many refugees fleeing the 1980–1988 Iran-Iraq War, due to its eastern location, far from the Iran-Iraq border. It is now Iran's second largest city, after Tehran.

What was surprising to me in this ostensibly con-servative city was its well-stocked, modern Western-style mall, with stores selling everything from knockoff Ralph Lauren and Versace to blenders and washing machines. The mall also hosts a supermarket with a large foreign foods section and a Pizza Hut–style eat-ery called Fast Food Proma, which occupies most of the ground floor. Five floors above is a children's activity center and a bowling alley. The latter displayed a sign stating that bowling is "not permitted for ladies"—an interesting collision of East and West.

Driving east from Mashhad is to leave these ame-nities of urban life quickly behind. Much of Khorasan Province is sparsely populated. Traveling southeast toward the Afghan border, Mashhad's suburbs soon give way to sun-scorched agricultural land, intermittent vil-lages with low adobe houses, and shepherds tending to flocks of sheep. This last scene transported me not only toward the Afghan border, but also back in time.

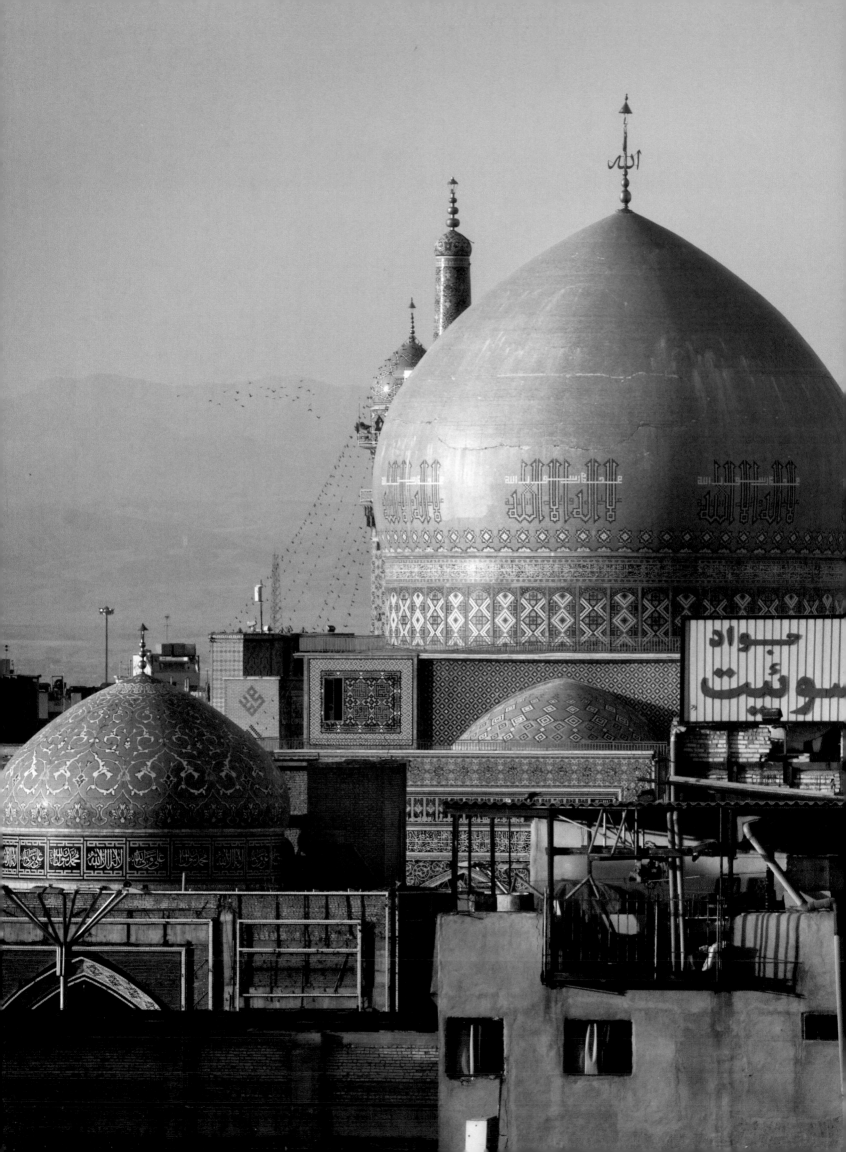

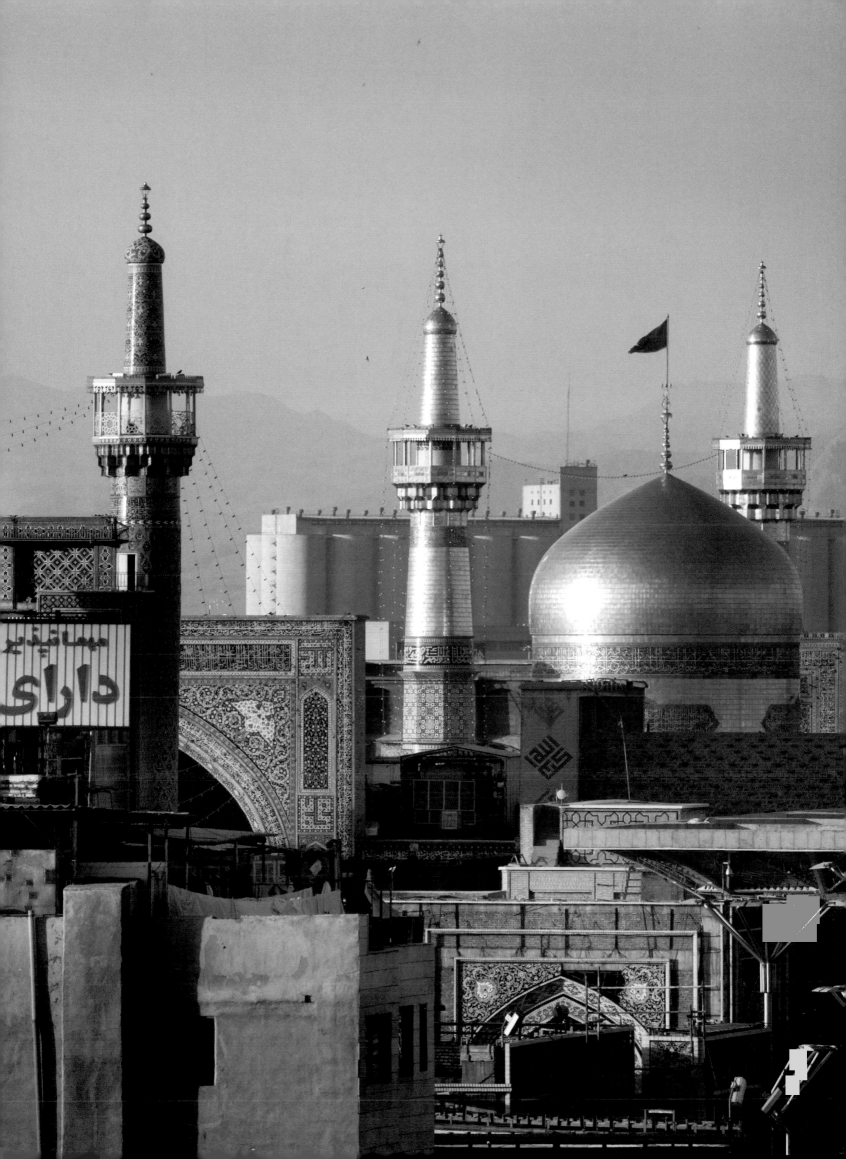

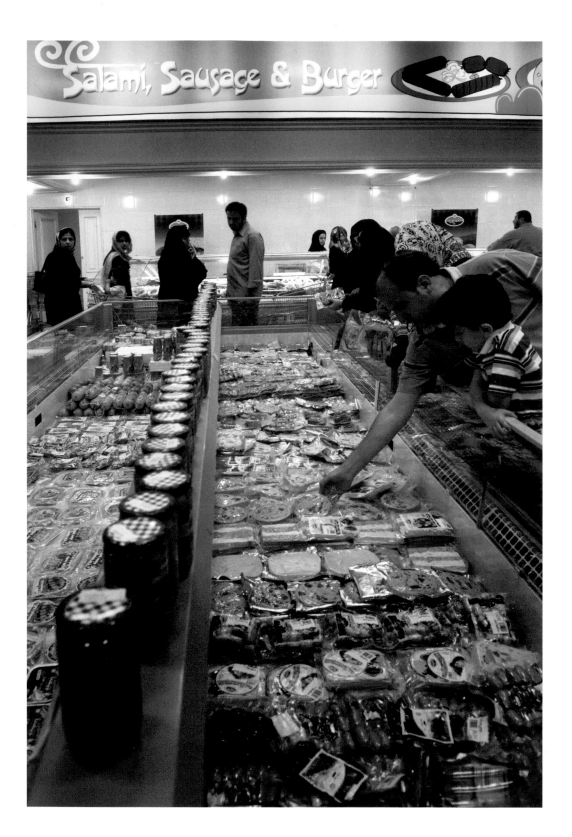

THIS SPREAD
A major spiritual pilgrimage site, Mashhad also features modern Western-style shopping and entertainment amenities.

PREVIOUS SPREAD
A view of the shrine complex at Mashhad. Millions of pilgrims come to Mashhad each year. In the 1980s, many people fleeing from the Iran-Iraq War took refuge here, the farthest major Iranian city from the war zone.

MASHHAD AND EASTERN IRAN

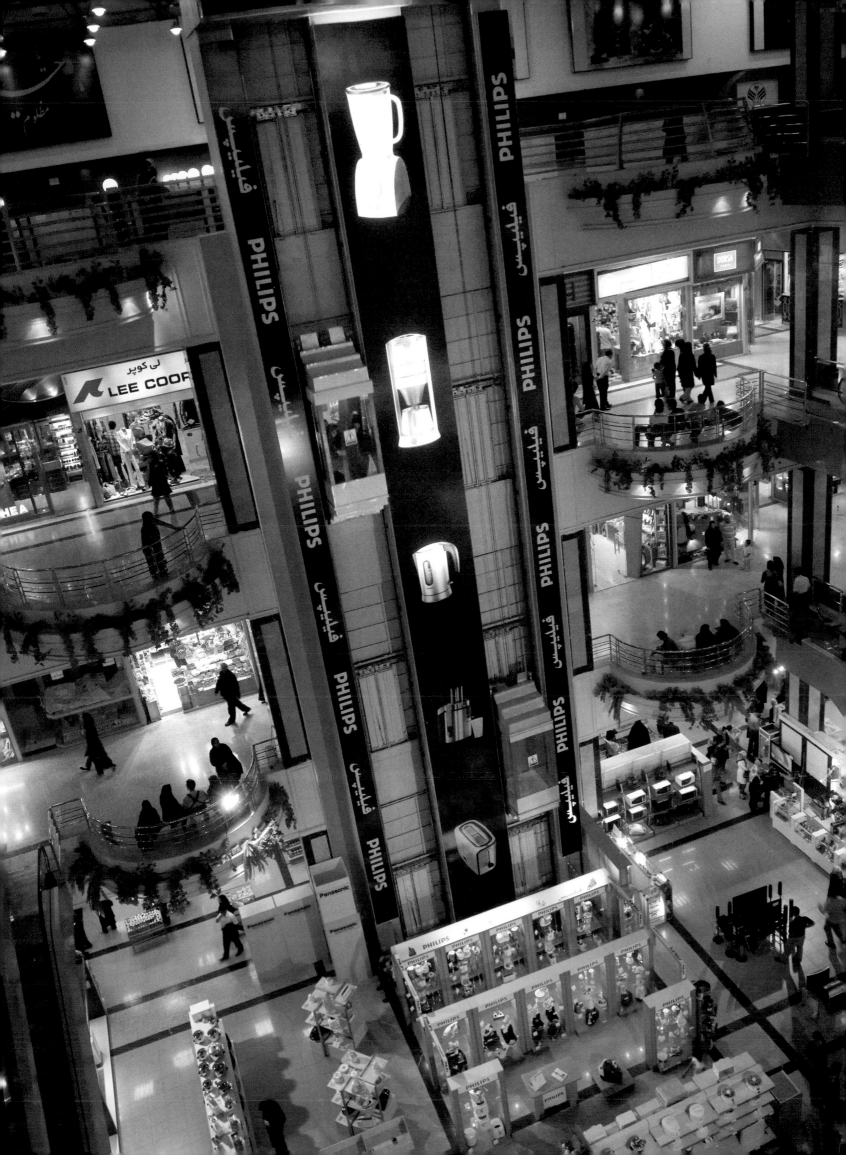

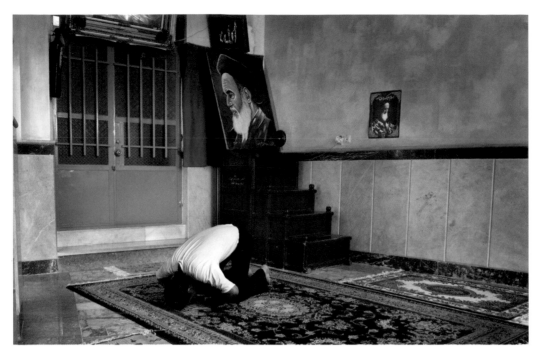

LEFT, TOP
A man praying at a shrine in Golestan.

LEFT, BOTTOM
A family at a Golestan shrine.

OPPOSITE, TOP
A baby is ready for his closeup in Golestan.

OPPOSITE, BOTTOM
Women with a young boy in the courtyard of Torbat-e Jam's Sheikh Ahmad Jami mausoleum.

134

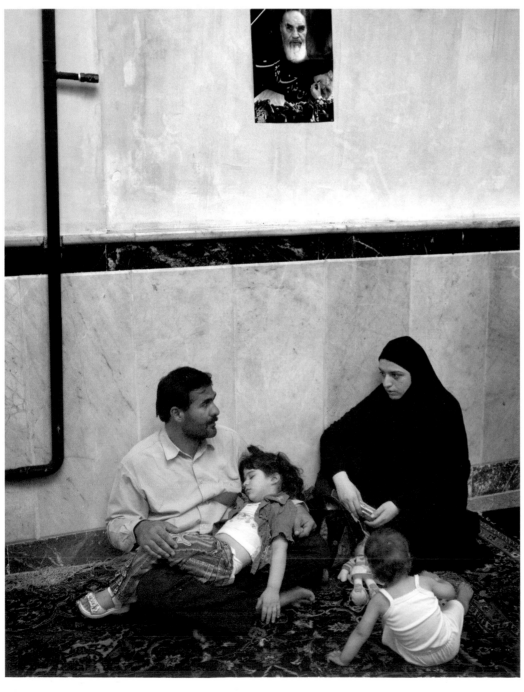

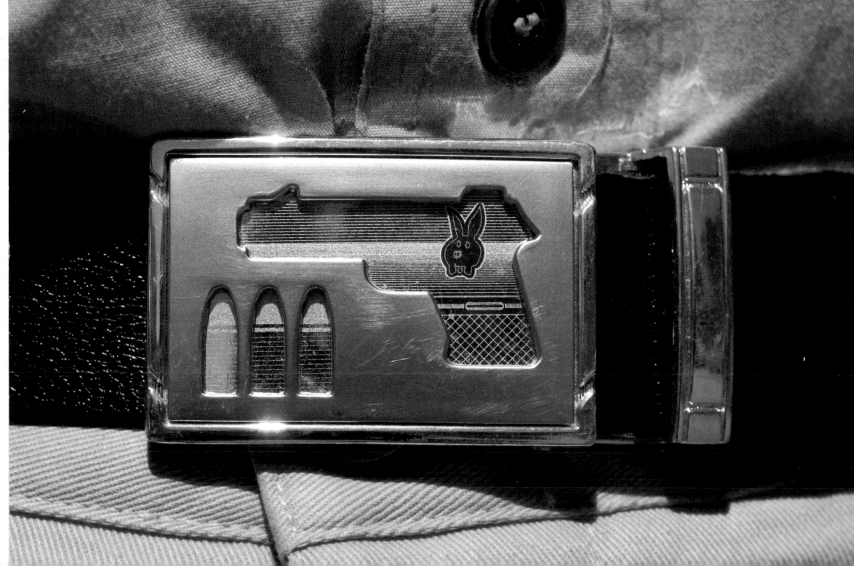

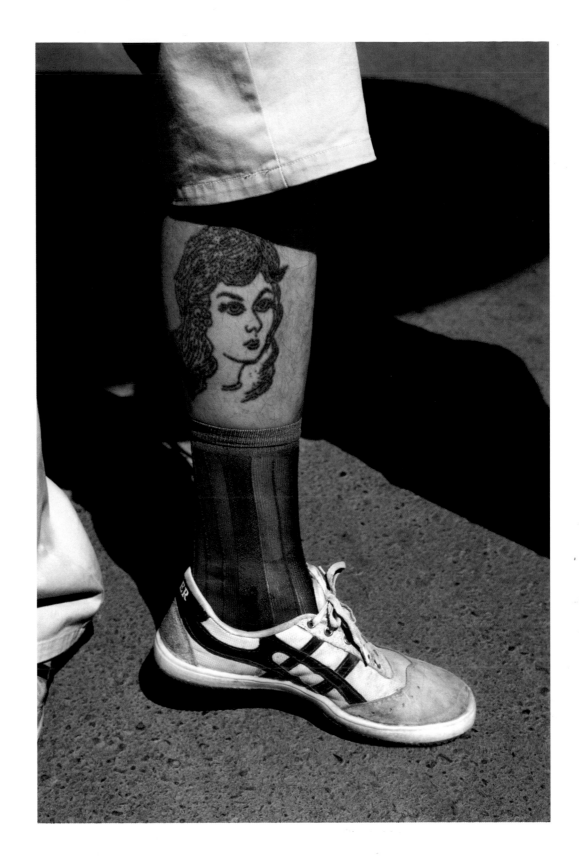

ABOVE AND OPPOSITE, BOTTOM
A former member of the Iranian navy shows off his tattoo and belt buckle.

OPPOSITE, TOP
An advertisement for a pool hall in Torghabeh, 15 miles east of Mashhad.

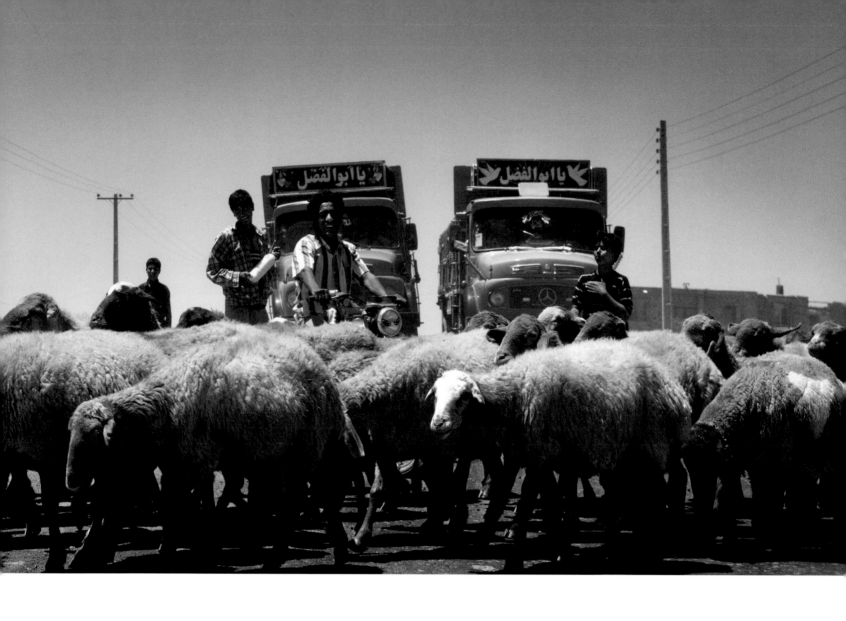

THIS SPREAD
Many of the villages in Khorasan Province between Mashhad and the
Afghan border are mud-walled houses surrounded by sun-scorched
agricultural and grazing land dotted with flocks of sheep.

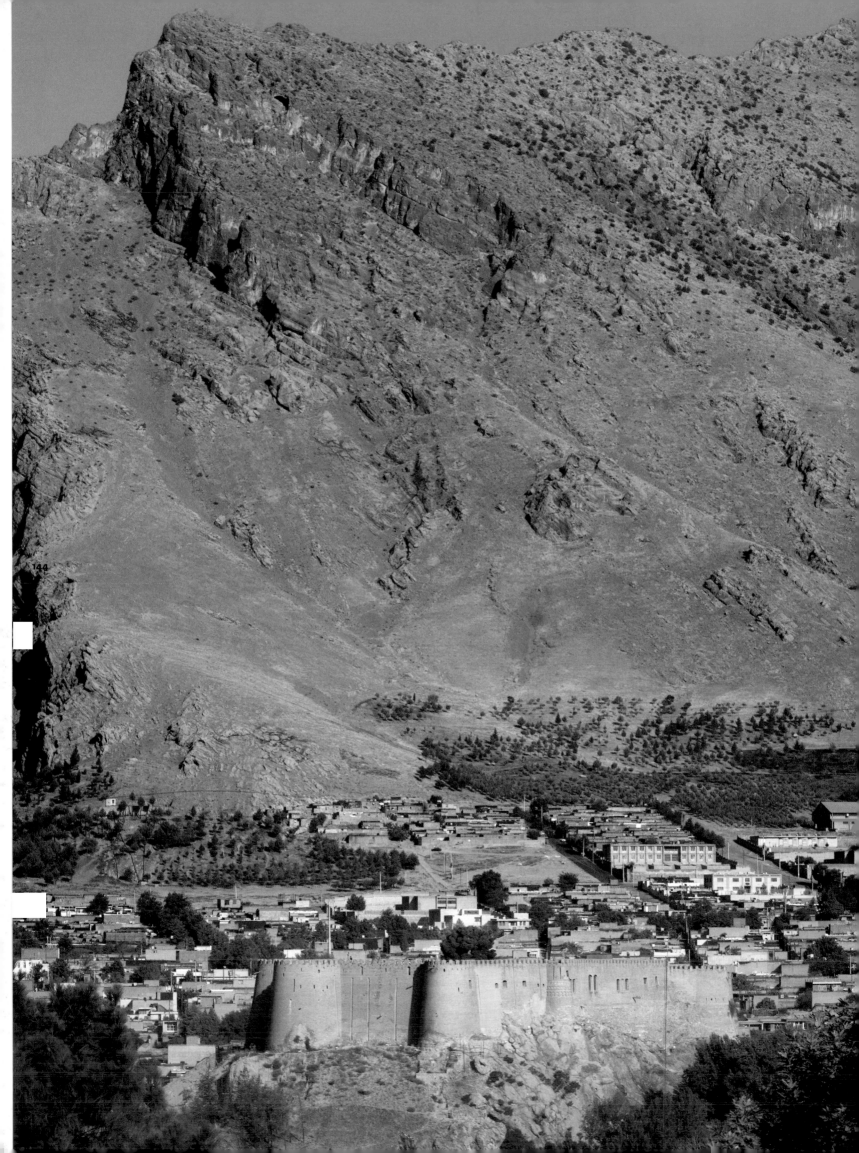

144

WESTERN IRAN

SEVERAL CITIES IN WESTERN IRAN ARE KNOWN THROUGHOUT THE WORLD BECAUSE OF THE RUGS ATTRIBUTED TO THEM. WHILE NOT TYPI-CALLY THE MOST EXPENSIVE PERSIAN RUGS, THEY ARE AMONG THE MOST POPULAR, WITH THOSE FROM TABRIZ AND HAMADAN PARTICU-LARLY IN GREAT DEMAND. IRONICALLY, SUCH RUGS ARE OFTEN MADE WITH TURKISH DOUBLE KNOTS *(TURKI-BAFF)* RATHER THAN PERSIAN SINGLE KNOTS *(FARSI-BAFF).*

Western Iran is largely mountainous, its heights freezing in the winter months, and is relatively little traveled by Western visitors. In Hamadan, 6,000 feet up on the west side of the Zagros Mountains, I was able to witness the noon prayer on Friday, the one time and day when Shia gather in large groups to pray at mosques around the country. The police cordoned off several blocks from vehicle traffic in the vicinity of the Imam Khomeini Mosque. (A terrorist bombing at a major shrine in Mashhad in 1994 has reinforced the need for security throughout the country, and the Shia-Sunni conflict in neighboring Iraq has heightened those concerns.) I was allowed to go into the mosque with the other men but without my camera. Women went in the side entrance and then up to their smaller second-floor viewing area. I stayed for a preprayer sermon on the evils of premarital sex, which the mullah referred to as street sex *(eshgh baziye khiyabani)*. I then left the mosque and retrieved my camera from my interpreter.

I heard the second part of the sermon outside the mosque over loudspeakers, as part of an overflow crowd filling the courtyard beyond the gates. The theme of this part of the sermon, according to my interpreter, was vigilance—citizens should be on the lookout for American spies. The mullah said that Iranian-born American "spies" being held in Iran—referring to Kian Tajbakhsh, Haleh Esfandiari, and Ali Shakeri—had "admitted" they were linked to groups dedicated to bringing about political change in Iran.

As the only American for who knows how many miles and no less one sporting a 180 mm lens on my Nikon, I felt it was time to take my leave. But this was my first opportunity to observe Friday prayer. *Just a few more shots.* At this point a soldier grabbed my arm and started "escorting" me toward a group of assembled military and police officers. Fortunately, we were intercepted by a man in a long coat who worked at the mosque. A discussion ensued that resulted in my being released by the soldier and the man in the coat giving me a piece of hard candy. No more photos, but I could leave.

On our way out of town, we stopped at a grocery stand and bought nuts and nonalcoholic beer for the road (alcohol is illegal in Iran). My Russian beer tasted so close to the real thing that I felt guilty drinking it in the car alongside the driver and translator.

Two hours south of Hamadan, just after leaving a gas station, our car was waved over by a paramilitary group wielding AK-47s. My passport and the driver's and translator's identification cards were taken for inspection by a bearded man in his thirties. Another man wearing jeans and a camouflage top leaned in the window and asked me in accented English, "Do you love Iran?" Instinctively, I replied, "Yes, I love Iran." "What do you mean, *love?*" he demanded. "The country and its people are beautiful," I said, and extended my hand through the open window, which he accepted. It was true—the Iranians I met in my travels were warm and hospitable, present company excepted.

Fortunately for us, a pickup truck carrying smuggled petrol had just been pulled over, which was a coup for the group. We were handed back our IDs and waved away. Gasoline rationing had been implemented that summer, ironic for a country with massive oil reserves (but lacking sufficient refineries to process its crude).

OPPOSITE
Though it's now a museum, the Falak-ol-Aflak Castle, also known as the Black Fortress, still looms over the city of Khorramabad. It was the seat of the governors of Lorestan Province between 1155 and 1600. The various regions of western Iran host a range of different cultures (and languages), including Kurds, Azaris, and the Lors, namesake of this province.

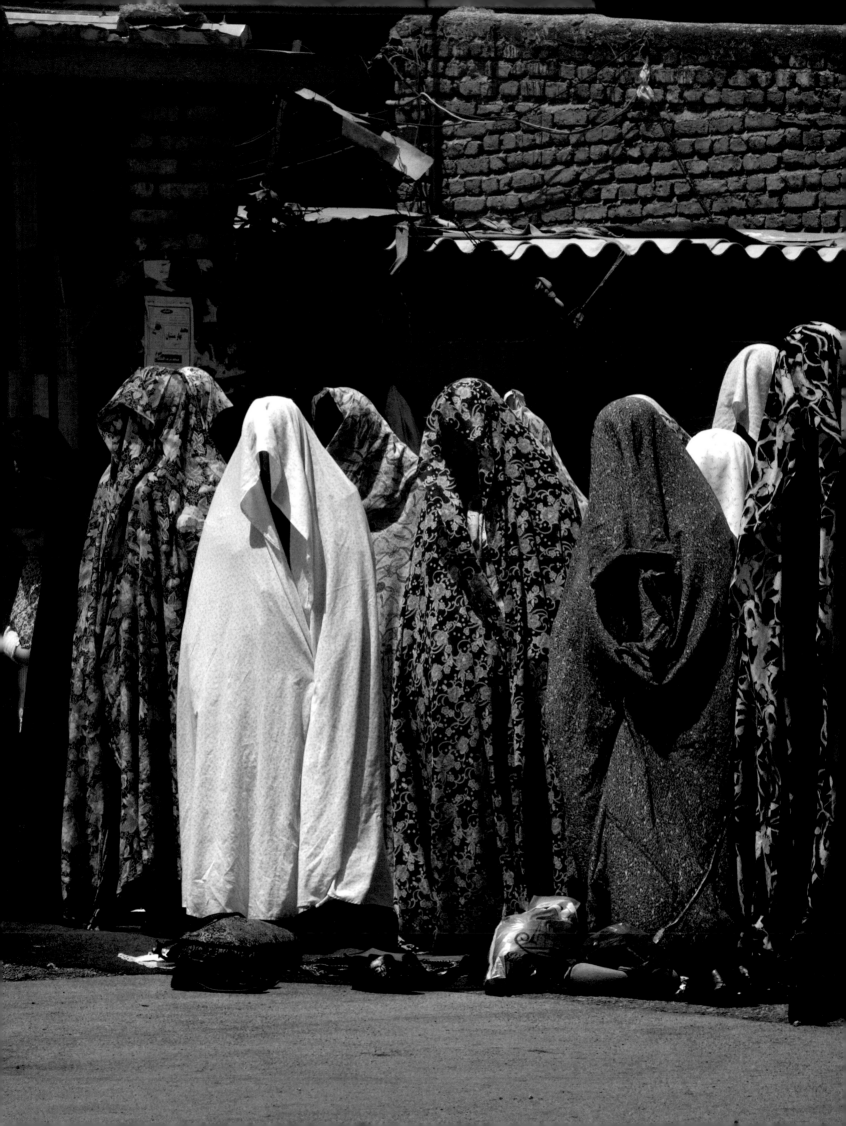

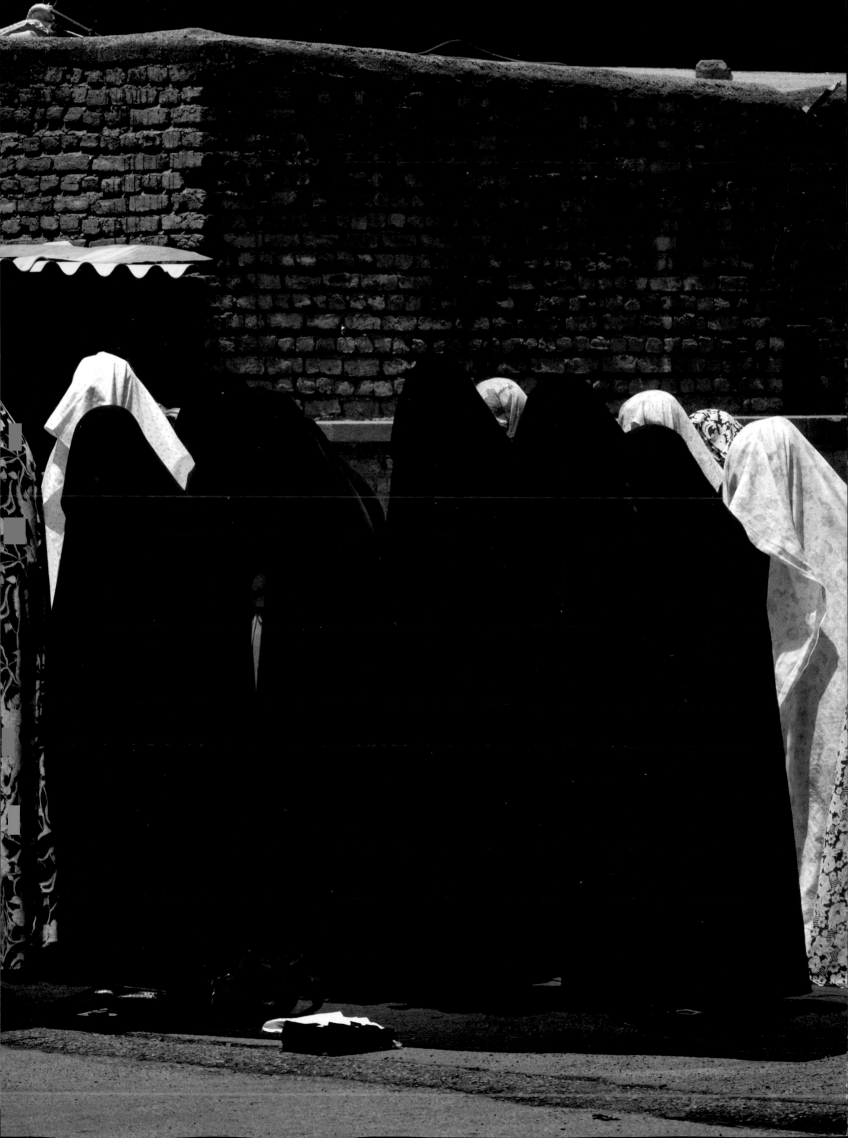

LEFT
A Star of David, also known as the Shield of David, with bullet holes and two points broken off, at the entrance to the compound containing what many believe are the final resting places of Esther, the Achaemenian queen and wife of Xerxes (Khashayar-shah), and her uncle, Mordechai.

OPPOSITE
Rabbi Rasad of Hamadan, with the tombs of Esther and Mordechai.

PREVIOUS SPREAD
Friday noon prayer at the Imam Khomeini Mosque in Hamadan. In the Shia-dominated world of Iran, the Friday noon prayer is the one time—except for religious occasions—when people are seen en masse in the mosques. Yet the actual percentage of people who attend is small. It is hardly a case in which everything stops at the call to prayer. Throughout the country, I witnessed people praying, but they always made up a relatively small percentage of the general populace. This was similar to what I found in another religious state, Israel—religious people lived externally secular lives. Hamadan (Hagmatana in ancient Persian, and Ecbatana in ancient Greek) is among the oldest cities in the world, and archeological excavation sites are common here, especially in the city's center.

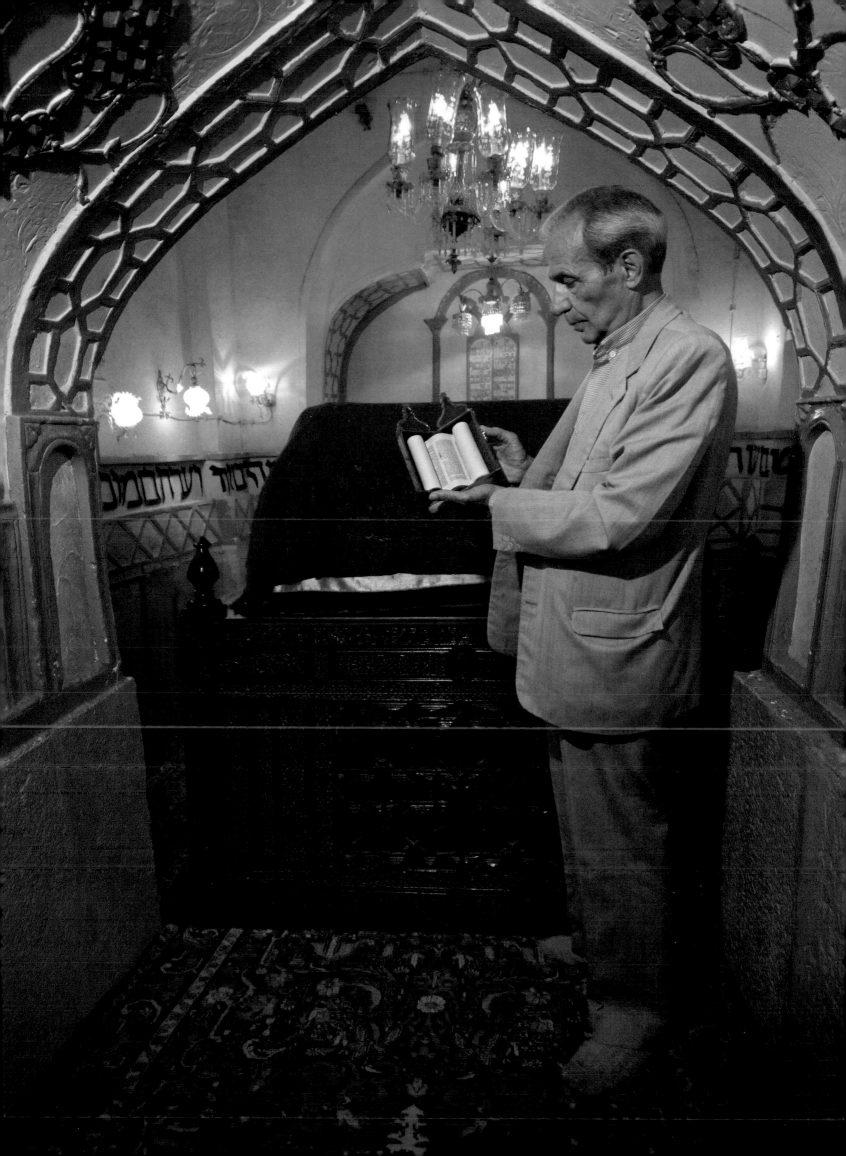

150

ABOVE
Iranian soldiers are honored in this monument at the southern entrance to
Asadabad, a small town near Hamadan.

OPPOSITE
A Ferris wheel in the town of Asadabad.

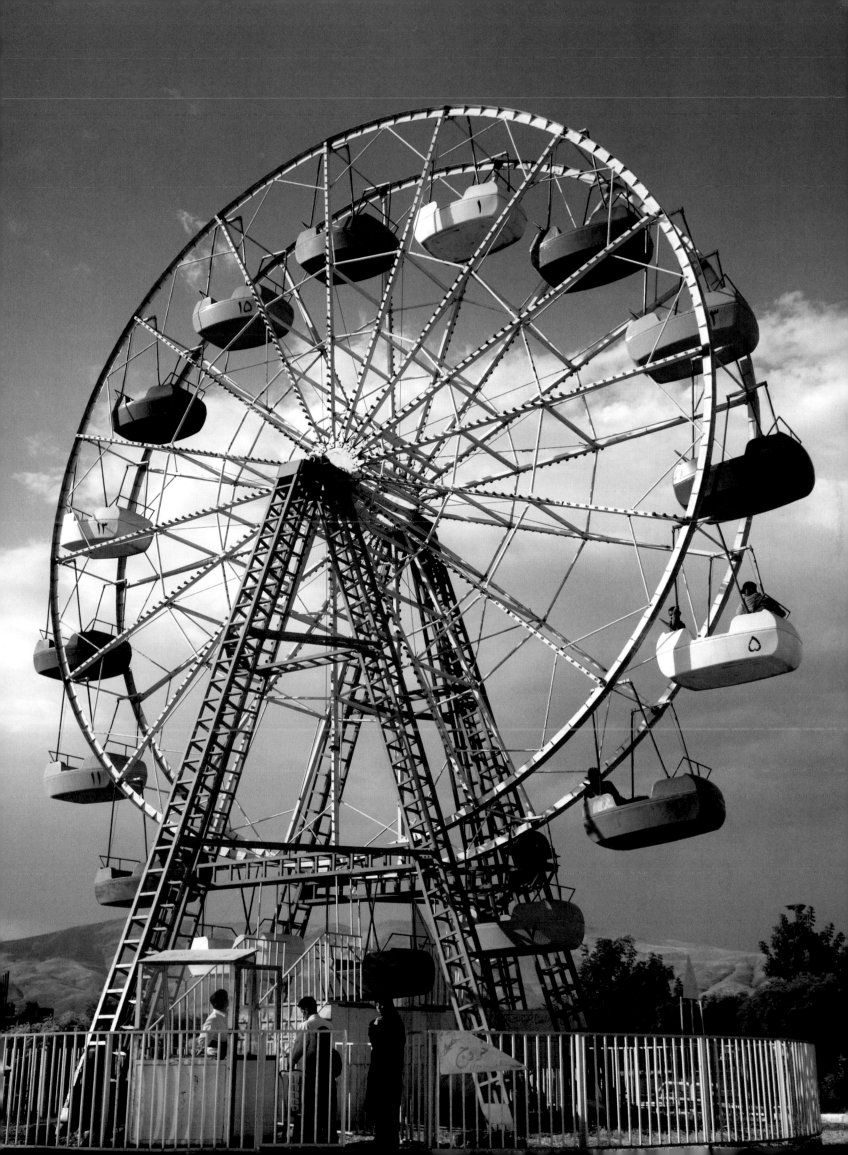

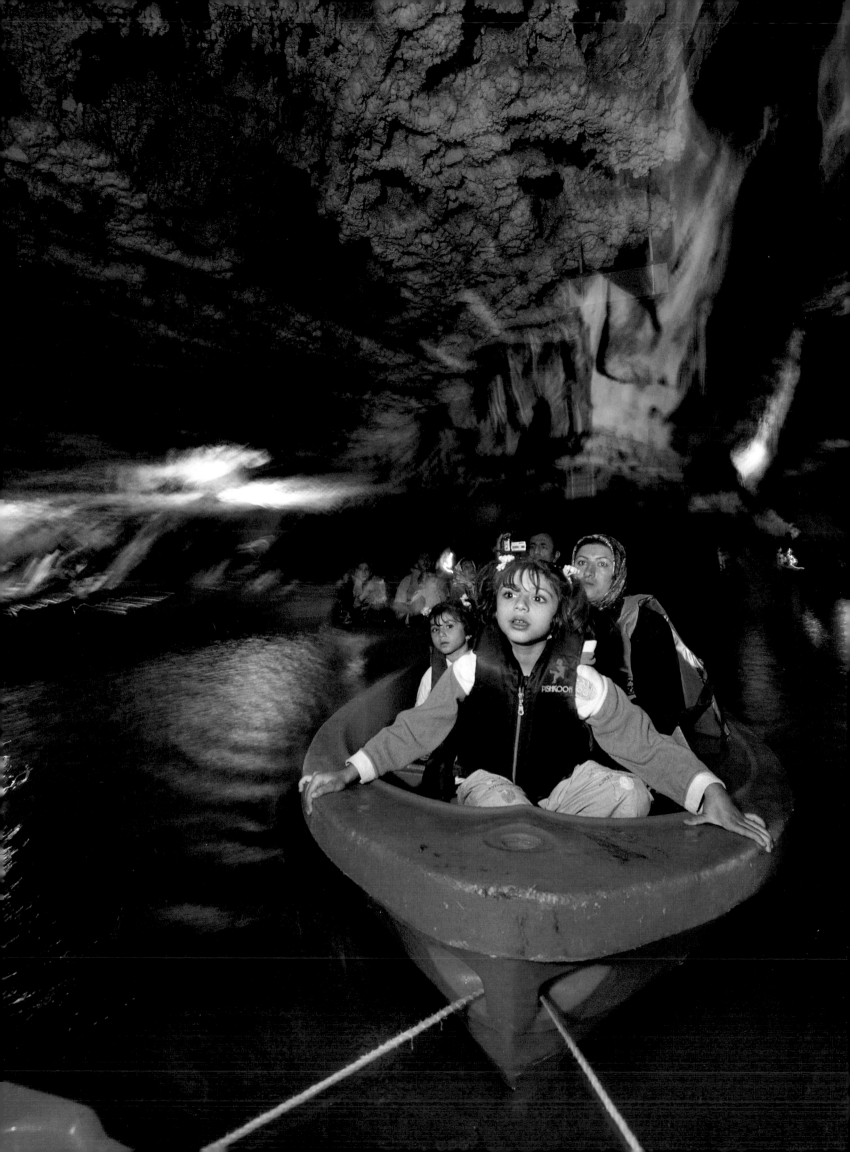

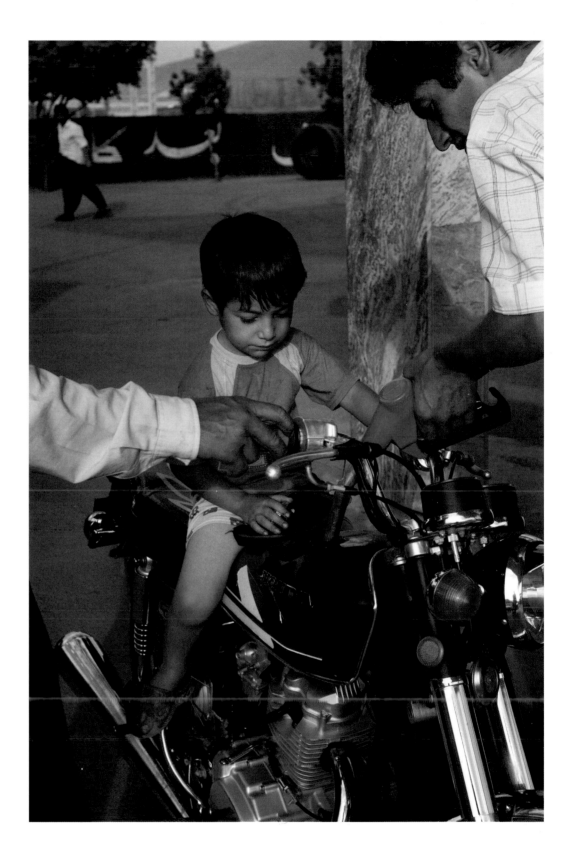

ABOVE
A young passenger in the driver's seat at a gas station in Kangavar.

OPPOSITE
Iranians enjoy exploring the Ali Sadr Cave in boats pulled by local guides
in pedal boats. Although the caves had been known about in the time of
Darius I, they were forgotten until the late 1970s, when a local shepherd
rediscovered them. They have since become a popular tourist attraction just
a short trip from Hamadan.

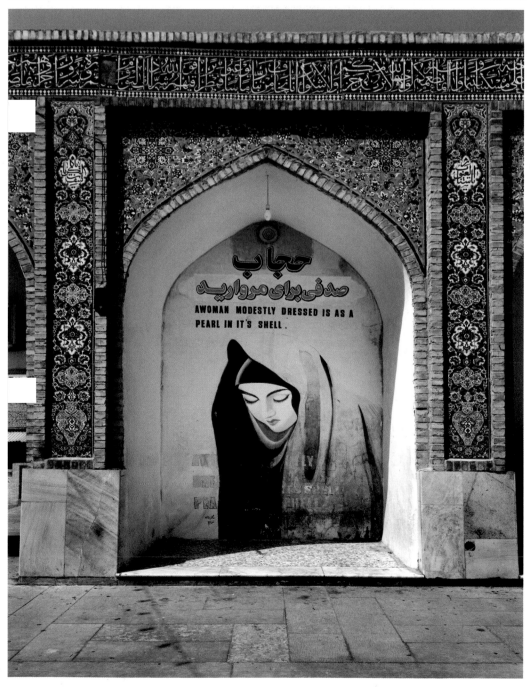

The tomb of the prophet Daniel in the biblical town of Shush (Shushan) at the southwestern base of the Zardkouh Mountains. The shrine was severely damaged during the Iran-Iraq War but has since been restored.

LEFT, BOTTOM
A mural extolling the virtues of Islamic dress for women at Daniel's tomb in Shush.

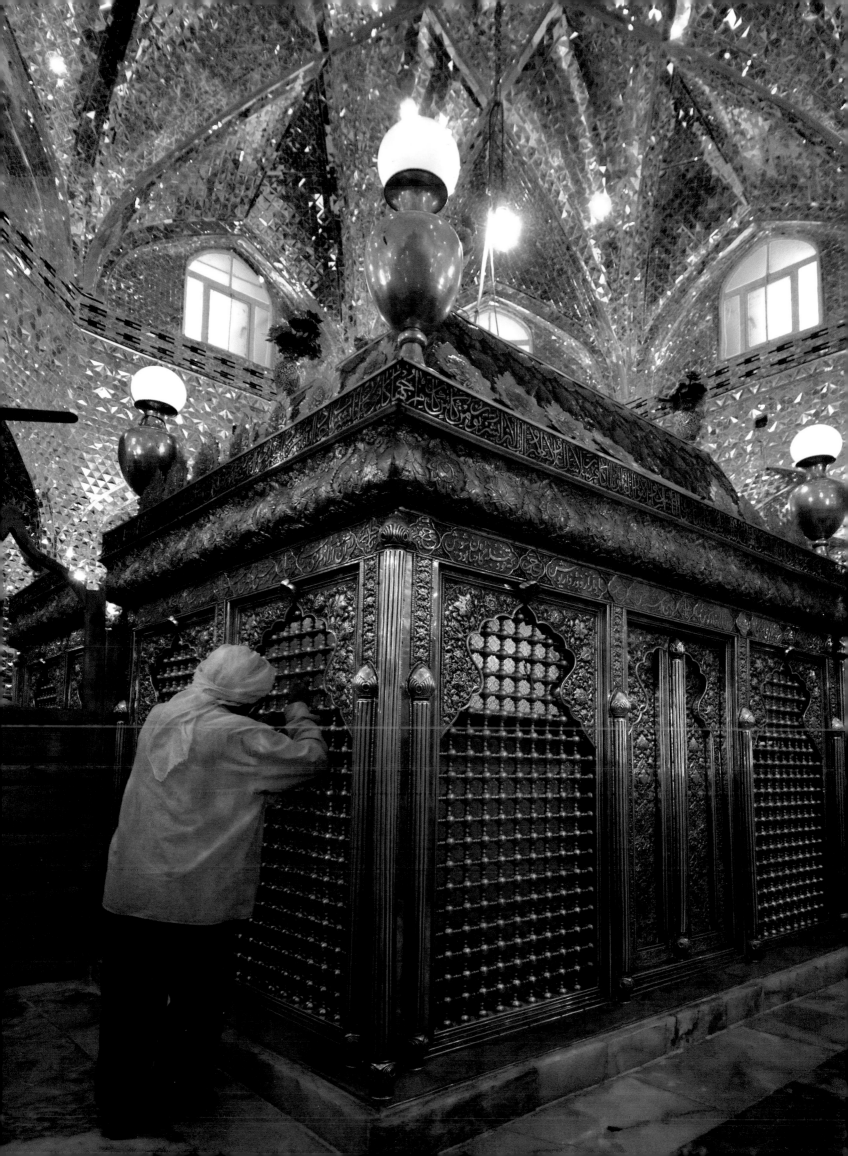

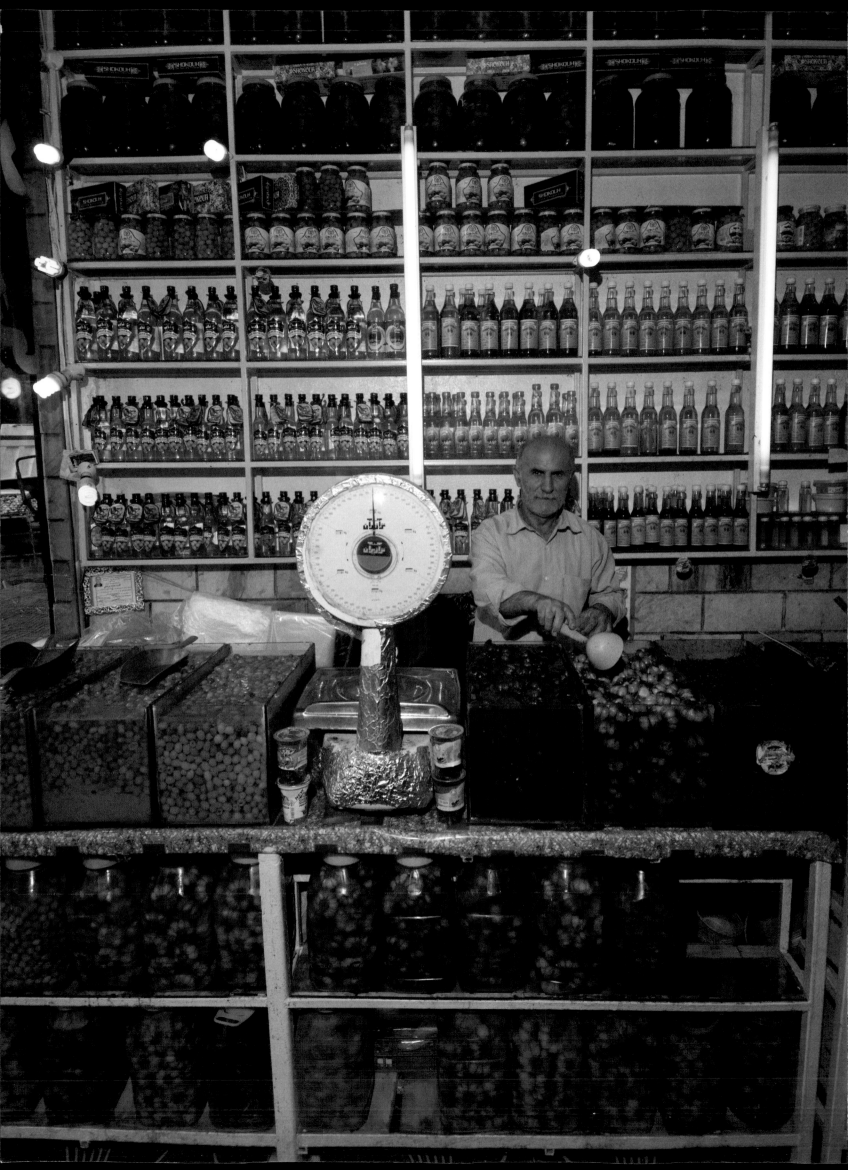

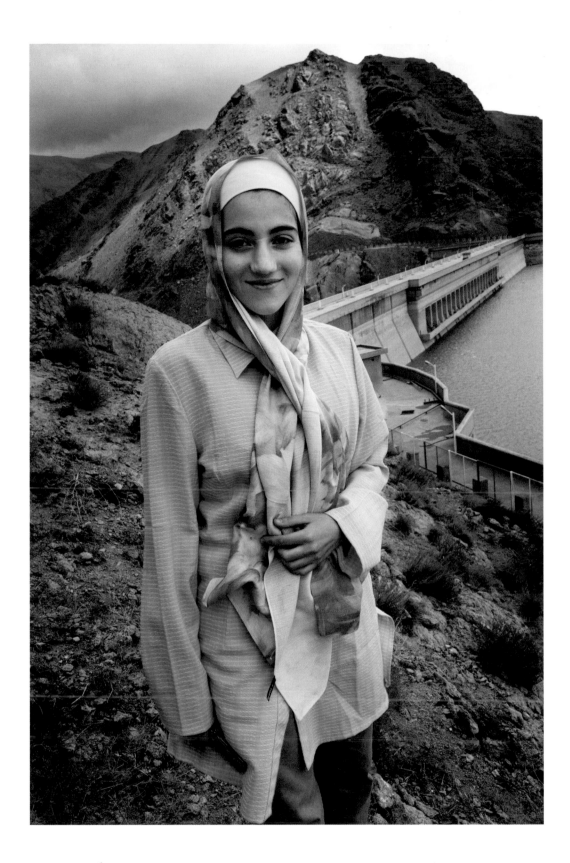

ABOVE
A young woman near the town of Rudbar, with a dam in the background.

OPPOSITE
A store sells olives, walnuts, oils, and spices in Rudbar, Gilan Province.
Olives thrive in the area.

THIS SPREAD
The fourteenth-century brick mausoleum of Oljeitu (Dome of Soltaniyeh),
a descendant of Genghis Khan. The mausoleum is part of a UNESCO World
Heritage Site.

WESTERN IRAN

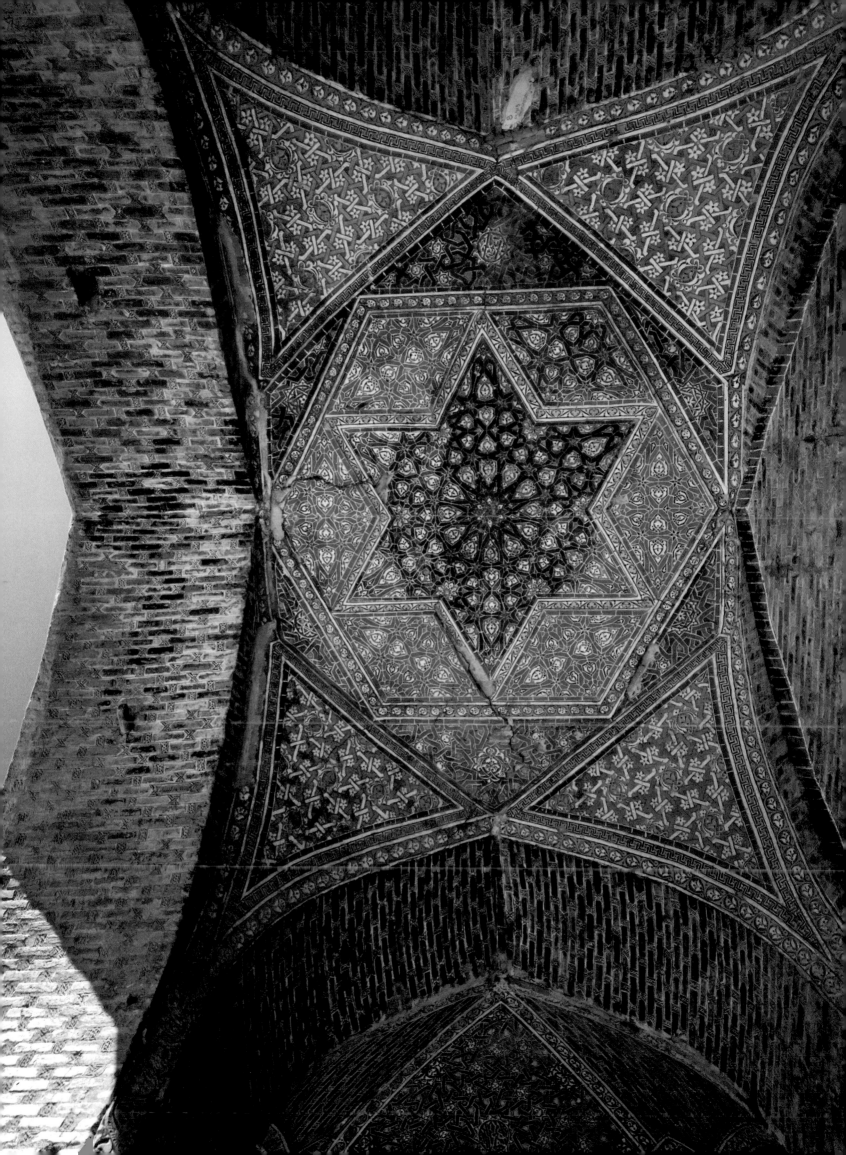

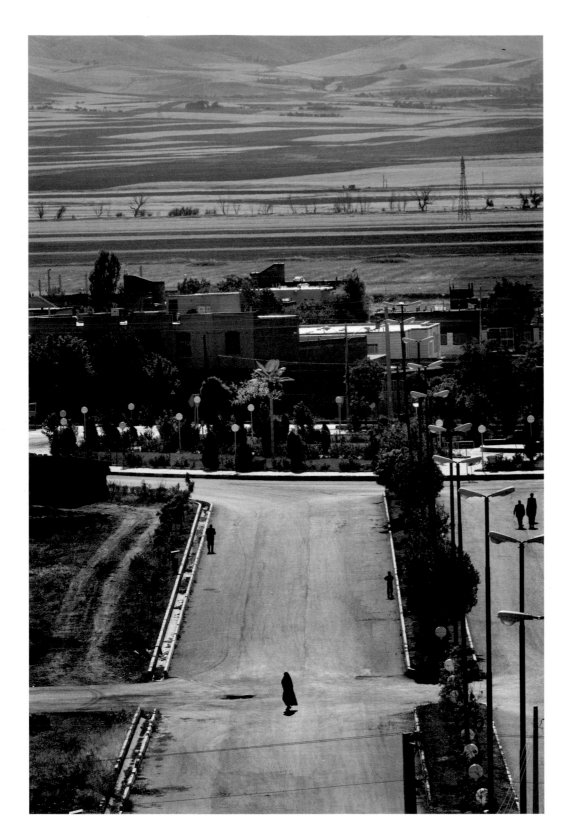

ABOVE
A street view from the mausoleum of Oljeitu in Soltaniyeh (town of the sultans).

OPPOSITE
Passing an oil field near Pol-e Dokhtar in Lorestan Province.

WESTERN IRAN

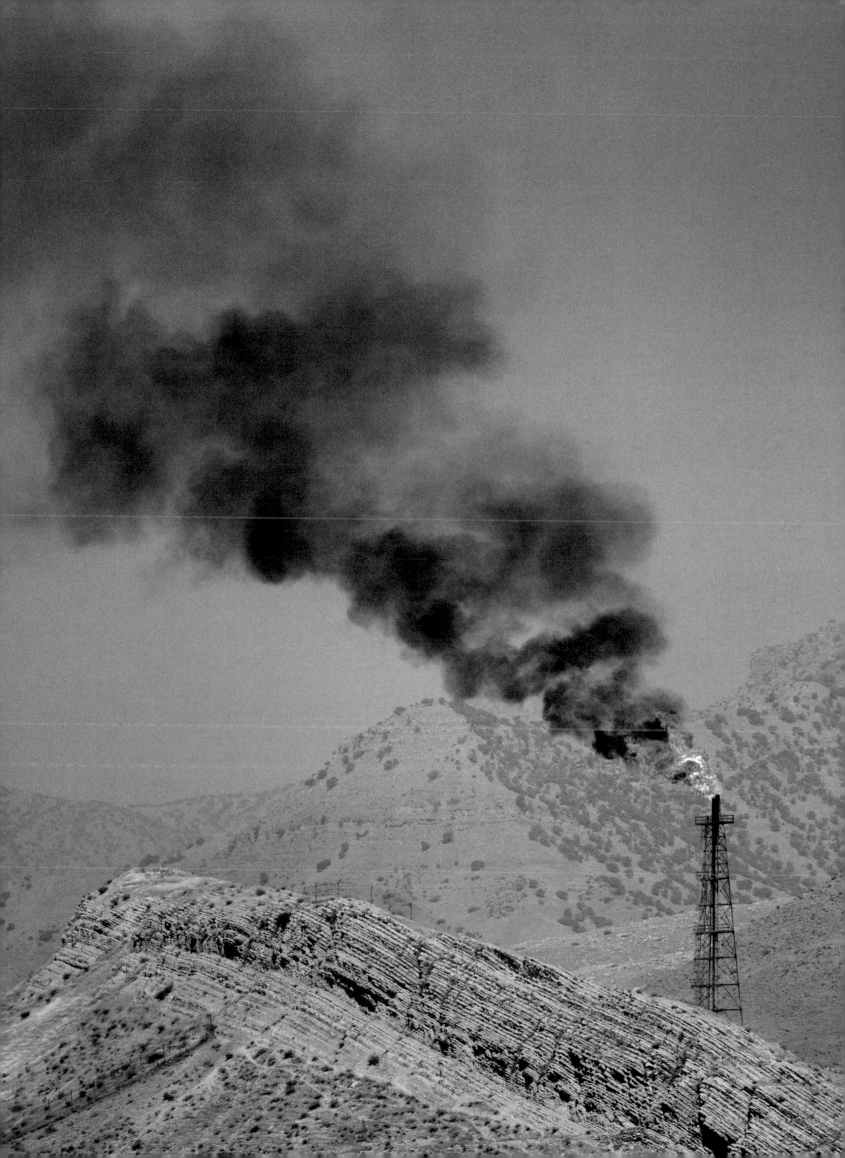

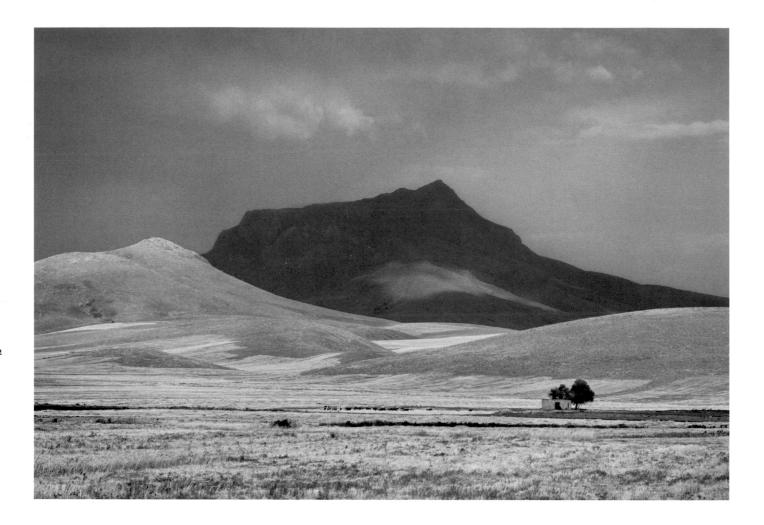

ABOVE
A landscape in western Iran.

OPPOSITE
Iran's coat of arms carved into the hillside near Rostam Abad.

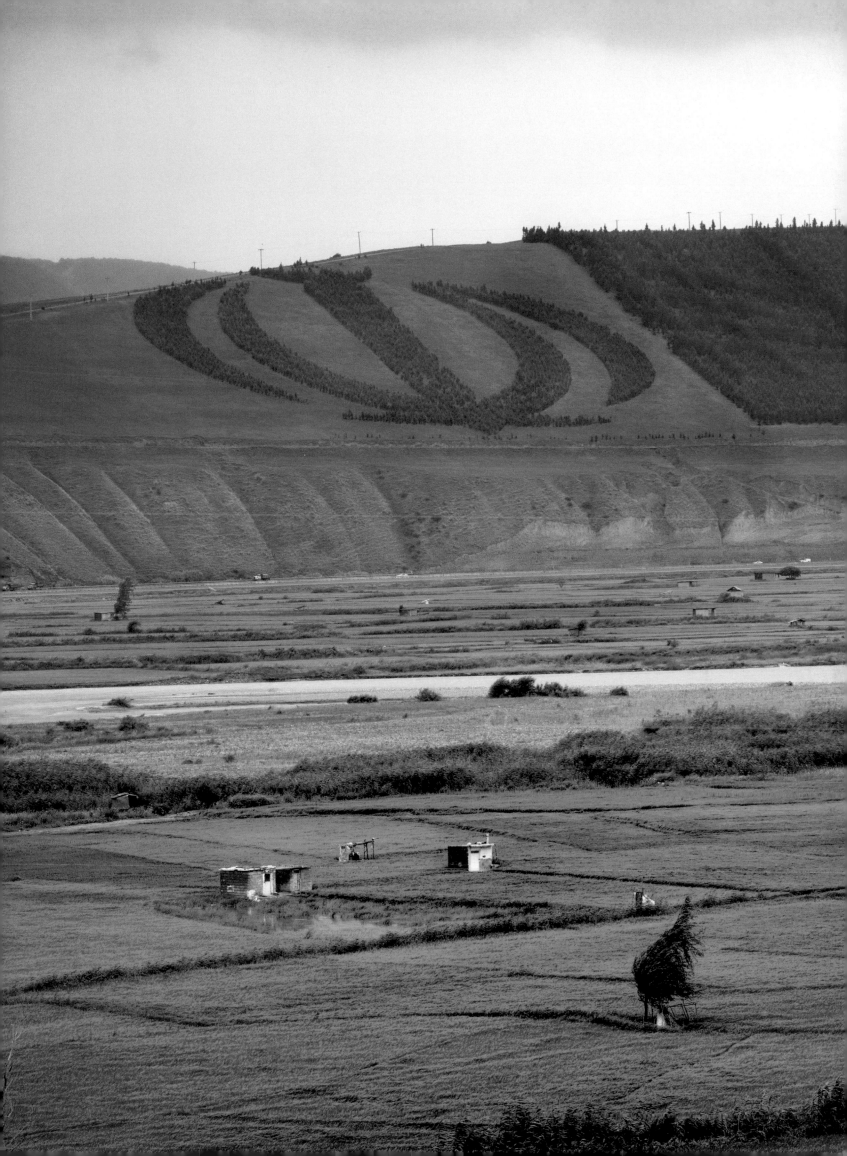

ABOVE
An advertisement on the wall of a roadside general store in the Alborz Mountains.

OPPOSITE
A woman performs the noontime prayer next to her car in the Alborz Mountains.

FOLLOWING SPREAD
The village of Zaker.

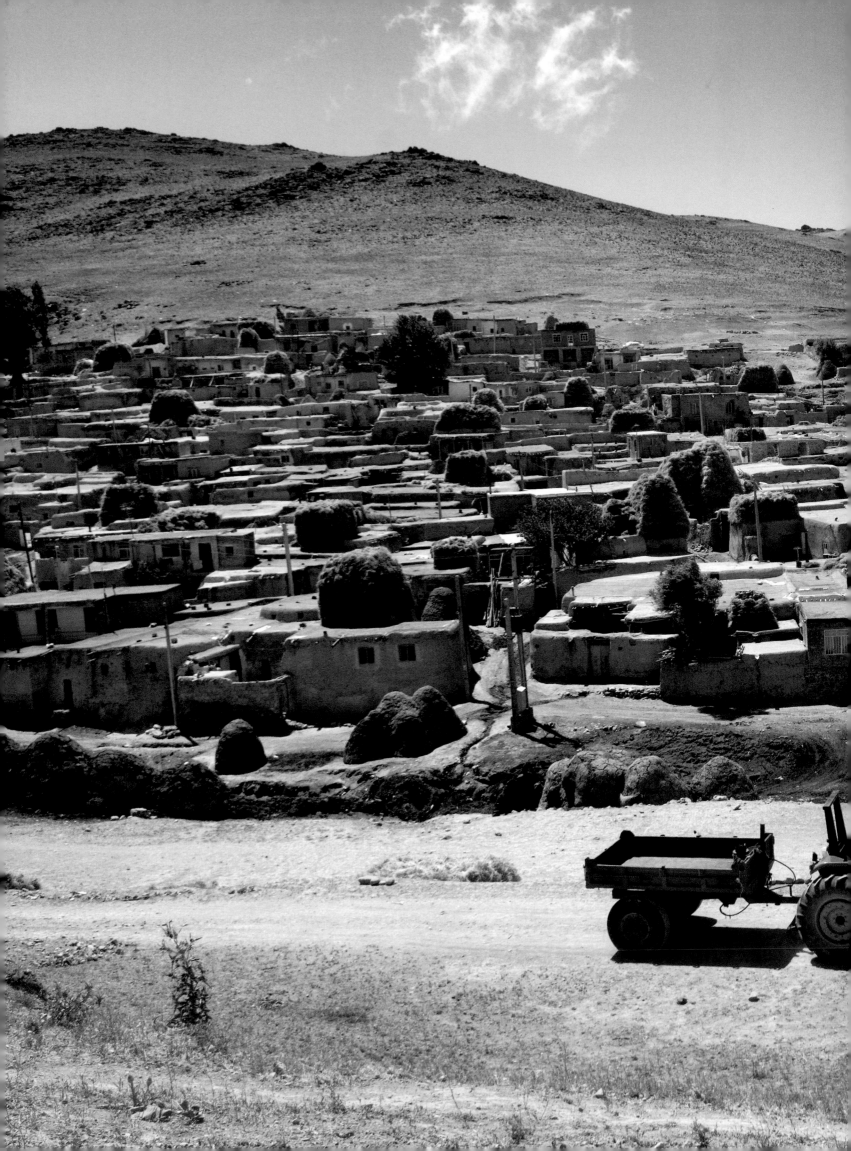

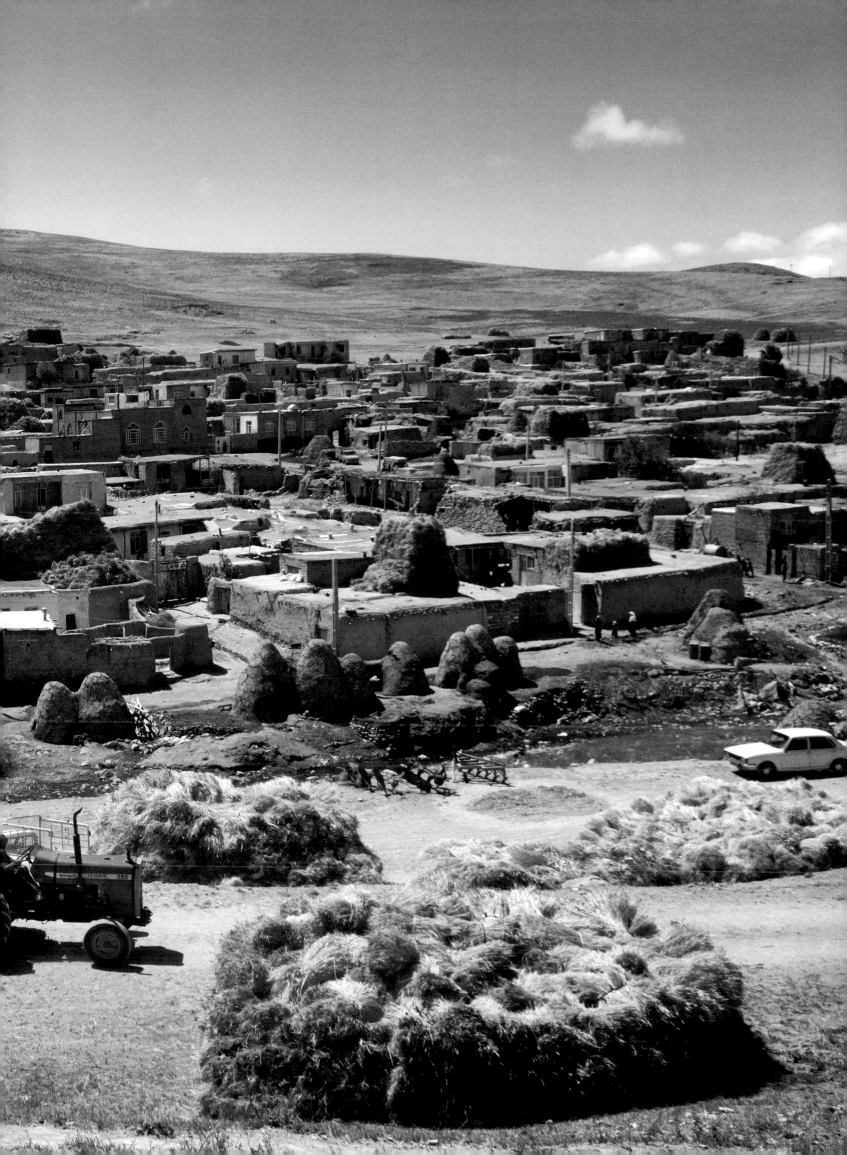

THE CASPIAN SEA

THE WORLD'S LARGEST INLAND BODY OF WATER, COVERING NEARLY 150,000 SQUARE MILES, THE CASPIAN SEA IS BORDERED BY IRAN, RUSSIA, AZERBAIJAN, KAZAKHSTAN, AND TURKMENISTAN. WHILE THE AREA PRODUCES AN ESTIMATED 90 PERCENT OF THE WORLD'S CAVIAR, THIS INDUSTRY HAS BEEN CRITICALLY UNDERMINED BY POLLUTION AND OVERFISHING OF ITS EGG-PRODUCING STURGEON BY THE COUNTRIES SURROUNDING THE SEA ... OR IS IT _LAKE?_ THE BORDERING COUNTRIES HAVE COMPETING ECONOMIC INTERESTS IN DEFINING THE BODY AS EITHER A LAKE, THE VALUE OF WHOSE RESOURCES WOULD BE EVENLY DIVIDED, OR A SEA, WHOSE RESOURCES ARE CARVED UP ACCORDING TO SEPARATE NATIONAL TERRITORIES WITHOUT BEING SHARED. THE RECENT DISCOVERY OF MAJOR OIL FIELDS BENEATH THE SEABED HAVE, AS ONE MIGHT EXPECT, BROUGHT THESE DISAGREEMENTS TO THE FORE. PREEXISTING PACTS THAT HAD DIVIDED THE OIL FIELDS BETWEEN IRAN AND THE SOVIET UNION ARE NO LONGER RELEVANT WITH THE DEMISE OF THE LATTER, AND EXACTLY HOW TO DIVIDE UP THE DRILLING RIGHTS HAS BEEN A SOURCE OF CONSIDERABLE CONTROVERSY IN THE REGION.

The area around the Caspian Sea enjoys a cooler climate and is a popular vacation spot—especially for those looking to escape Tehran's summer heat. Most Iranians drive or fly over the Alborz mountain range to get there.

The start of a gas rationing program in June 2007 had an impact on the number of people making the journey, with many Iranians unable to take their vacations by car, and mobility in general—including air travel—reduced. Iran has massive oil reserves but lacks refining capacity, importing about 40 percent of its oil, which makes it vulnerable to international sanctions. But for a country in which gas has been heavily subsidized by the government (to the point where it is cheaper than bottled water) and during the administration of a president who promised to "put the oil money on everyone's dinner table," the energy crisis hit home.

On my trip over the mountains, by car, I was amazed at the fast transition from a dry and somewhat barren landscape on the Tehran-facing south side of the Alborz Mountains to a dense fogbank as soon as we began our descent on the Caspian side. The cool fresh air and greenery are obvious incentives for coming to this area and thus are an economic boon to towns like Rasht, Ramsar, Chalus, and Masouleh.

The dramatic geology of this long, thin mountain range has come at a high cost—it's extremely prone to powerful earthquakes. On June 20, 1990, the Rudbar-Tarom 7.7 magnitude earthquake destroyed three cities and more than 700 villages here, killing 40,000 people.

One of the most important positive steps in the international ecology movement took place at the Caspian resort town of Ramsar in 1971 with the signing of the Ramsar Convention for the protection of wetlands. More than 150 countries have signed on to the convention, which aims to promote wise use and protection of natural resources and includes a list of internationally important wetlands, which now covers more than 1,600 sites.

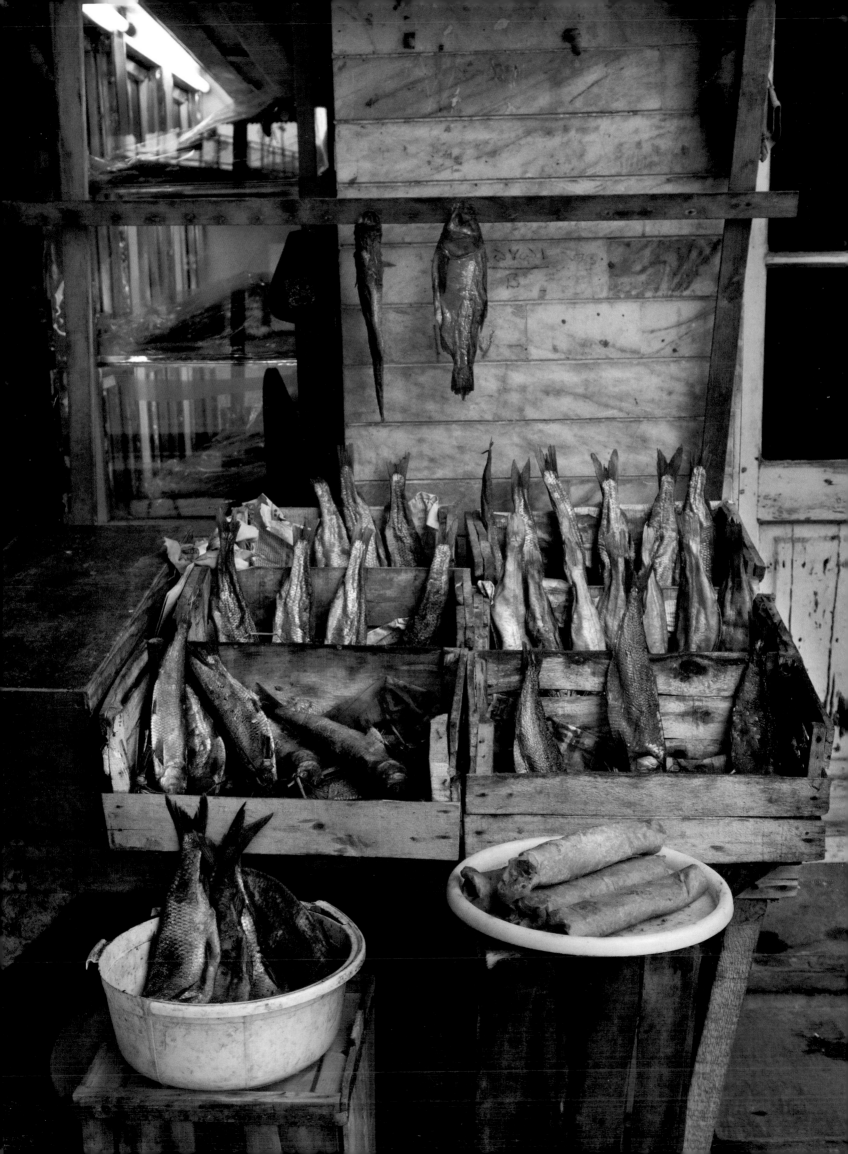

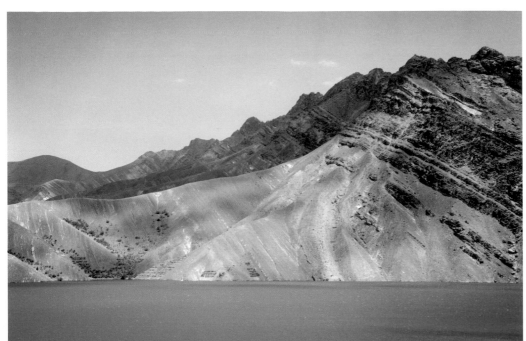

OPPOSITE
Dried fish for sale in the Caspian port city of Bandar-i Anzali, the major Iranian port on the Caspian Sea.

LEFT, TOP
A dam in the Alborz Mountains between Chalus and Tehran.

LEFT, BOTTOM
Between Tehran and the Caspian Sea lie the Alborz Mountains. South of the range the landscape is dry and barren, but north of the peaks the landscape is full of trees and greenery with fresh air and moderate temperatures. The pleasant climate makes the Caspian coast a popular holiday destination, especially for Tehranians.

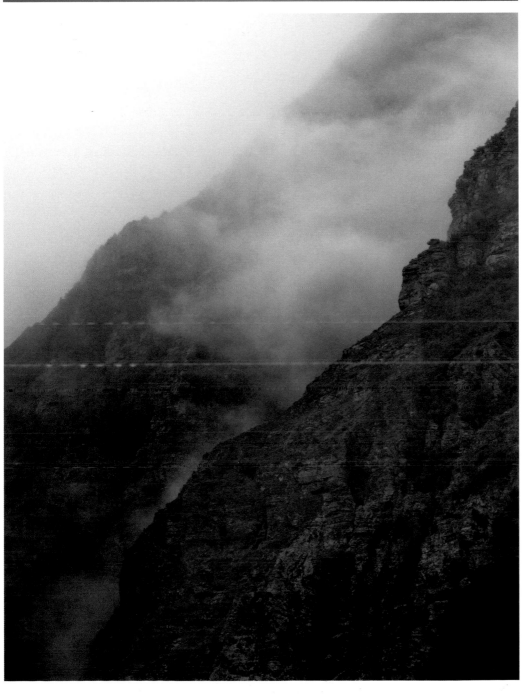

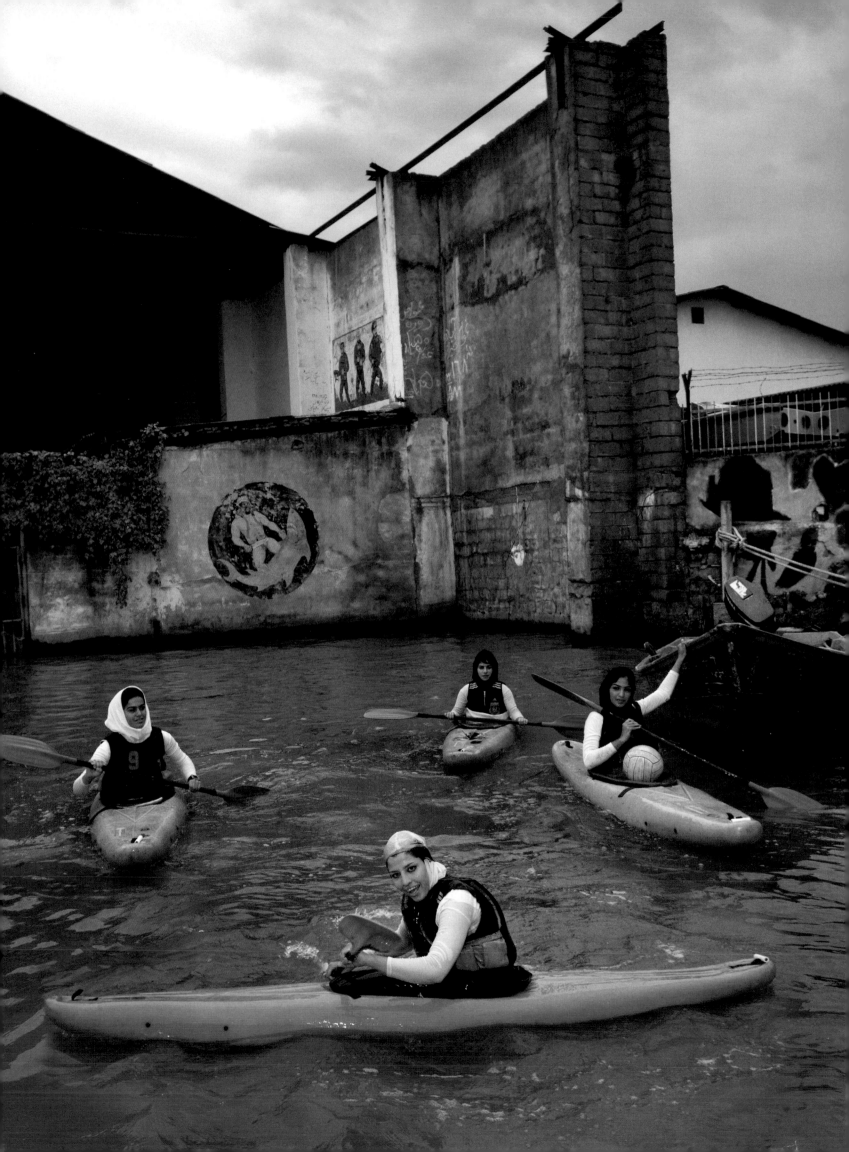

ABOVE
A mural depicts members of an Iranian Navy SEAL team.

OPPOSITE
Kayakers ply the waters at the mouth of the Mordab-e Anzali.

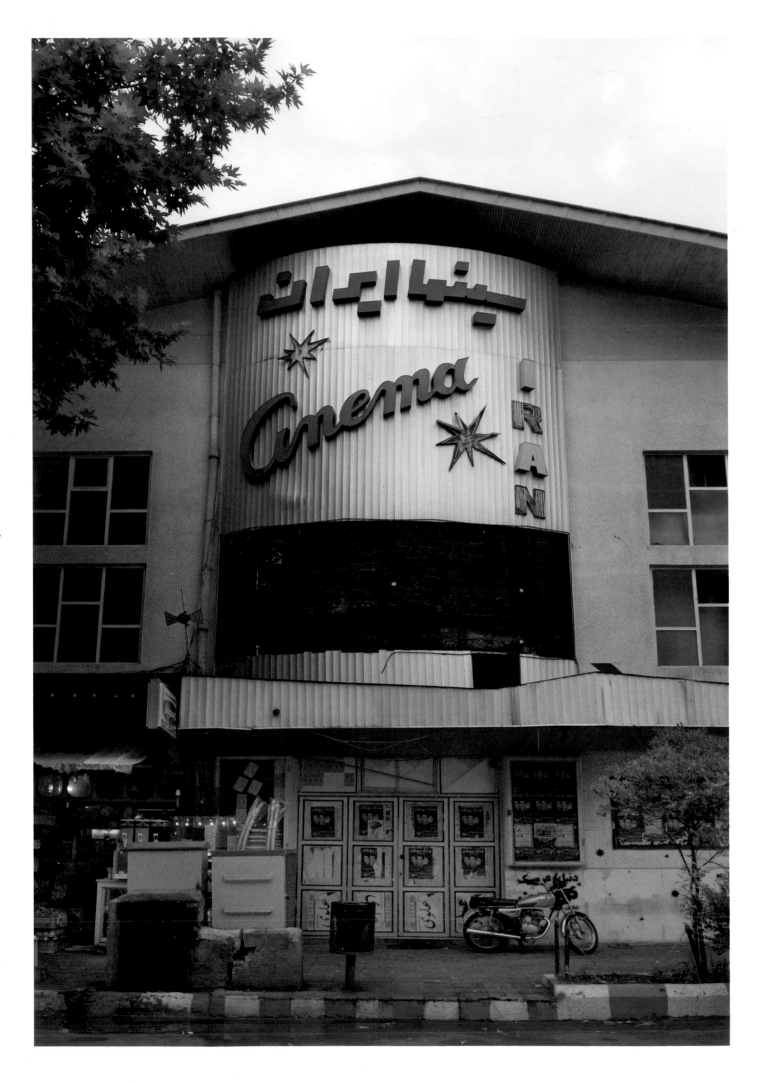

174

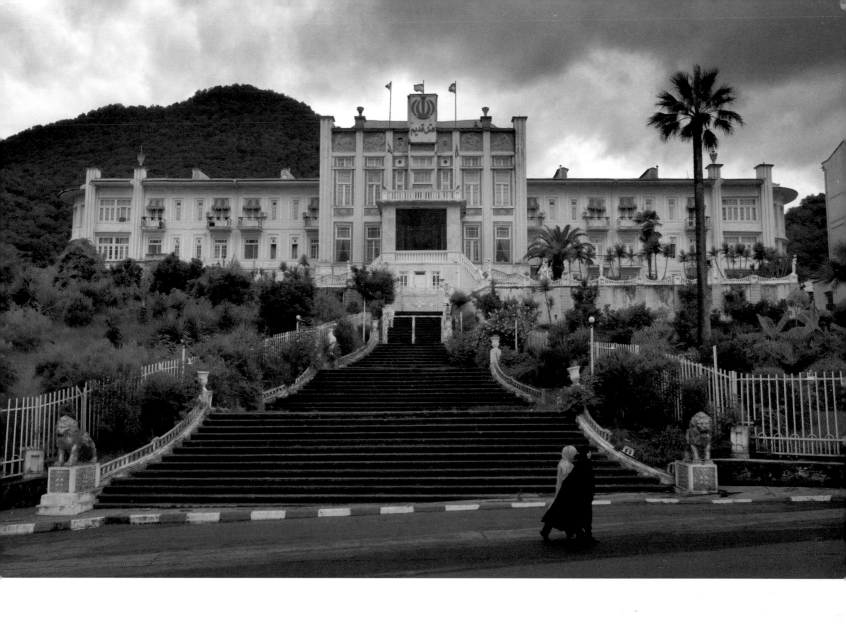

ABOVE
The Ramsar Grand Hotel, located above Ramsar with views of the Caspian Sea, has been maintained in its original, elegant 1930s style, though the casino it once hosted is now just a memory.

OPPOSITE
A boarded-up movie theater in the Caspian port town of Bandar-e Anzali.

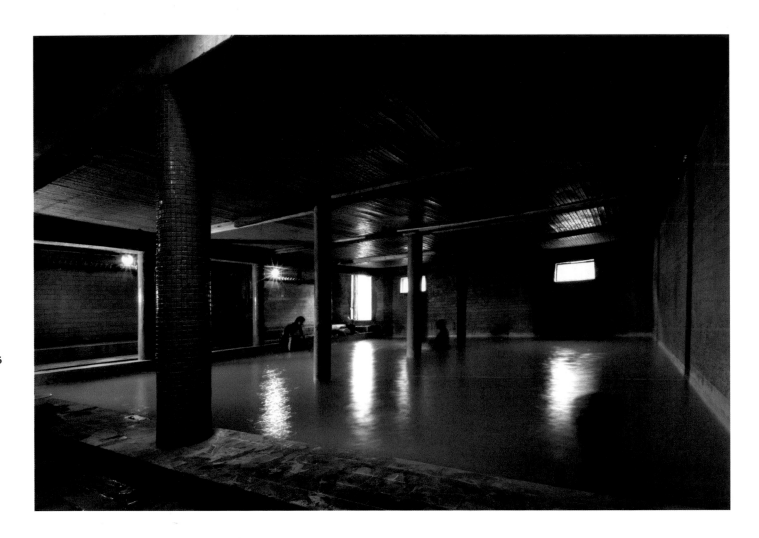

176

ABOVE
An indoor hot spring used by vacationers staying in Ramsar.

OPPOSITE
A major international conference to protect wetlands took place in the Caspian resort town of Ramsar near the Mordab-e Anzali in 1971. Wet-lands around the world have benefited from the signing of the Ramsar Convention.

THE CASPIAN SEA

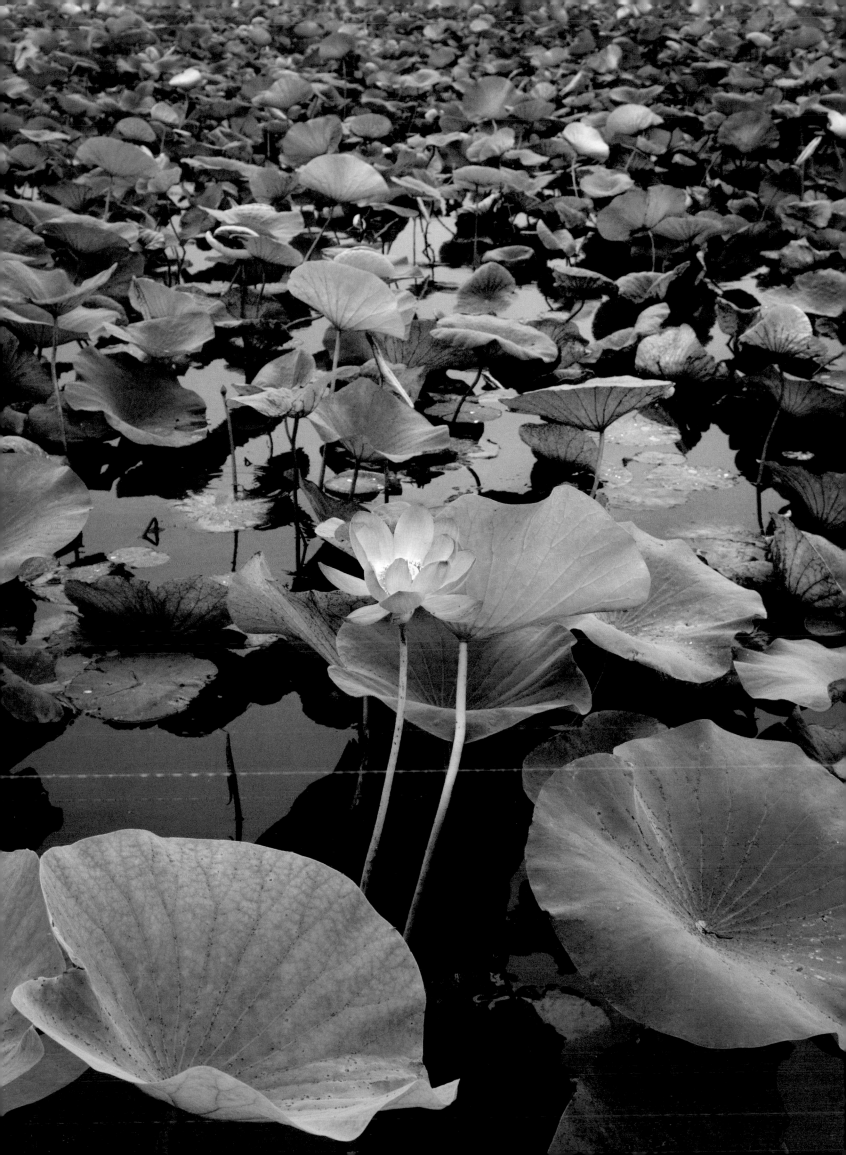

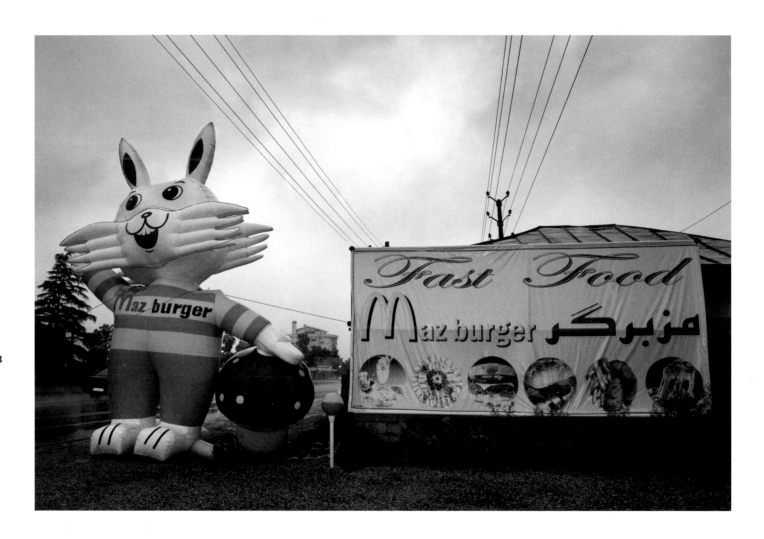

178

ABOVE
The Golden Arches, Iranian style. The Maz Burger mascot waves down
drivers along the main road to the Caspian Sea near Chalus.

OPPOSITE
A man attacks a wasp nest with insect spray at the Ramsar Azadi Hotel.

ABOVE
A view of the Ramsar skyline and Caspian Sea.

OPPOSITE
In Chamkhaleh, tea is served on a tray with an image of Iranian actress
Hadis Foladvand.

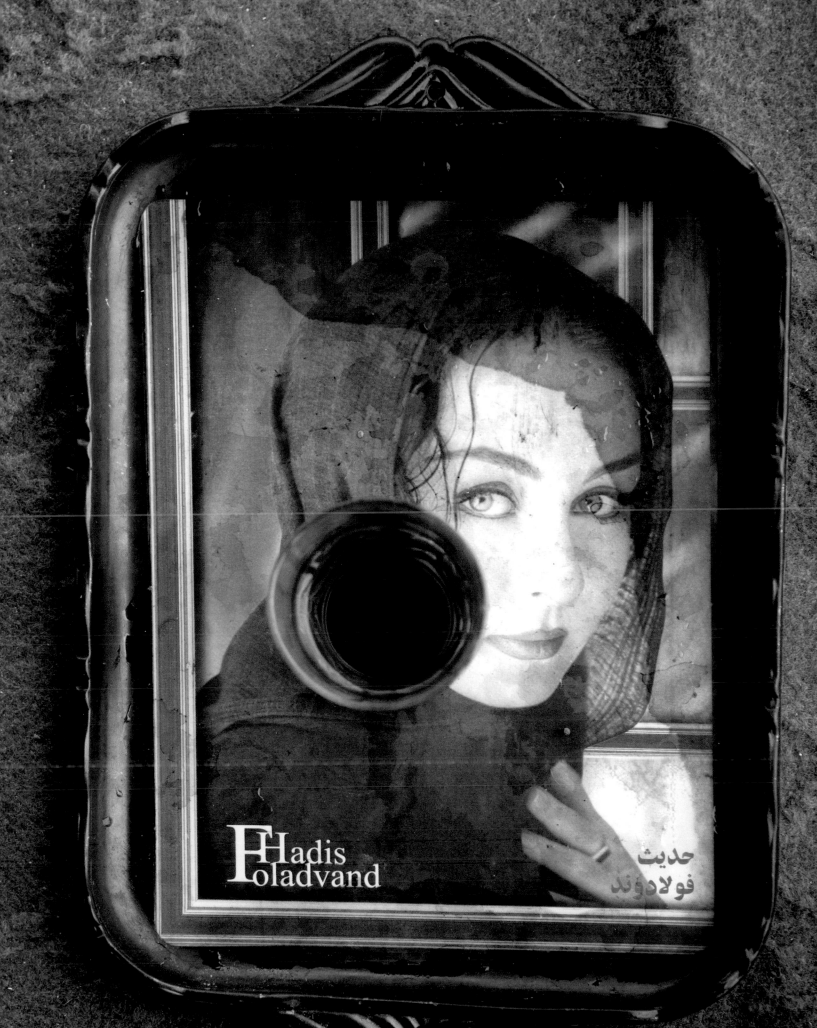

Hadis Foladvand

حدیث
فولادوند

ABOVE, LEFT
A ceramic statue in honor of the Iranian soldiers who fought in the Iran-Iraq War, at an intersection in Fuman (15 miles west of Rasht). The boulevards here are lined with trees and statues.

ABOVE, RIGHT
A young girl plays with ceramic statues in Fuman.

OPPOSITE
Cookies filled with a walnut paste called *kluch-e Fuman* are a popular item in the town of Fuman.

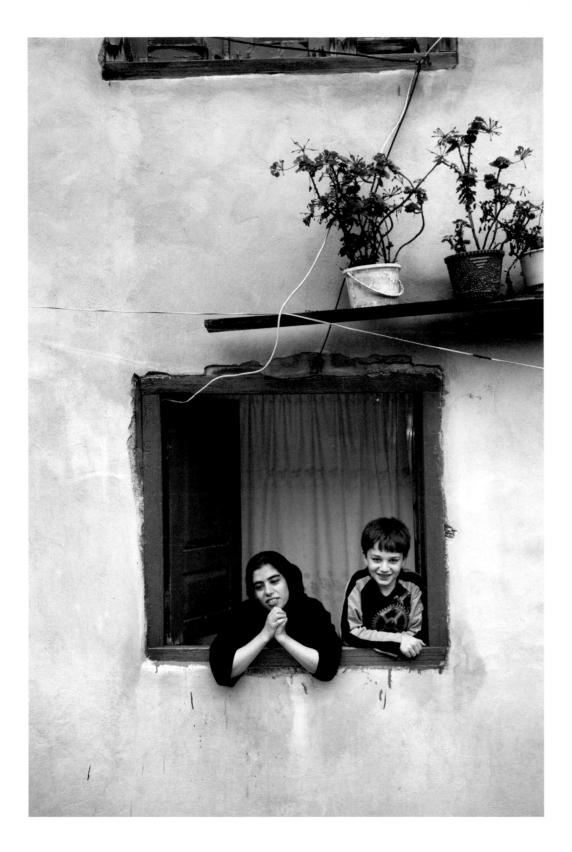

THIS SPREAD
Located 40 miles southwest of the Caspian Sea, Masouleh
(3,500 feet above sea level) is one of the most beautiful and
traditional villages in Gilan Province.

THE CASPIAN SEA

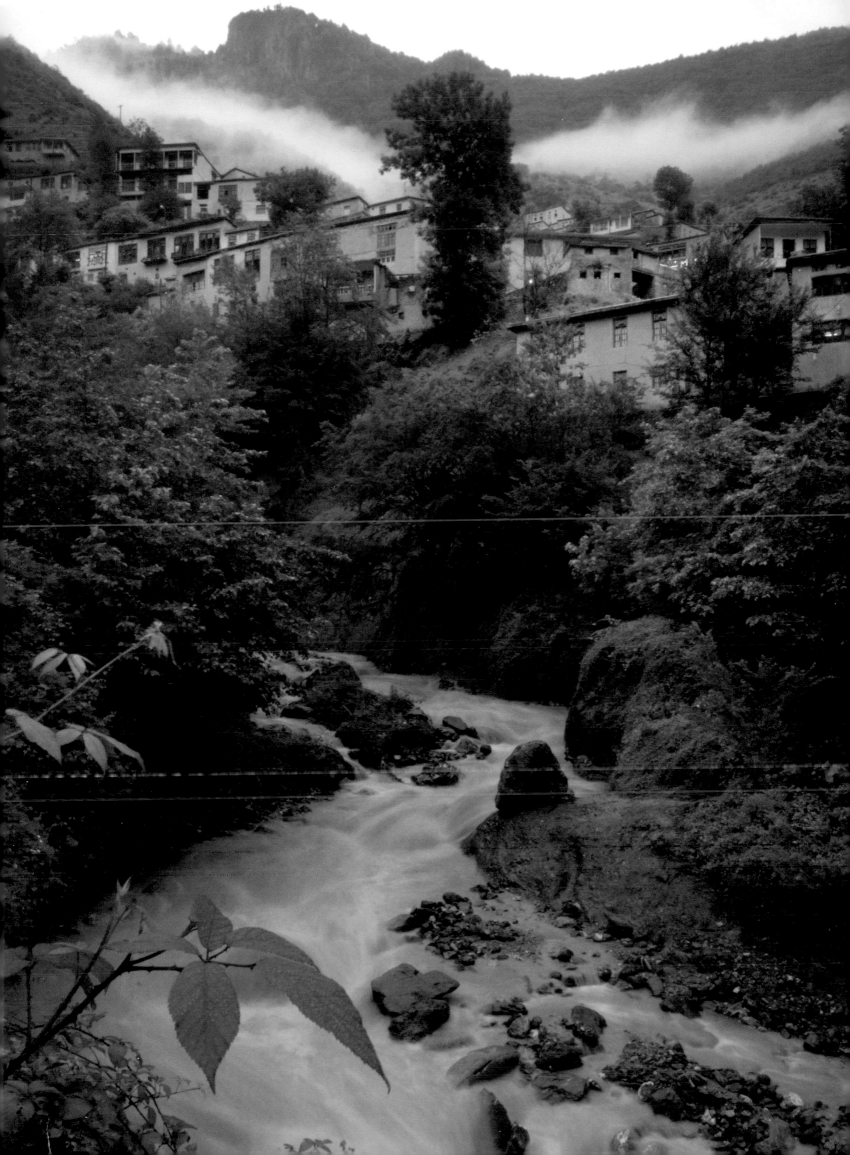

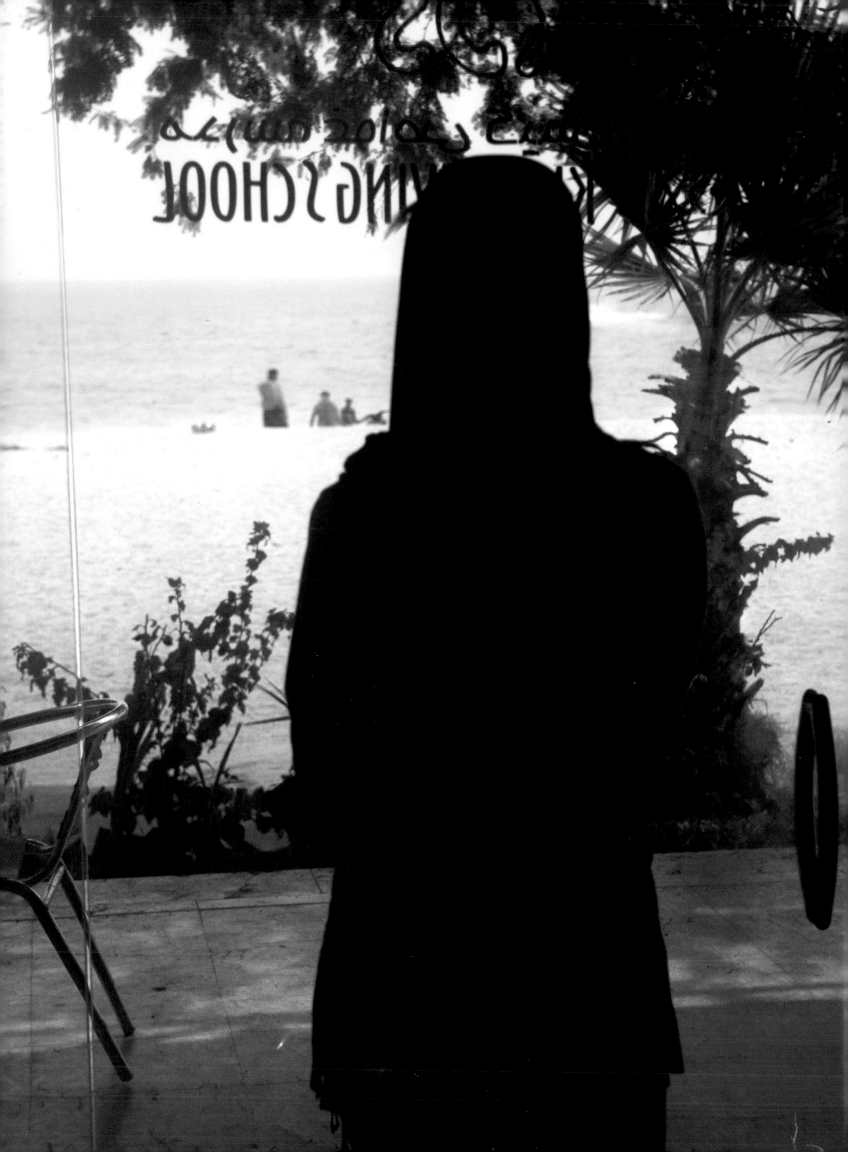

KISH ISLAND AND THE PERSIAN GULF

APPROXIMATELY 40 PERCENT OF THE WORLD'S CRUDE OIL EXPORTS (ABOUT 16 MILLION BARRELS PER DAY) PASS INTO OR OUT OF THE PERSIAN GULF THROUGH THE STRAIT OF HORMUZ, WHICH SEPARATES IRAN FROM THE ARABIAN PENINSULA. THE IRAN-IRAQ WAR PLAYED OUT HERE IN PART AS A "TANKER WAR," WITH EACH COUNTRY ATTACKING CIVILIAN COMMERCIAL SHIPPING IN THE GULF IN AN ATTEMPT TO GAIN THE UPPER HAND, AND THE AREA IS AN ECONOMIC AND POLITICAL HOTSPOT. AN EXAMPLE OF THE GULF'S ROLE IN INTERNATIONAL TENSIONS IS EVIDENT IN FORMER U.S. FEDERAL RESERVE CHAIRMAN ALAN GREENSPAN'S STATEMENTS IN A SEPTEMBER 2007 INTERVIEW WITH THE *WALL STREET JOURNAL:* "MY VIEW OF THE SECOND GULF WAR WAS THAT GETTING SADDAM OUT OF THERE WAS VERY IMPORTANT, BUT HAD NOTHING TO DO WITH WEAPONS OF MASS DESTRUCTION, IT HAD TO DO WITH OIL. MY VIEW OF SADDAM OVER THE 20 YEARS ... WAS THAT HE WAS VERY CRITICALLY MOVING TOWARDS CONTROL OF THE STRAIT OF HORMUZ AND AS A CONSEQUENCE OF THAT, CONTROL OF THE OIL MARKET."

In the heart of the Persian Gulf is the island of Kish, which the late shah had begun developing as an international luxury resort and which, amid economic reconstruction and reforms by former president Hashemi Rafsanjani, was eventually developed as a free-trade zone (along with the gulf island of Qeshm). The Kish Free Zone Organization targets foreign investment and promotes the island's offshore banking opportunities. The development of Kish is an attempt to create a kind of Iranian Dubai, with duty-free shopping malls selling everything from TVs to copies of well-known clothing brands to decorative items with Persian bling. It is a popular holiday and honeymoon destination for Iranians who have few opportunities to leave Iran, and the atmosphere there is more relaxed than in mainland Iran. It's a place to figuratively let your hair down. Well-off Iranian city dwellers own apartments on the island, where they can vacation in the winter months. During the summer months, with temperatures rising to 100 degrees Fahrenheit and high humidity, most stay away. The estimated island population is 20,000, with approximately 1. million people visiting each year from the mainland and other gulf states.

Men and women are able to bowl together but not bathe together in the crystal clear waters. Such prohibitions had been relaxed in the 1990s but returned with the 2005 election of conservative President Mahmoud Ahmadinejad. Men are allowed to swim right outside their hotels, while women must use the remotely located Women's Beach Club, which is surrounded on three sides by a seven-foot-high fence.

A foreign female visitor described the Kish segregated bathing experience to me. At the entrance, two young women searched her bags. All cameras and camera phones had to be left in the dressing room. A third woman frisked her for hidden cameras. While there was no topless bathing, she said that there were as many thongs, tattoos and piercings as you would find on a beach in Europe. And of course the lifeguards are women.

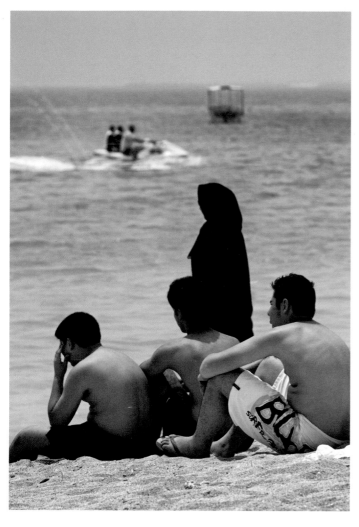

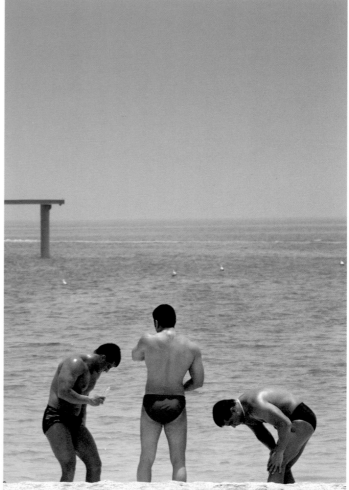

ABOVE, LEFT
Women must keep their bodies and heads covered on any beach on the island of Kish except for one fenced-off area for women only. The island is a popular holiday and honeymoon destination.

ABOVE, RIGHT AND OPPOSITE
Bathers on the beach on the island of Kish. Women may go to any beach but must remain fully covered, while Speedos seem to be popular attire with men.

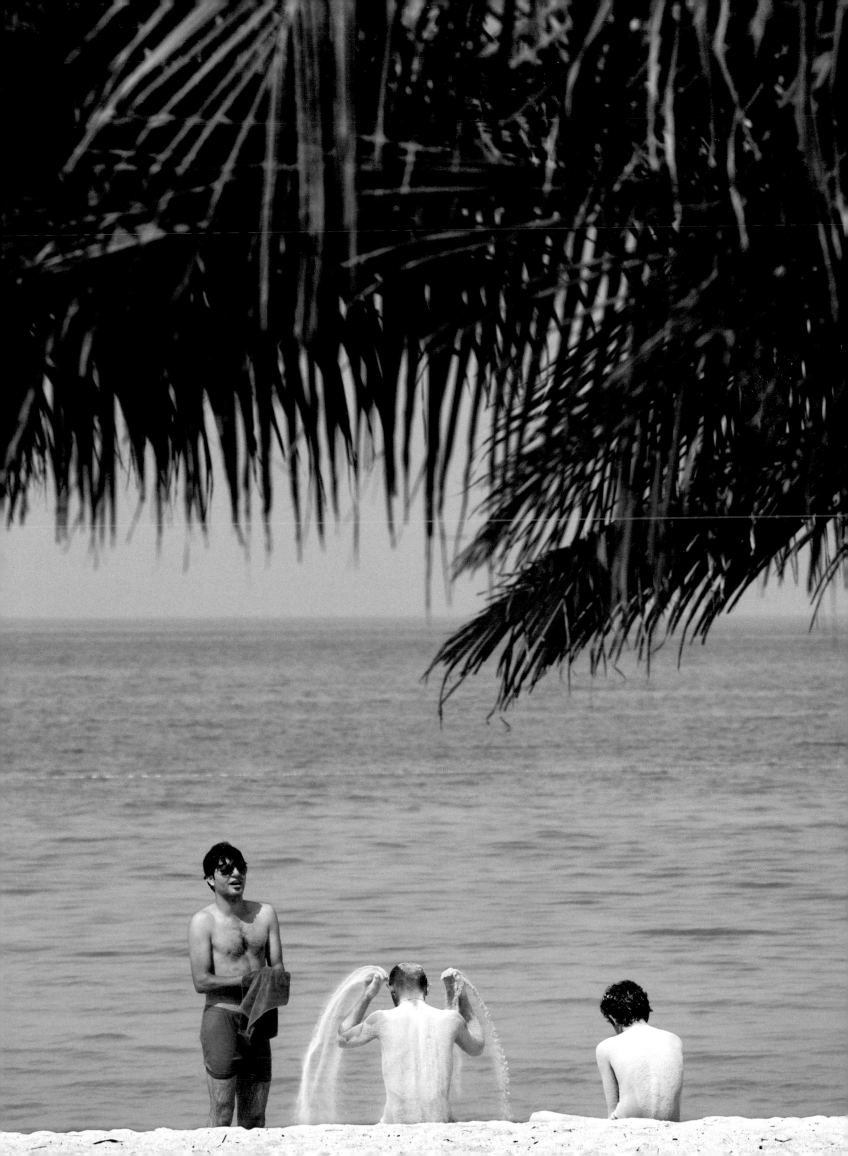

ABOVE AND OPPOSITE, TOP
The Dolphin Park is one of Kish's main nonshopping attractions.

OPPOSITE, BOTTOM
A restored and colorfully lit 2,000-year-old cavern known as a *payab* (bottom of the sea) on the island of Kish. The ancient inhabitants collected and stored rainwater in these underground reservoirs.

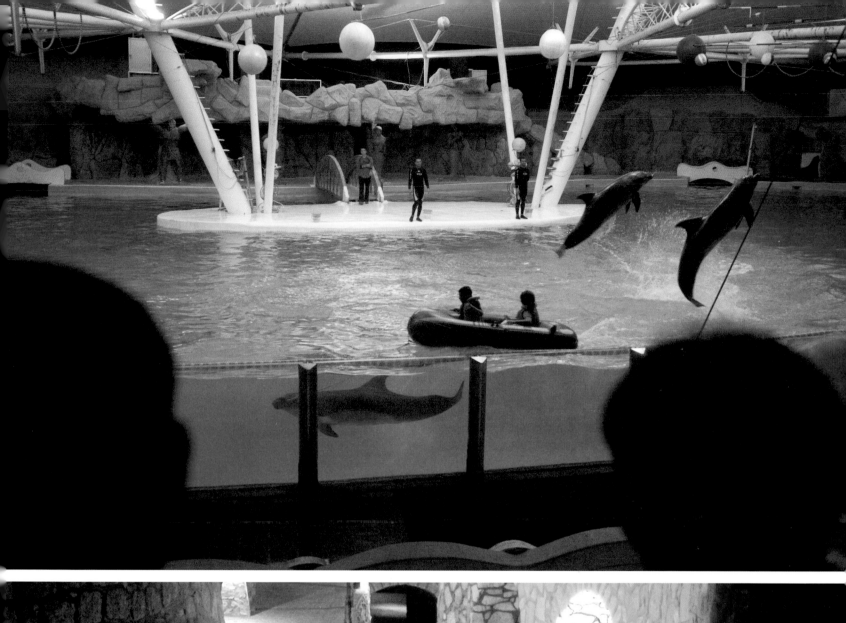

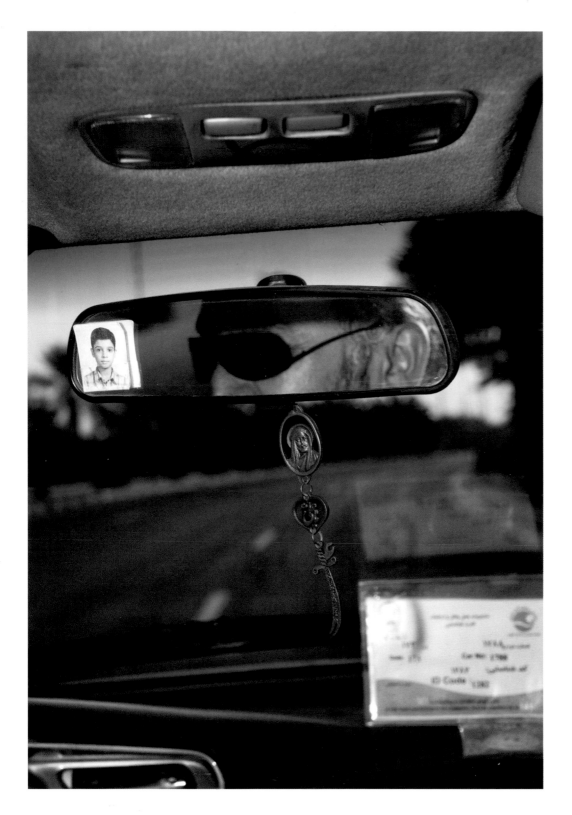

ABOVE
A taxi driver has a picture of his son and an amulet with the image of Ali, the
first imam, hanging from his rearview mirror.

OPPOSITE, TOP
A group of Filipinas who came to the island from the United Arab Emirates
play pool while they wait for their new visas for that country, where they
work as housekeepers and nannies. Kish is a popular destination for this
purpose.

OPPOSITE, BOTTOM
The interior of one of several malls on Kish, an island in the Persian Gulf
known for its duty-free shopping.

KISH ISLAND AND THE PERSIAN GULF

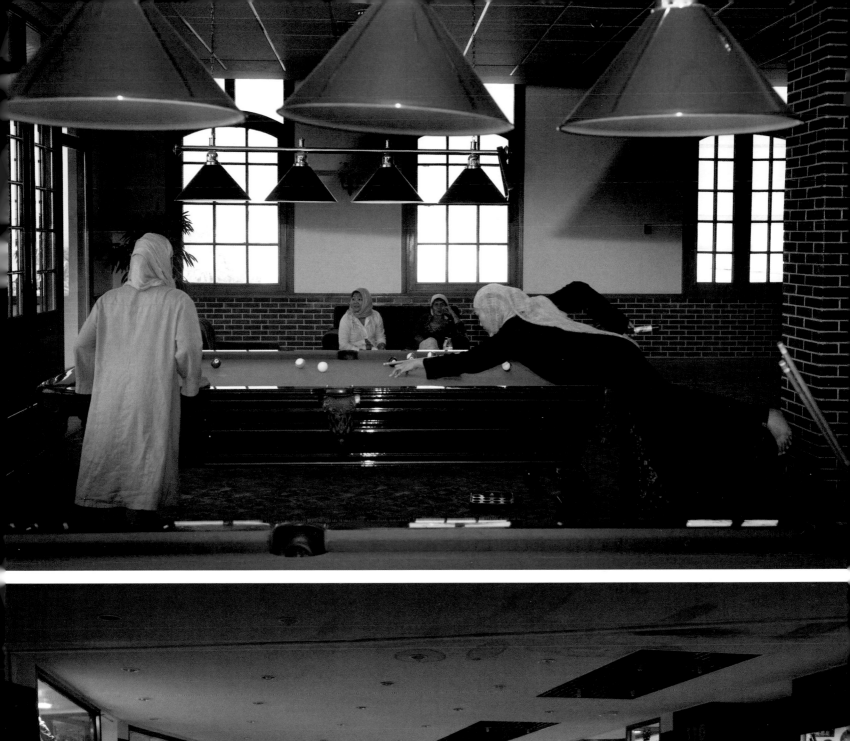

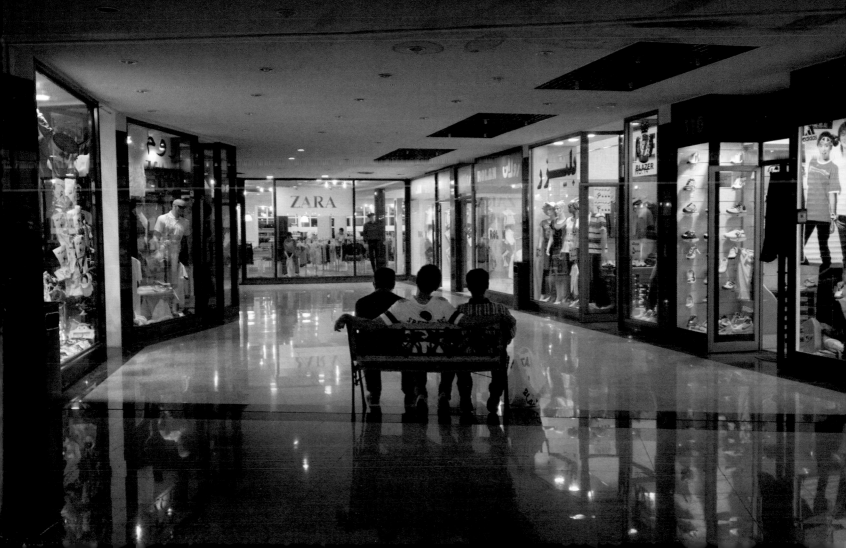

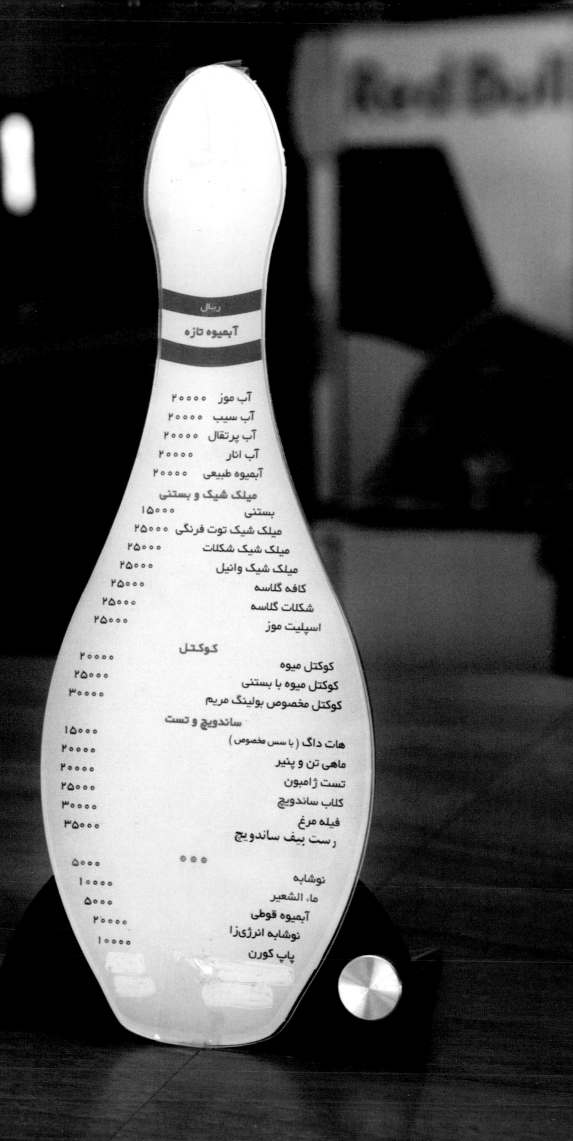

ریال

آبمیوه تازه

آب موز ۲۰۰۰۰
آب سیب ۲۰۰۰۰
آب پرتقال ۲۰۰۰۰
آب انار ۲۰۰۰۰
آبمیوه طبیعی ۲۰۰۰۰

میلک شیک و بستنی

بستنی ۱۵۰۰۰
میلک شیک توت فرنگی ۲۵۰۰۰
میلک شیک شکلات ۲۵۰۰۰
میلک شیک وانیل ۲۵۰۰۰
کافه گلاسه ۲۵۰۰۰
شکلات گلاسه ۲۵۰۰۰
اسپلیت موز ۲۵۰۰۰

کوکتل

کوکتل میوه ۲۰۰۰۰
کوکتل میوه با بستنی ۲۵۰۰۰
کوکتل مخصوص بولینگ مریم ۳۰۰۰۰

ساندویچ و تست

هات داگ (با سس مخصوص) ۱۵۰۰۰
ماهی تن و پنیر ۲۰۰۰۰
تست ژامبون ۲۰۰۰۰
کلاب ساندویچ ۲۵۰۰۰
فیله مرغ ۳۰۰۰۰
رست بیف ساندویچ ۳۵۰۰۰

٭ ٭ ٭

نوشابه ۵۰۰۰
ماء الشعیر ۱۰۰۰۰
آبمیوه قوطی ۵۰۰۰
نوشابه انرژی‌زا ۲۰۰۰۰
پاپ کورن ۱۰۰۰۰

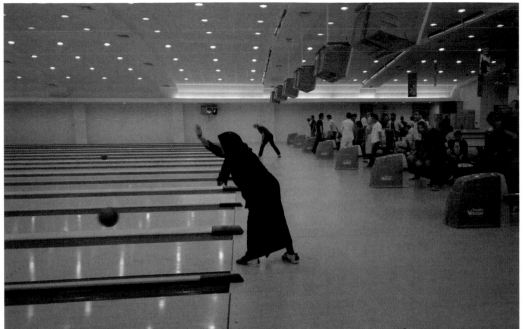

OPPOSITE
A snack menu at the Maryam
Bowling Center.

LEFT, TOP AND BOTTOM
Unlike at the bowling alley in
Mashhad, men and women can
bowl together on Kish.

FOLLOWING SPREAD
A grandfather holds up his grand-
daughter as the sun sets behind the
stranded Greek cargo ship *Koula F*,
which ran aground here in 1966.
I showed the proud grandfather the
image on my camera's LCD screen and
was rewarded with a big kiss on the
cheek.

195

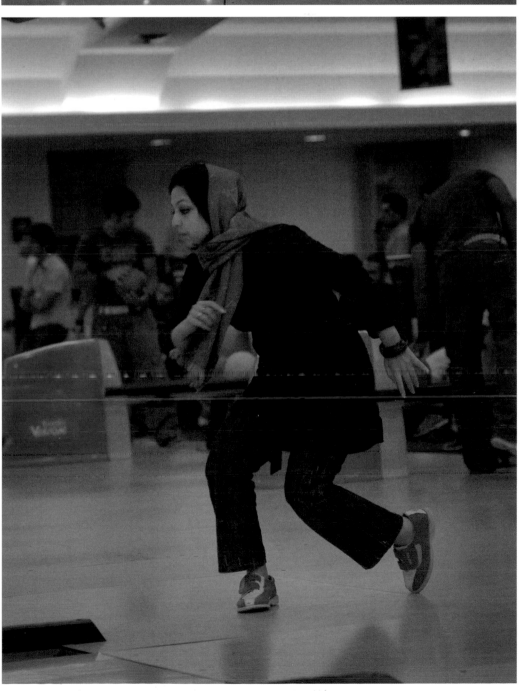

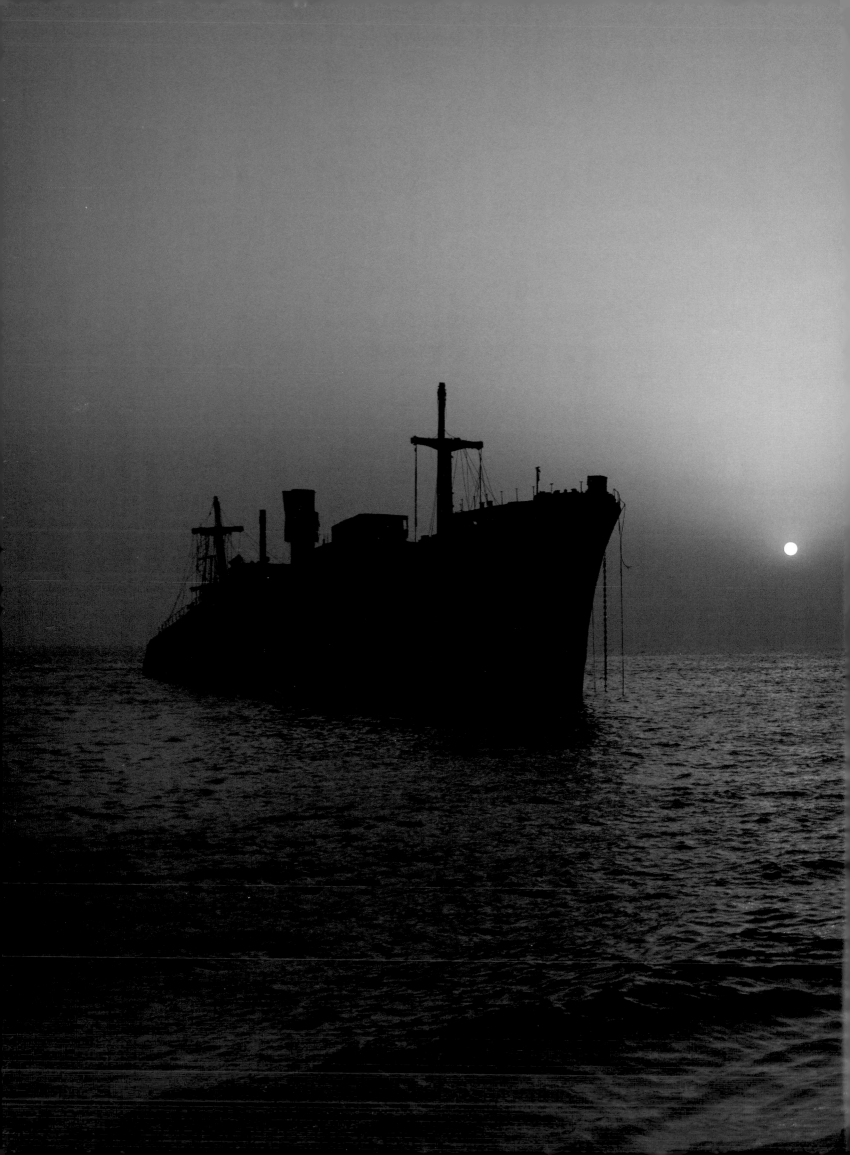

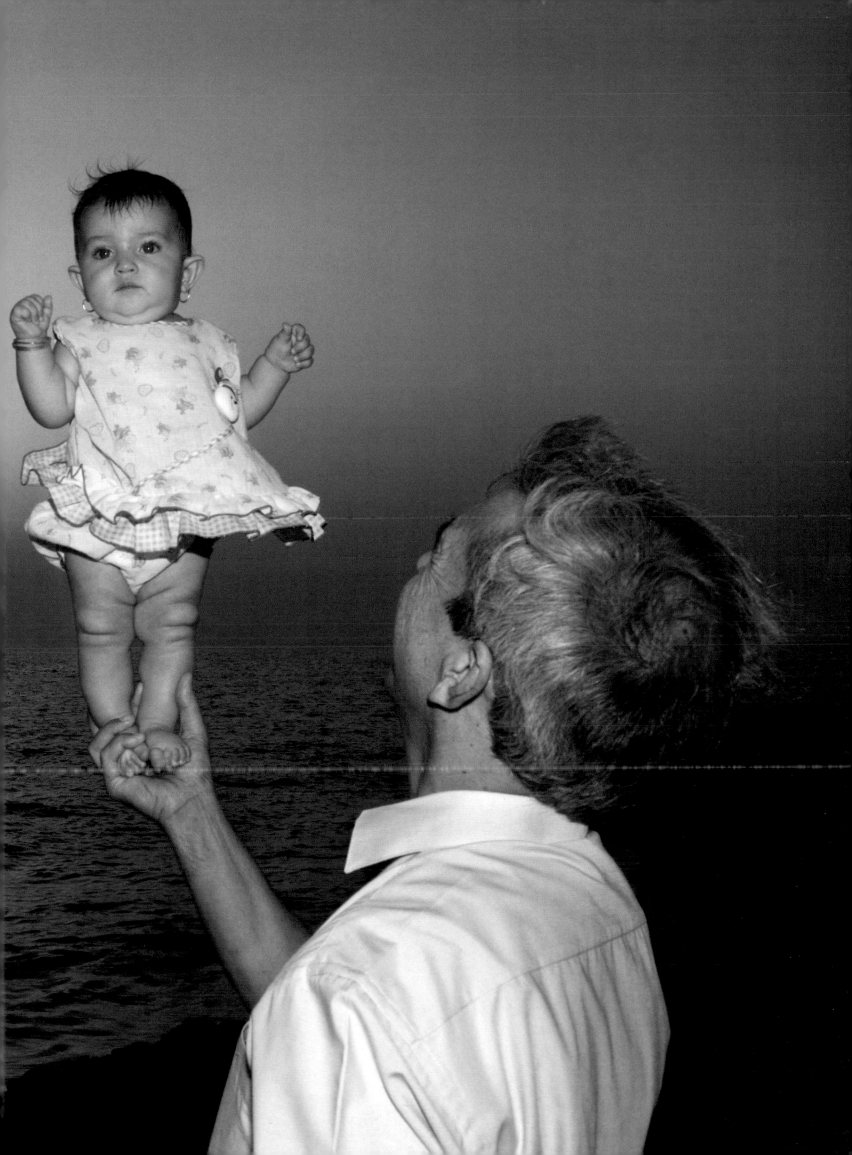

THE SHATT
AL-ARAB
WATERWAY

THE SHATT AL-ARAB (COAST OF THE ARABS) IS THE DIVIDING LINE BETWEEN THE ARAB WORLD AND THE PERSIAN WORLD. THERE ARE TWO MAJOR IRANIAN PORT CITIES—ABADAN AND KHORRAMSHAHR—ON THE 110-MILE WATERWAY THAT FLOWS FROM THE CONFLUENCE OF THE TIGRIS AND EUPHRATES RIVERS IN IRAQ. BEFORE IT EMPTIES INTO THE PERSIAN GULF, THE WATERWAY IS JOINED BY IRAN'S KARUM RIVER. AT ITS SOUTHERN END, IT SERVES AS THE DIVIDING LINE BETWEEN IRAN AND IRAQ.

When Saddam Hussein attacked Iran, initiating the 1980–1988 war known to the Iranians as the Iraqi-Imposed War, Abadan and Khorramshahr were in harm's way. Signs of the violence are still visible throughout these cities and the waterway that separates the two countries. The memory of that confrontation is still fresh in the hearts and minds of the Iranian people, and it certainly shapes the government's international policies. Town after town throughout the country has memorials to the estimated half a million Iranians who lost their lives in that war.

Hussein attacked when he thought the Iranians would be the most vulnerable, with the dissolution of much of the shah's forces due to the Islamic revolution a year earlier. He also felt that Iran's newly formed Islamic government would get little help from the West. A major motivation for Hussein was the desire to gain complete control over the waterway, his only major access point to the gulf. By contrast, the Iranians have hundreds of miles of Persian Gulf coastline in addition to the Shatt al Arab.

On March 23, 2007, Iran's Revolutionary Guards captured fifteen British marines and sailors near the mouth of the Shatt al-Arab, claiming that they had crossed a median line into Iranian waters. They were released two weeks later.

OPPOSITE

A shot-up door with a map of Iran on display at the Holy Defense Cultural Center in Khorramshahr. The Iranians recaptured the city on May 24, 1982, after two days of intense street fighting, taking 19,000 Iraqi soldiers prisoner. At one point Saddam Hussein was stranded in the middle of the city, surrounded by Iranian forces with Iraqi troops unable to rescue him, but he was ultimately able to cross back into Iraq. The Iranians executed more than 2,000 prisoners in revenge for the rape of Iranian women early in the war. In Iraq, May 24 is known as Martyr's Day, and the Iranians remember it as the Liberation of Khorramshahr.

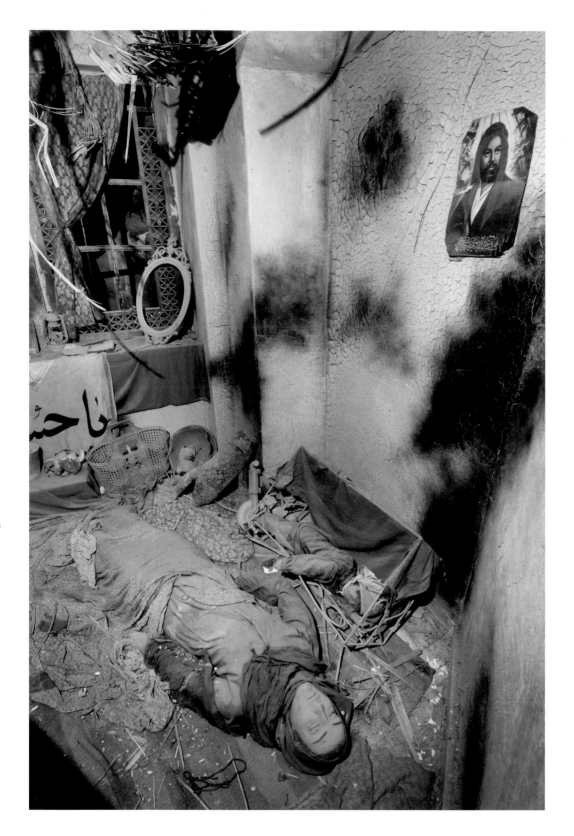

200

ABOVE
A display at the Holy Defense Cultural Center in Khorramshahr showing the
civilian toll from the Iran-Iraq War.

OPPOSITE
Destroyed tanks and countless bullet-riddled buildings stand as testament
to the fierce street fighting that took place in and around Khorramshahr
during the Iran-Iraq War.

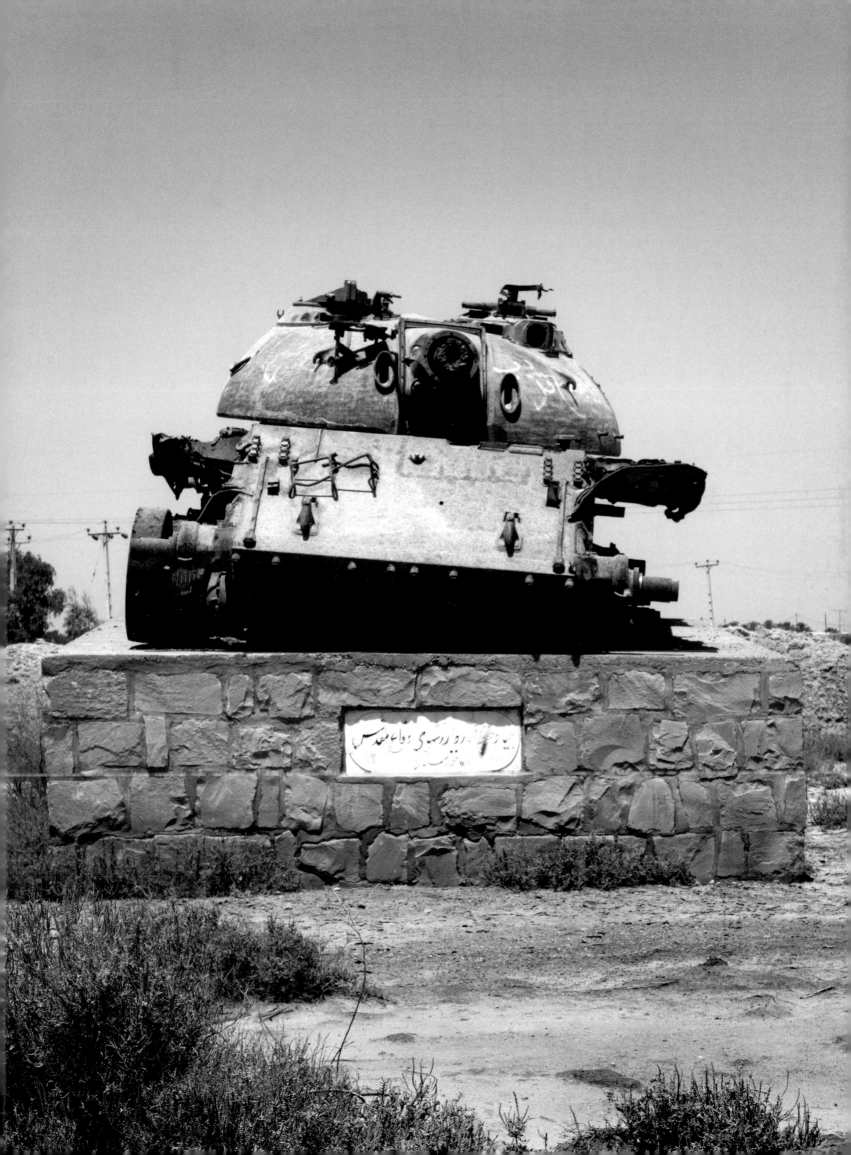

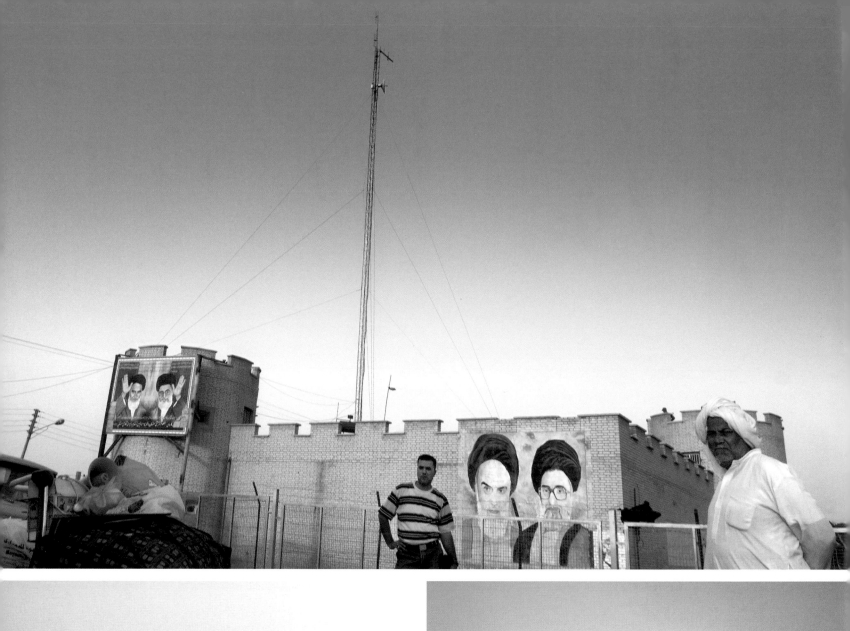
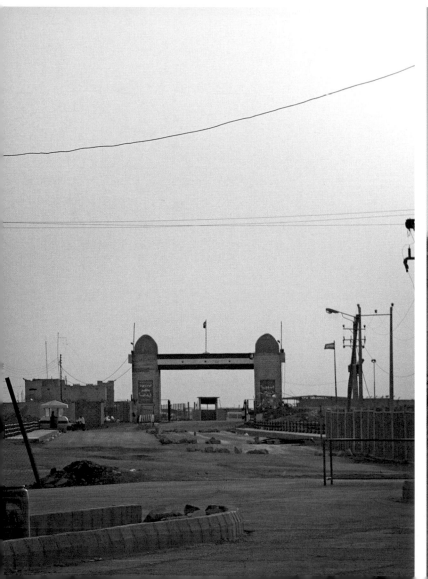
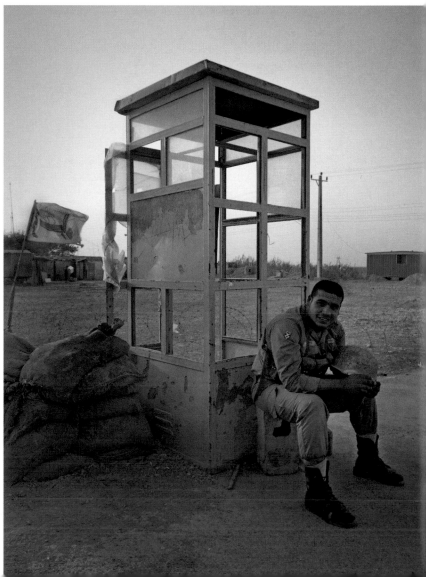

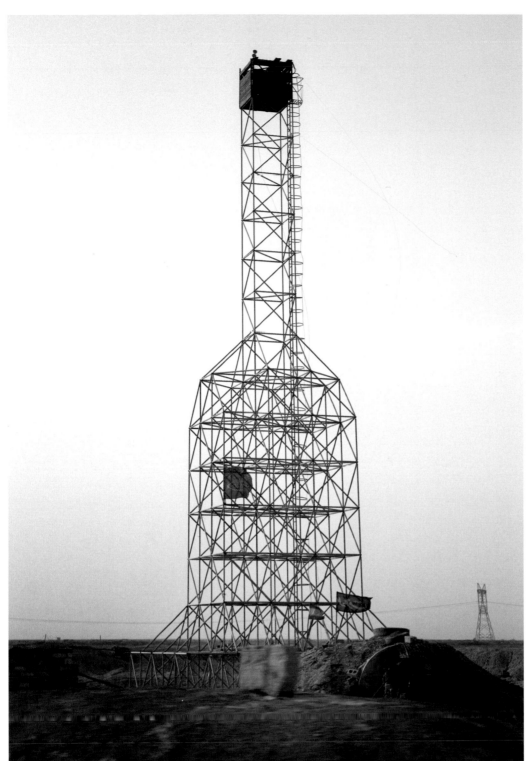

OPPOSITE, TOP
The Iranian side of the Iran-Iraq border near Khorramshahr. There is a small Iranian military outpost and a building with a waiting room for people who want to cross the border. Basra, Iraq's second largest city, is a twenty-minute drive away.

OPPOSITE, BOTTOM LEFT
The Iran-Iraq border near Khorramshahr.

OPPOSITE, BOTTOM RIGHT
An Iranian soldier at his post near an old telephone booth at the Iran-Iraq border.

LEFT
An observation tower near the Iran-Iraq border north of Khorramshahr. This no-man's-land is a dry, flat, and featureless landscape still strewn with land mines.

203

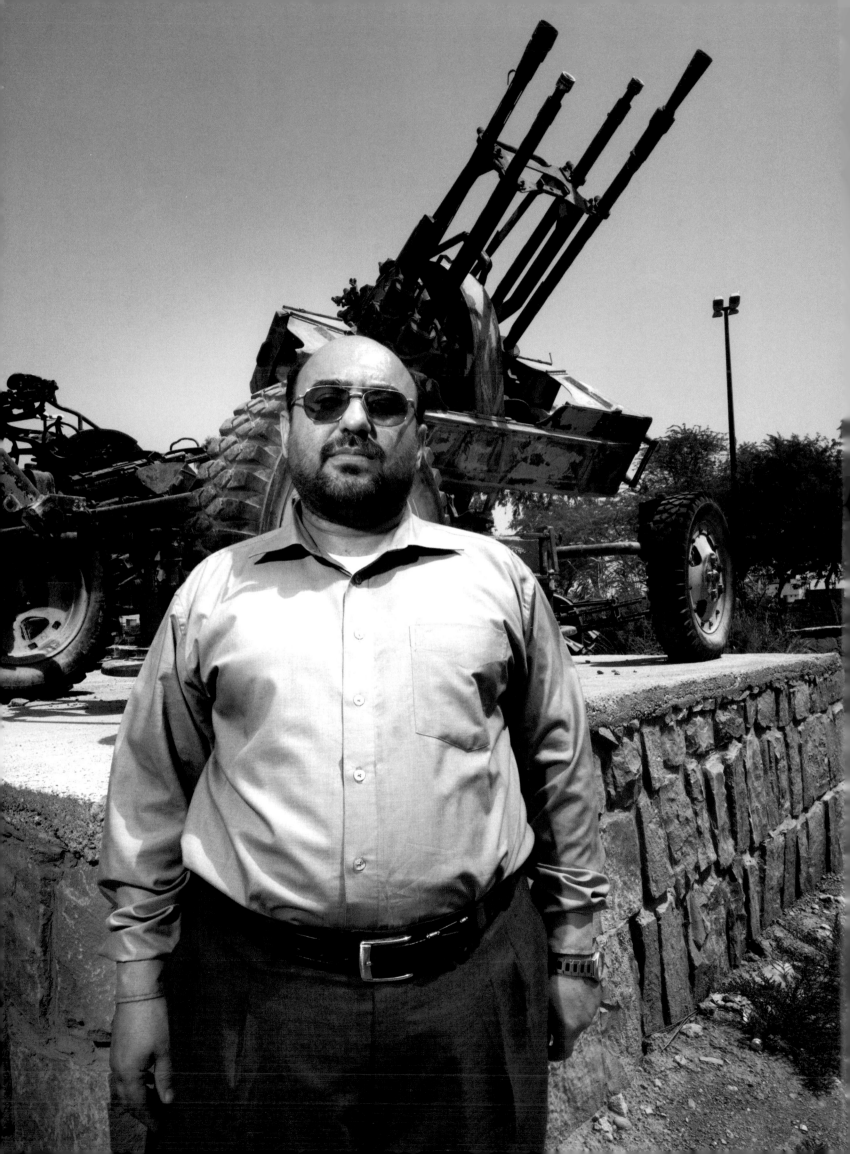

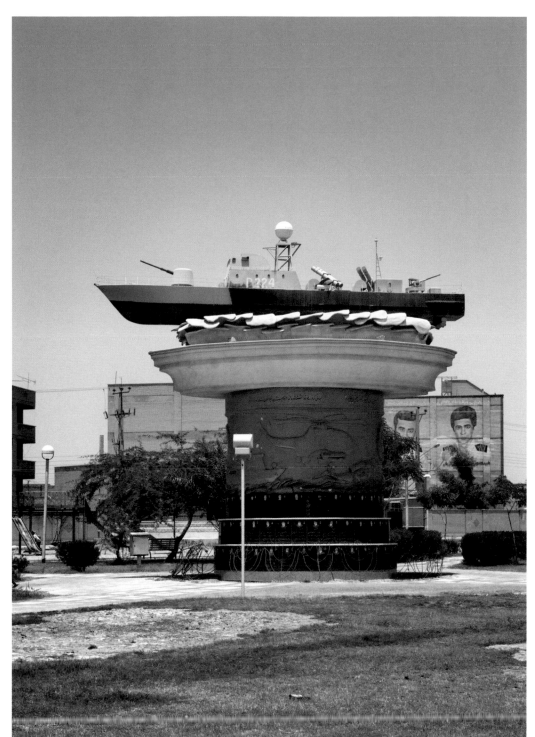

OPPOSITE
The Holy Defense Cultural Center in Khorramshahr is located in a building that functioned as the headquarters for the Iraqi forces during the Iraqi occupation of the city. Khorramshahr was captured at the beginning of the Iran-Iraq War in 1980 and was finally liberated in 1982. Outside the center, U.S. and Israeli flags are painted on the ground in front of the entrance, an invitation for visitors to step on them.

After my visit I was invited to have tea and a discussion with the director of the museum, who is also a journalist and a war veteran. We were able to have a frank and friendly exchange of views on the relationship between Iran and the United States. One incident that still weighs heavily in the minds of Iranians in relation to the United States is the encounter between the USS *Vincennes* and Iranian Air flight 655 in the final year of the Iran-Iraq War.

The Airbus A300 with 290 passengers and crew was shot out of the air on July 3, 1988, by the guided missile cruiser USS *Vincennes* near the Strait of Hormuz in a grievous case of mistaken identity.

LEFT
A naval display in Khorramshahr.

205

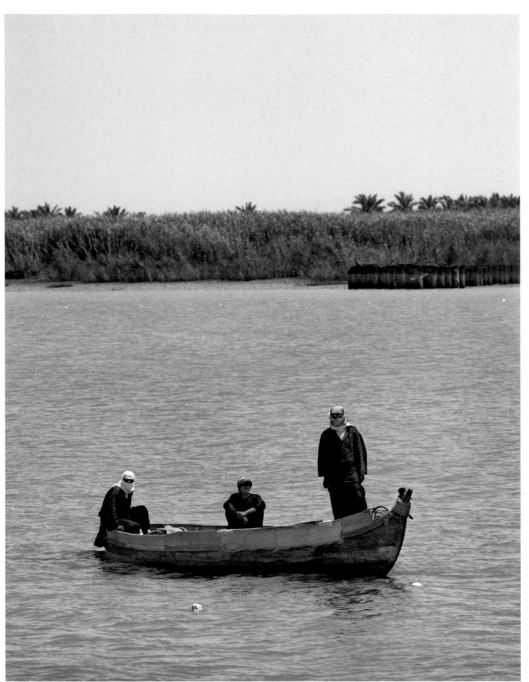

206

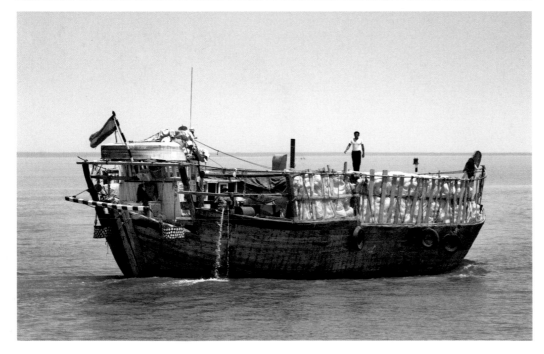

LEFT, TOP
Iraqis on the Shatt al-Arab.

LEFT, BOTTOM
An Iranian boat filled with cargo makes its way down the Shatt al-Arab waterway.

OPPOSITE, TOP
An oil refinery in Abadan on the Shatt al-Arab waterway. The city of Abadan was constructed initially as a company town by the Anglo-Persian Oil Company in 1909 (renamed the Anglo-Iranian Oil Company in 1935). Iranian Prime Minister Mohammed Mossadegh nationalized the company and the country's oil industry in 1951, leading to a British embargo on Iranian oil and American C.I.A. involvement in a coup that would reinstate exiled Shah Mohammed Reza Pahlavi by 1953. In a speech on U.S.-Iranian relations in March 2000, U.S. Secretary of State Madeleine Albright acknowledged, "The coup was clearly a setback for Iran's political development, and it is easy to see now why many Iranians continue to resent this intervention by America in their internal affairs." The shah was later removed from power during the 1979 Islamic revolution.

OPPOSITE, CENTER
An Iranian military outpost along the Shatt al-Arab.

OPPOSITE, BOTTOM
The Iraqi city of Al-Faw on the Shatt al-Arab. In the 2003 U.S.-led invasion of Iraq, the waterway was a key military target for the coalition forces. The British Royal Marines made an amphibious assault, capturing oil installations and shipping docks at Umm Qasr on the Al-Faw Peninsula at the beginning of the war.

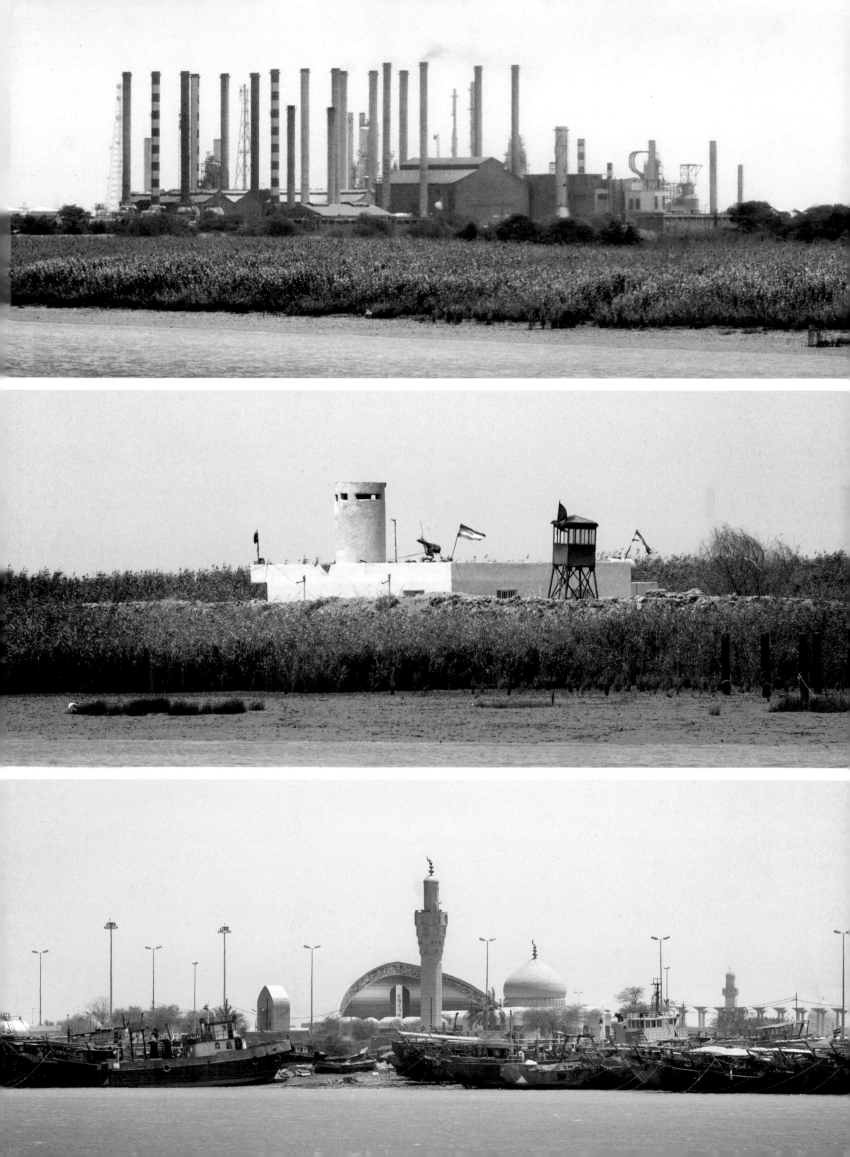

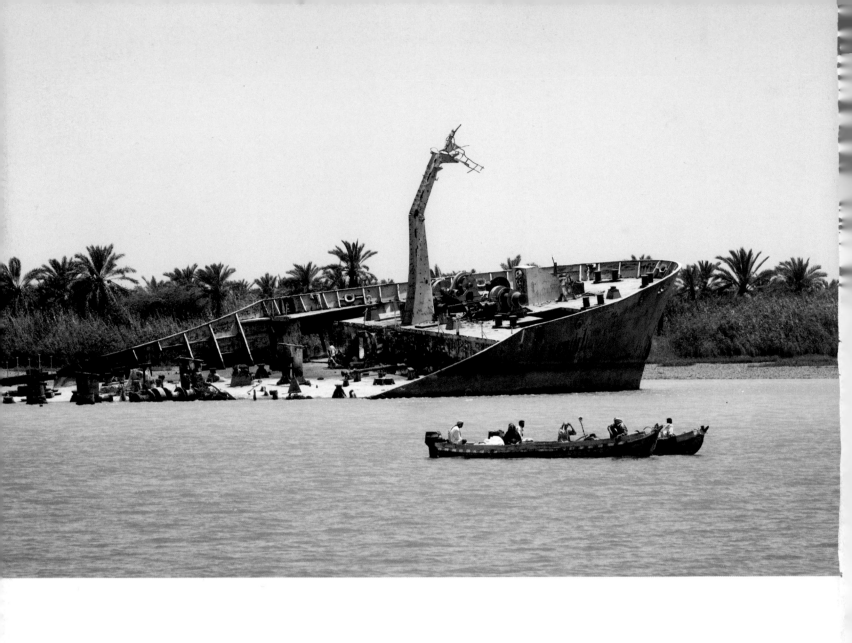

Iraqis pass the *Al Tanin*, which was caught in the crossfire of the Iran-Iraq War. Twenty-three Britons were rescued from the Iraqi side. Tankers of Iranian and Iraqi oil routinely flow past half-submerged casualties of war down to the Persian Gulf and out to markets worldwide.